UNCLE TOM'S CABIN

AS VISUAL CULTURE

UNCLE TOM'S CABIN

AS VISUAL CULTURE

JO-ANN MORGAN

University of Missouri Press Columbia and London

Copyright © 2007 by
The Curators of the University of Missouri
University of Missouri Press, Columbia, Missouri 65201
Printed and bound in the United States of America
All rights reserved
5 4 3 2 1 11 10 09 08 07

Library of Congress Cataloging-in-Publication Data

Morgan, Jo-Ann.
Uncle Tom's cabin as visual culture / Jo-Ann Morgan.
p. cm.
Summary: "Examines the artwork of Hammatt Billings, George Cruikshank, Winslow
Homer, Eastman Johnson, Henry Ossawa Tanner, and Thomas Satterwhite Noble to
show how, as Uncle Tom's Cabin gained popularity, visual strategies were used to
coax the subversive potential of Stowe's work back within accepted boundaries that
reinforced social hierarchies"—Provided by publisher.
Includes bibliographical references and index.
ISBN-13: 978-0-8262-1715-8 (hard cover : alk. paper)
ISBN-10: 0-8262-1715-X (hard cover : alk. paper)
 1. Stowe, Harriet Beecher, 1811-1896. Uncle Tom's cabin. 2. Uncle Tom (Fictitious
character) 3. Southern States—In literature. 4. Art and society—United States—
History—19th century. 5. Art and literature—United States. 6. African Americans in
art. 7. National characteristics in art. I. Title.
PS2954.U6M67 2007
813'.3—dc22 2006035380

♾ This paper meets the requirements of the
American National Standard for Permanence of Paper
for Printed Library Materials, Z39.48, 1984.

Designer: Jennifer Cropp
Typesetter: Bookcomp, Inc.
Printer and binder: Thomson-Shore, Inc.
Typefaces: Palatino and Golden Cockerel

For Natasha

Honor your history to know
who you are and what you must do

CONTENTS

ACKNOWLEDGMENTS

In a misty-eyed, heart-pulsing swoon, which I imagined to be much like that of a nineteenth-century woman encountering Uncle Tom, Aunt Chloe, Eliza, and Cassy for the first time, I found myself transported from my doctoral studies at the University of California, Los Angeles to the slave cabins of the antebellum South through the guilty pleasure of reading sentimental fiction. Harriet Beecher Stowe's *Uncle Tom's Cabin* was not an assigned text, nor something regularly studied in art history programs. My curiosity had been piqued by references to the author and her famous characters and to the members of the Beecher family that kept cropping up in historical and cultural accounts about nineteenth-century America. As I delved into visual representations of African American women in paintings and prints—my eventual dissertation topic—mine became an odd study plan, a search into all the corners of our culture that took in the requisite canonical works of American art along with nearly forgotten broadsides, sheet music, trade cards, and book illustrations. I was intrigued by the similarity between the individuals described in the novel: light-skinned young slaves, hefty cooks, and pious mothers, and the images of females found elsewhere. Even full-figured Aunt Jemima and her pancakes of 1890s advertising fame had a precedent in Uncle Tom's wife Aunt Chloe with her "plump countenance" and "hoe-cakes, dodgers, muffins." On a hunch, I sought out Stowe's original 1852 edition in the UCLA Special Collections and was delighted to find that it was illustrated, for this brought the book within the purview of art history.

My first teaching job took me to Cottey College, into the rural wonderland of western Missouri where a favorite weekend pastime is attending the outdoor auctions at which I began acquiring black collectibles. This

coincided with the rise of ebay as an all-encompassing provider of information. I expanded my habitual quest for images of "Mammy" or "Aunt Jemima" to search for "Uncle Tom" and soon owned an original 1852 edition of the novel, with more illustrated versions to follow into my budding collection of "Tomiana." Finding so many playbills and posters for sale alerted me to Tom's extensive career on the stage and in motion pictures. With each acquisition questions emerged. How did Tom get so old? Why were pictures of him and the white child Eva so prevalent? How did the Christian father become that malignant epithet from the 1960s?

I was living near the Kansas border, where the events that precipitated the Civil War are as known as recent history. Our town had a Bushwhacker Museum in what was once the old jail. Bushwhacker Day is annually celebrated around the courthouse square with a parade and picnics. Civil War memorabilia are heatedly vied for, bringing high prices at auctions. At one estate sale, as I sat waiting to bid on a set of Arbuckle Coffee trade cards, a local fellow nodded toward the framed old print I had just bought. "Only $3.00. No one even bid on it," I marveled, holding up my picture of General William Tecumseh Sherman for his inspection. "Blue belly," he sneered. That sectional passions could still be triggered by an image further compelled my interest in the historical period of slavery, its aftermath, and the sensitive regional, racial, and political touch-points left in its wake.

I didn't know I was writing *"Uncle Tom's Cabin" as Visual Culture* at first. All the chapters began as conference papers, and I want to thank everyone who listened, asked questions, showed interest, or disagreed with me. Your attention has meant everything. Winslow Homer, the subject of chapter 4, is an artist highly esteemed by historians of American art, yet I couldn't shake my intuition that his depictions of ragged ex-slave women weren't really so different from popular images. In 1991, during my second year of graduate work, I presented on Homer's painting *A Visit from the Old Mistress* during a conference session on American art at an American Studies Association (ASA) meeting in Baltimore. I am grateful to Richard J. Powell, panel chair, for honoring my inchoate alternative opinion with the respect of disagreement. Homer's paintings continued to preoccupy me as a Predoctoral Fellow at the Smithsonian Museum of American Art (SMAA) in Washington, D.C. My thanks to William H. Truettner for serving as my advisor and to the congenial community of scholars and fellows in residence during that winter of the "blizzard of 1996." Thanks also to personnel at SMAA for the opportunity to speak on Winslow Homer in a lunchbox lecture the following year. I presented "Winslow Homer and the Picturesque Freedwoman" at an ASA conference in Detroit in 2000. Thanks to Jean Fagin Yellin for valuable commentary and to Patricia Hills for suggestions.

When a connection between Hammatt Billings, the first illustrator of Uncle Tom, and Winslow Homer became obvious, my idea for *"Uncle Tom's Cabin" as Visual Culture* gained momentum. I shared the discovery at a Southeastern College Art Conference (SECAC) held in Jacksonville in 2004. Thanks to Pamela H. Simpson for suggesting I submit that paper to the *SECAC Review.* I am grateful to Michael Duffy, the *SECAC Review*'s editor, for accepting "Winslow Homer Visits Aunt Chloe's Old Kentucky Home" for publication in 2005.

Henry Ossawa Tanner's painting *The Banjo Lesson* always struck me as more complicated than scholarly consensus held, which made chapter 5 as challenging as the chapter on Homer. The hardest paper I ever wrote was about Tanner's *The Banjo Lesson* for a panel on African American artists hosted by Leslie King-Hammond at a 1999 College Art Association (CAA) meeting in Los Angeles. Feedback from Dewey F. Mosby following the presentation buoyed my commitment to continue swimming against the tide of other points of view. I am extremely grateful for his more recent suggestions as chapter 5 neared completion.

I thank editors Kathy Merlock Jackson and William M. Jones for publishing "Picturing Uncle Tom with Little Eva: Reproduction as Legacy" in the *Journal of American Culture* (2004). This material that became chapter 1 was presented in 2003 at SECAC in Raleigh, chaired by Janet Headley, and at the American Culture/Popular Culture Association in New Orleans.

A presentation for a 2004 CAA meeting in Seattle, "Evangelical Christianity Hitches a Ride Down the River: Visual Texts of *Uncle Tom's Cabin,*" became chapter 2. My thanks to Charles Colbert for selecting my paper and for his thoughtful commentary. This research was shared at a "Symposium on Art and Religion" at the Gallery of the American Bible Society in New York City later that year. A longer version became a public lecture at the University of South Carolina, Columbia. I thank Bradford Collins for inviting me to speak and for then offering me a graduate course to teach from my research. Thanks also to Andrew Graciano, the art history coordinator at USC–Columbia, for continuing support of my teaching on African American topics.

In a public lecture at the Walters Art Museum in Baltimore in 2002, I spoke about African Americans in the paintings of Richard Caton Woodville, material now in chapter 5. Thanks to Pat Creswell for inviting me. A talk on Thomas Satterwhite Noble, at SECAC in Little Rock, 2005, became chapter 3, and I thank session chair Helen Langa for continuing encouragement.

I want to say a special thanks to Jay Kleinberg, the editor of the *Journal of American Studies*, for twice allowing me to resubmit versions of chapter 3 for

consideration before selecting to publish "Thomas Satterwhite Noble's Mulattos: From Barefoot Madonna to Maggie the Ripper" (2007). Thanks also to Natalie Zacek for critical reviews and generous advice.

Working with University of Missouri Press has been a joy. Beverly Jarrett is an ever-gracious director and editor-in-chief. She understood the importance of pictures and I am grateful so many can be included. I thank managing editor Jane Lago, Susan King for careful editing, and Beth Chandler, Karen D. Renner and everyone in marketing. Special thanks to Kenneth W. Goings and Ernestine Jenkins whose careful review of the manuscript produced valuable suggestions that improved the book.

Many helpful people at libraries and collections aided this work and it is my failing to not be more diligent in noting their names. The Archives Center at the National Museum of American History in Washington, D.C., has been a valuable resource for its vast collections of trade cards and sheet music. I thank personnel at Harvard Theater Collection, Houghton Library; American Antiquarian Society; Moorland-Spingarn Library, Howard University; UCLA Special Collections; and the Huntington Library. Thanks to Teresa A. Carbone from the Brooklyn Museum for securing permission from a private collector for me to reproduce an Eastman Johnson work, and to Paul Bernish of the National Underground Railroad Freedom Center for providing a transparency and permission to reproduce *Margaret Garner* at no charge. Thanks to the Harriet Beecher Stowe Center, Hartford, for sharing their treasure trove of Tom show posters and playbills, and to John Reazer for helping me photograph them.

Among academic faculty with whom I have worked, I thank Jill Sessoms, Charles Joyner, Preston McKever-Floyd, and John Beard in South Carolina for scholarly support; Michel Ashmore and Rusalyn Andrews in Missouri for friendship; and Will Hipps, Irene Liotis, and Christopher Gerteis for moral support. Thanks also to Rebekah Presson-Mosby for long-standing friendship and encouragement.

The American Council of Learned Societies through a Henry Luce Foundation Doctoral Dissertation Fellowship in American Art provided invaluable support to my initial research. I thank the Department of Art History at UCLA for twice awarding me Edward A. Dickson Fellowships and for the many professors who made a lasting impact on my career. From David Kunzle I realized that if Donald Duck comics are art history the field is boundless. Thanks to Jay Last for sharing his collection of popular lithography, through which Zena Pearlstone was my first guide to ephemera as a provocative intersection of race, class, and gender. Albert Boime set a high benchmark as I aspired to understand the representation of African Americans. I thank him for his example and for his support. Thanks to

Richard Yarborough and Valerie Smith for approving my doctoral topic. I feel blessed that Cécile Whiting was my dissertation advisor. Her advice and encouragement continue to be a reassuring beacon.

For years I dreamed of thanking family within the pages of a book and I am fortunate a husband and daughter now share this moment. I love you both. As a teenager I envisioned the perfect mate—a truck driver who wrote poetry, a builder with brains. In Charles Wright I found that ideal, a sculptor of steel who knows the history of art and African American culture. For all the times my daughter asked, "Are you going to be writing all day?" I dedicate this book with a prayer: May you find passions that leave you no choice but to give your best.

UNCLE TOM'S CABIN

AS VISUAL CULTURE

Introduction

Uncle Tom's Cabin was published more than 150 years ago, two years after Congress passed the Fugitive Slave Law. By requiring northerners to aid in the return of escaped slaves, that law brought the ugliness of slavery out into the open nationwide. Residents in border cities such as Cincinnati, where author Harriet Beecher Stowe lived from 1832 to 1850, were becoming habituated to the sight of pitiful runaways being led off in chains on their sorry trek back to the South and back into the bonds of slavery. Even before it was a book, installments of "Uncle Tom's Cabin; or, the Man That Was a Thing" appeared weekly in the abolitionist newspaper *National Era*, published in Washington, D.C., sharing the pages with coverage of the enforcement of the Fugitive Slave Law.[1]

Uncle Tom's Cabin is the story of a fugitive slave named Eliza, who fled with her young son over ice floes on the Ohio River to Cincinnati and then, with the help of northerners defying the Fugitive Slave Law, to Canada. Eliza was just one of more than one hundred fully realized characters that Stowe created in composing her novel. By personalizing for readers the lived experiences of slaves, Stowe's words profoundly influenced public attitudes about slaveholding, this law, and political events on the eve of the Civil War.[2] Many, including Abraham Lincoln, believed the novel changed

1. Susan Belasco Smith, "Serialization and the Nature of 'Uncle Tom's Cabin,'" 78–79.
2. Josephine Donovan, *"Uncle Tom's Cabin": Evil, Affliction, and Redemptive Love*, 13.

the course of history: during a private visit with Stowe and her son Charles in 1862, Abraham Lincoln reputedly said, "So this is the little lady who wrote the book that made this great war."

In *"Uncle Tom's Cabin" as Visual Culture* another kind of text will be considered: pictures. Stowe proposed the few episodes she envisioned about a slave named Tom to *National Era* editor Gamaliel Bailey by analogizing words as images. Her writing would prompt imagined pictures through which readers could visualize slavery. "There is no arguing with pictures and everybody is impressed with them, whether they mean to be or not," she said in her letter to Bailey.[3] Just as words create imagined pictures that leave a profound impression, actual pictures in a book are graphic vignettes that can reiterate the written text or that can pioneer new narratives within the reverie of the reader.

Illustrations were usually not found in antebellum fiction, especially that of a first-time novelist. Before Stowe was finished, her story had grown immensely, unfolding throughout forty-one segments in the antislavery press. When the time came to compile it all into a book, her publisher John P. Jewett of Boston may have calculated that enhancing the book with illustrations would cushion the shock of a necessary higher price for the two-volume set. He hired Hammatt Billings, a local illustrator and architect, who drafted six full-page engravings and a tiny imprint of Tom's wife, Aunt Chloe, at the cabin door for the title page and embossed cover. Not only did readers anguish over the written story of poor Eliza in her death-defying escape across the icy Ohio River, they saw Billings's drawing of the diminutive, nearly white figure shielded by a wisp of shawl as she swaddled her child and tripped barefoot in flight.

Neither the story nor the pictures remained stable entities. Within a year of publication, the novel, newly entitled *Uncle Tom's Cabin; or, Life among the Lowly,* had gone from page to stage. Three separate interpretations were scripted as plays that were mounted in New York City. With legal protection of copyright not instituted until 1856, adapters were free to do as they pleased with the story.[4] Nor were there royalty laws deeming intellectual property as deserving compensation. "From the autumn of 1852 until 1931, at least, *Uncle Tom's Cabin* was never 'off the boards' in America," according to biographer Forrest Wilson, although Stowe realized no profit from these performances or had any say in shaping the script.[5] Depending on the talents of a troupe, "Tom shows" would showcase certain characters

3. Forrest Wilson, *Crusader in Crinoline: The Life of Harriet Beecher Stowe,* 260.
4. Thomas F. Gossett, *"Uncle Tom's Cabin" and American Culture,* 260–61
5. Wilson, *Crusader in Crinoline,* 325.

or invent new ones.[6] Productions billed as "Double Mammoth" boasted that their shows included two Topsys, the popular little slave girl who tragically never knew her parents.[7] Several companies wowed audiences with huge dogs that pursued poor Eliza as she fled across the stage, even though there were no dogs at that point in the novel, while creaking pulleys moved wood and canvas constructions of "ice" along. Amateur productions of the story were perennial fund-raisers for community booster clubs into the 1950s. Beginning in 1903, until as recently as 1989, as new entertainment technology developed, Tom appeared in motion pictures.[8] A Jack Benny radio program featured a skit called "New Orleans," a takeoff on *Uncle Tom's Cabin* done in dialect.[9] Cartoon character Popeye's girlfriend Olive Oyl once acted the role of Eliza in animation. With each venue the story spawned posters, playbills, souvenir photo cards, and assorted ephemera.

Uncle Tom's Cabin was an international as well as a national best seller that was quickly translated into thirty-seven languages. It was especially popular in England, where, shortly after the initial U.S. printing, pirated versions were issued from twelve publishing houses. Several of these editions were illustrated.[10] John Cassell published the best-selling version, which included twenty-seven illustrations by George Cruikshank, who was known for illustrating the work of Charles Dickens. In the U.S., Jewett contracted with Billings for even more pictures for a second edition to be released before Christmas 1852. Between Billings and Cruikshank, the prototypes for later illustrators were established early. As had happened in the theater, without copyright protection, publishers too were free to amend, abridge, and bowdlerize Stowe's text. For the most part, the written story was kept intact, although when marketed for children it was regularly condensed. Pictures for the new books followed the popular trends: Tom the slave and Eva the slaveholder's daughter sitting together under a tree was ever present, although Eva's frock went from empire-style simplicity to frilly Gilded Age shirtwaist, while her wavy blonde hair eventually

6. Ralph Eugene Lund, "Trouping with Uncle Tom: Fay Templeton and Mary Pickford and All the Other Little Evas," 329–37; Christine Hult, "*Uncle Tom's Cabin*: Popular Images of Uncle Tom and Little Eva," 3–9.

7. Harry Birdoff, *The World's Greatest Hit: "Uncle Tom's Cabin,"* 5.

8. Ibid., 395–407.

9. Joseph Boskin, *Sambo: The Rise and Demise of an American Jester,* 180. Jack Benny radio script, November 3, 1932, 2.

10. Douglas A. Lorimer, *Colour, Class and the Victorians: English Attitudes to the Negro in the Mid-Nineteenth Century,* 85–86; Van Wyck Brooks, *The Flowering of New England, 1815–1865,* 420–21.

became Shirley Temple's ringlets. At times the pictures took on the qualities of stage performances.[11]

Because *Uncle Tom's Cabin* took form and became popular and influential on so many cultural fronts, there have been numerous investigations of it as written text, performed story, and cultural phenomenon. Literature studies are, understandably, the most prolific. As interest in women authors has increased in the last few decades, gender theorists have found new relevance in the novel. In that vein, an analysis Elizabeth Ammons made in 1977 posing Uncle Tom as the embodiment of feminine ideals still resonates today: "Stowe displays in *Uncle Tom's Cabin* a facility for converting essentially repressive concepts of femininity into a positive (and activist) alternative system of values in which woman figures not merely as the moral superior of man, his inspirer, but as the model for him." Tom was Stowe's ideal person—"pious, pure, non-competitive, unselfish, emotional, domestic, and outwardly submissive."[12] Writing soon after, Jane Tompkins concurred: "Out of the ideological materials at their disposal," sentimental novelists such as Stowe "elaborated a myth that gave women the central position of power and authority in the culture."[13]

In many respects, *Uncle Tom's Cabin* experienced a fate similar to the fine art/popular culture dichotomy that leaves engraved and lithographic prints less studied while oil paintings are respected historical record. Categorized as "sentimental" fiction, something women read, *Uncle Tom's Cabin* ranked beneath the "great American novels" that were written by men, and as a result, what was in fact a rather radical message could be dismissed as mere sentiment and relegated to a subclass of literature. According to Tompkins, Stowe's conservatism and choice to draft a domestic story centered on conventional women's roles and their traditional beliefs gave her novel its revolutionary potential.

> Stowe means to effect a radical transformation of her society. The brilliance of the strategy is that it puts the central affirmations of a culture into the service of a vision that would destroy the present economic and social institutions; by resting her case, absolutely, on the saving power of Christian love and the sanctity of motherhood and the family. Stowe relocates the center of power in American life, placing it not in the government, nor in the courts of law, nor in the factories, nor in the marketplace, but in the kitchen.[14]

11. Birdoff, *World's Greatest Hit,* 292–305.

12. Elizabeth Ammons, "Heroines in Uncle Tom's Cabin," 153.

13. Jane Tompkins, *Sensational Designs: The Cultural Work of American Fiction, 1790–1860,* 125.

14. Tompkins, *Sensational Designs,* 145.

The story reached most people by way of stage performances. Thomas Gossett wrote, "Perhaps as many as fifty people would eventually see *Uncle Tom's Cabin,* the play, for every one person who would read the novel."[15] No mere footnote to stage history, *Uncle Tom's Cabin* revolutionized American theatergoing. It was the first play ever performed as a full evening of entertainment, lasting into durations of five hours. Because of its popularity, productions of *Uncle Tom's Cabin* stayed in theaters for weeks and even months, inaugurating the long run. Matinees were established so that women and children could more easily enjoy the "moral" drama.[16]

The most profound effect *Uncle Tom's Cabin* has had on American culture may be the way the black characters have become familiar stereotypes. Everyone has heard the term *Uncle Tom* used in ways that share little resemblance to the fictional Tom of the novel. From the beginning, black critics were aware that Stowe had created, in the words of Richard Yarborough, a "Trojan horse named Uncle Tom." Stowe's "melodramatic story proved so captivating and her exposé of the abuses of slavery so moving" that her incursion into "male hegemony went largely unnoticed," as did the potential for any true advancement toward equality for African Americans. "Ultimately, Stowe's challenge to the racial and gender hierarchies in American society was bounded by the same assumptions that helped support the superstructure she strove to topple."[17] In perhaps the most frequently cited commentary on *Uncle Tom's Cabin* by an African American critic, James Baldwin made a similar observation in an essay he wrote in 1949. Baldwin used the novel to voice concerns about ongoing limitations faced by African Americans in mid-twentieth-century American society and the ineffectual results of relying on a so-called protest novel to effect change.[18]

For all the interest in Uncle Tom, *"Uncle Tom's Cabin" as Visual Culture* is the first examination of Stowe's work that focuses solely on the imagery related to the story. I am indebted to my predecessors whose research brought an awareness of how African Americans have been represented in American art and, especially, of how the popular arts have been complicit in this accounting. Groundbreaking in this respect was Albert Boime's *The Art of Exclusion: Representing Blacks in the Nineteenth Century,* in which he examined fairly well-known paintings, along with some lesser-known prints and popular art examples. Boime argued that in representing African Americans, nineteenth-century European American artists "visually rendered ideas [that] reinforce

15. Gossett, *"Uncle Tom's Cabin" and American Culture,* 260.
16. Birdoff, *World's Greatest Hit,* 9.
17. Richard Yarborough, "Strategies of Black Characterization in *Uncle Tom's Cabin* and the Early Afro-American Novel," 65–66.
18. James Baldwin, "Everybody's Protest Novel," 578–85.

institutional priorities," via a system of "visually encoding hierarchy and exclusion."[19] Boime was speaking of how blacks were marginalized as servants, for example, within pictorial enactments of American daily life.[20] Instances of hierarchy and exclusion of African Americans within fine art were in evidence at a Corcoran Gallery exhibition in 1990 called *Facing History: The Black Image in American Art, 1710–1940*.[21] This prominent show divulged the breadth of fine art in which African Americans have been depicted. Peter H. Wood and Karen C. C. Dalton's catalog, *Winslow Homer's Images of Blacks: The Civil War and Reconstruction Years*, for a 1988 exhibition at the University of Texas at Austin was another important study of African American representation. By showcasing the interrelatedness between Homer's paintings and the print engravings he made for *Harper's Weekly*, their study revealed how popular arts informed his work.[22] The institutional priorities of which Boime spoke are reinforced when designations of "high" art and "popular" culture go unquestioned. *"Uncle Tom's Cabin" as Visual Culture* strives to uncover why schemes of connoisseurship are enabled and why they persist.

Occasionally scholars who look at visual representations of African Americans mention artwork in which scenes from *Uncle Tom's Cabin* are depicted. Jan Nederveen Pieterse's *White on Black: Images of Africa and Blacks in Western Popular Culture* and Marcus Wood's *Blind Memory: Visual Representation of Slavery in England and America, 1780–1865*, both include discussion on illustrations of *Uncle Tom's Cabin*. In addition, there have been quite a few studies of advertising ephemera and collectibles in which Tom and other "uncles" are discussed at length.[23]

That characters from *Uncle Tom's Cabin* are known by physical appearances different from Stowe's descriptions of them in the book indicates how popular imagery insinuates itself into collective thought. Despite Stowe's original description of a "large, broad-chested, powerfully made man" and Billings's picture of a dark-haired man in the prime of life, Uncle

19. Albert Boime, *The Art of Exclusion: Representing Blacks in the Nineteenth Century*, 16.

20. See Elizabeth Johns, *American Genre Painting: The Politics of Everyday Life*.

21. See catalog by Guy C. McElroy, *Facing History: The Black Image in American Art, 1710–1940*.

22. Peter H. Wood and Karen C. C. Dalton, *Winslow Homer's Images of Blacks: The Civil War and Reconstruction Years*.

23. Jan Nederveen Pieterse, *White on Black: Images of Africa and Blacks in Western Popular Culture*, 61–62; Marcus Wood, *Blind Memory: Visual Representation of Slavery in England and America, 1780–1865*, 84–86, 157–205; *Ethnic Notions: Black Images in the White Mind*; Patricia A. Turner, *Ceramic Uncles and Celluloid Mammies*; Kenneth W. Goings, *Mammy and Uncle Mose: Black Collectibles and American Stereotyping*.

Tom is understood to be old. How and why did that happen? As if progeny of society, representations are reproduced and often take on new meanings, burlesques, but are partially accepted as true nevertheless. In the tradition of Stowe and Uncle Tom, Joel Chandler Harris began telling stories of Uncle Remus in newspaper installments in the *Atlanta Constitution* during the 1870s. Thomas P. Riggio calls Uncle Remus "a 'reconstructed' Uncle Tom." In 1880 Harris compiled these recollections of an idyllic South and a benign, if cagey, old black storyteller into an illustrated book. Although fictional, Harris's "uncle" is regarded as if he once existed, and by extension, other aging southern black men are readily believed to loll away sleepy summer days telling tales of crafty animals that begin "I'se gwine. . . ."[24] Thankfully, James F. O'Gorman, an architectural historian, became interested enough in the man who first pictured Uncle Tom to write *Accomplished in All Departments of Art: Hammatt Billings of Boston, 1818–1874.* As a result, Uncle Tom's origin can be traced not only to an author but also to an artist. That Tom's progenitors can be identified, however, in no way makes him a predictable icon.

Popular culture rarely issues from the consumer but rather is fashioned by someone with something to gain. In studying representations of African Americans in pictures, Michael D. Harris distinguishes between written word and picture: "Language, after all, is available to common folk and often is enlivened with new twists, spins, and value-added meanings in vernacular culture, but images are produced by the few to be consumed but seldom manipulated by the masses."[25] In the nineteenth century, a commercial illustrator was not all that different from a painter. Both worked for financial recompense, which usually came from the same business and publishing class of white male opinion-makers. Whether selling a product or promoting an ideology, the producer sustained the patron's place in society so that the patron could continue to manufacture goods and to keep his connections to power. Lines of demarcation between sentimental fiction genres and serious literature, which had held back Stowe's novel from "serious" consideration, and between fine art and commercial art insulate the patron/opinion-maker from questions about motives. The popular is presumed to be a wellspring from the common man, woman, and child, while perceptions of fine art are groomed as noble expressions of gifted artists funded by an erudite elite for the edification of all.

24. Grace Elizabeth Hale, *Making Whiteness: The Culture of Segregation in the South, 1890–1940,* 49; Thomas P. Riggio, "*Uncle Tom* Reconstructed: A Neglected Chapter in the History of a Book," 142.

25. Michael D. Harris, *Colored Pictures: Race and Visual Representation,* 15.

Jackson Lears credits the Italian Marxist Antonio Gramsci with using a concept of cultural hegemony to suggest how a separation between high art and mass culture functions.

> [R]uling groups dominate a society not merely through brute force but also through intellectual and moral leadership. In other words, a ruling class needs more than businessmen, soldiers, and statesmen; it also requires publicists, professors, ministers, and literati who help to establish the society's conventional wisdom—the boundaries of permissible debate about human nature and the social order. Outside those boundaries opinions can be labeled "tasteless," "irresponsible," and in general unworthy of serious consideration. Even if ordinary people do not embrace the conventional wisdom, it shapes their tacit assumptions in subtle ways.[26]

To protect a hierarchy of taste, critics, scholars, professors, and other guardians of culture maintain a consensus that painters are purveyors of proper accounts of African American life, while illustrators, engravers, and chromolithographers are merely crass commercial producers outside the bounds of valid commentary. By erecting, cultivating, and regulating a border between the tasteful and the tasteless, art historians run the risk of being handmaidens of conventional wisdom or guardians of culture and of the status quo and all that it sustains. While the works of Thomas Satterwhite Noble, Eastman Johnson, Winslow Homer, and Henry Ossawa Tanner, the painters whom this book will consider, are viewed as being exceptional, sensitive in their portrayals of African Americans, the mass-produced caricatures of illustrators operate as persuasive documentation, cajoling and ridiculing African Americans. It is no accident that the word *stereotype* was first a printer's term for a stamp cut that could be inserted with text in a linotype machine. As multiple images are reproduced they forge in the viewer's mind an association with the represented individual as a type, reduced to essential graspable characteristics and behaviors, leaving no room for a fully fleshed-out humanity.

As best it can, *"Uncle Tom's Cabin" as Visual Culture* strives to be an exposé of gatekeeping or of how tastemakers protect cultural hegemony. Andrew Ross argues that the function of experts—and the art historian falls into this category—"is precisely to discourage participation and self-determination, because experts tend to serve interests which depend upon maintaining control over the means of social reproduction." Popular culture must not

26. Jackson Lears, *Fables of Abundance: A Cultural History of Advertising in America,* 4–5.

only be a history of producers (artists, dramatists, writers) and a history of consumers, "It must also be a history of intellectuals—in particular, those experts in culture whose traditional business is to define what is popular and legitimate, who patrol the ever shifting borders of popular and legitimate taste."[27] Revelations posed in *"Uncle Tom's Cabin" as Visual Culture* may prove useful to those who wish to build upon the landmark work of the scholars cited here and of others who have already made incursions to expand the purview of art history and make elastic the boundaries between high art and mass culture. If this book collapses the borders further it will be from making specific canonical paintings subsidiary to a focus on general mass-produced, and frequently anonymous, engravings, commercial prints, and ephemera, which a cursory look at the fine art will bolster. Using the tools of the art historian, *"Uncle Tom's Cabin" as Visual Culture* approaches this important story from within the framework of pictures, held up by decades of artists, each saying in his (and they were men) own way, *"Regarde vous s'il vous plait"*—and see this my way.

What is at stake here is not proving what the novel was intended to mean or accomplish, or whether it was or is worthy of scholarly attention. That discussion has been and will likely continue among scholars in fields of literature, theater, and popular culture. By pursuing an analysis of what the pictures say, this book will shed new light on those inquiries. Nor is this study intended to elevate in stature the artists whose depictions of *Uncle Tom's Cabin* were mass-produced. Visual culture is a product of the times; whether it is well crafted, imaginative, or in any other way outstanding or avant-garde is irrelevant. As always, popular images are as good as they need to be to get produced and purchased. If an iconography is successful to promote an idea or sell a product it is likely to be recirculated so long as it maintains that vitality.

Of course, Noble, Johnson, Homer, and Tanner were inspired by many subjects in their productive careers, but only those paintings that relate to *Uncle Tom's Cabin* are of interest here. *"Uncle Tom's Cabin" as Visual Culture* is not meant to be a systematic review of fine art and artists; instead, the visual culture generated by the novel or influenced by it—illustrations, posters, commercial lithography—are at the core of this study. At times paintings do enter this alliance. When, where, and how have the visual texts of *Uncle Tom's Cabin* played a role in molding American perceptions about African Americans and about African Americans in relation to European Americans?

Foremost, *"Uncle Tom's Cabin" as Visual Culture* seeks to reveal how images do "cultural work," to borrow from Jane Tompkins's title phrase.

27. Andrew Ross, *No Respect: Intellectuals and Popular Culture*, 3–5.

From illustrations in novels to visual spin-offs inspired by the story and the characters, this book will follow the original Billings/Stowe pictures as they have manifested in evolving forms throughout the decades. Images do not merely augment and illustrate *Uncle Tom's Cabin,* they are a type of text to be read and deciphered. The pictures tell their own story and have their own historical significance.

THE CHAPTERS

"Uncle Tom's Cabin" as Visual Culture begins with the work of Hammatt Billings, the illustrator of the two book versions of *Uncle Tom's Cabin* published by Stowe.[28] A good induction in those first imagined inscriptions of the story and its characters provides the basis from which to assess pictorial multiplicities. How and why do visions alternately persist or reappear in new guise? Once the foundational imagery is established, *"Uncle Tom's Cabin" as Visual Culture* will isolate selected paintings by better-known artists made in the decades following emancipation to show the far-reaching impact *Uncle Tom's Cabin* had on American culture.

Each chapter is concentrated on a different selection of imagery related to *Uncle Tom's Cabin* that addresses post-Civil War social agendas—emancipation, Reconstruction, and southern redemption. These chapters will chart the influence of the story and the characters resonating between high art and mass culture, searching the realm of fine art to discover whether the visual language is similar to that first developed in popular art forms.

Thomas Satterwhite Noble will be the representative artist for a chapter looking at the postemancipation years. His *Last Sale of Slaves in St. Louis* of 1865 (repainted *ca.* 1870) was something of a throwback to an earlier era when abolitionist iconography featured gentle mothers and imperiled slave families up for sale. Pretty, sensitive, light-skinned, and Christian, young women in antislavery prints were barely discernable from genteel white women. Auction scenes, such as Noble's *Last Sale,* had been in both sets of Billings's illustrations, as were images of mothers embracing children. In addition, *Last Sale* and another Noble painting, *Margaret Garner,* featured women corollary to two of the characters in *Uncle Tom's Cabin.* Did *Uncle Tom's Cabin* influence Noble's paintings?

Another American painter whose work may share a connection with *Uncle Tom's Cabin* is Winslow Homer. The paintings of interest here are

28. Harriet Beecher Stowe, *Uncle Tom's Cabin; Or, Life among the Lowly* (Boston: John P. Jewett, 1852). Jewett produced a second edition in 1852 in time for the Christmas holiday; the second edition has a publication date of 1853.

those that were completed at the end of Reconstruction. Art historians are invested in Homer as an exception for what is perceived to be his sympathetic depictions of freed people. Homer was an illustrator who took up painting. In revealing ways, he appears to have utilized the same visual strategies in his paintings that illustrators of *Uncle Tom's Cabin* employed.

The final artist to be considered will be Henry Ossawa Tanner, an African American who is best known for a genre picture he made during the 1890s, a period awash in romanticized visions of the Old South and marked by a collective national trend toward southern redemption. Similar to the way Homer is believed to have been an exemplary artist who saw beyond the stereotypes of his African American subjects, scholars have argued that Tanner refuted the negative imagery so abundant across the popular arts, using as evidence his *The Banjo Lesson*. Was Tanner's painting of an old man and a boy playing a banjo in their humble home also a response to popular renditions of *Uncle Tom's Cabin*?

REPRODUCTION AS LEGACY

Probably the most influential picture ever made for *Uncle Tom's Cabin* was "Little Eva reading the Bible to Uncle Tom in the arbor," one of Billings's six full-page engravings for the original 1852 Jewett publication. In this cut, a grown black man in the prime of life huddles with a tiny white girl out in a garden. Their relationship as expressed in scores of pictures went on to enjoy unprecedented longevity across several arts. Billings's composition fronted sheet music for a song, "Little Eva: Uncle Tom's Guardian Angel," which was set to words by John Greenleaf Whittier. African American artist Robert Scott Duncanson was commissioned by James Francis Conover, the editor of the *Detroit Tribune,* in 1853 to immortalize the couple in an oil painting. In addition, the pair appeared together on several lithographic prints intended to grace the walls of middle-class homes. From 1852 on, illustrations of Tom with Eva were not only requisite in plagiarized copies of the book, but were often on the covers.

The Tom hugged by little Eva in the 1852 illustrations was a far cry from the old geezer she read to on the cover of many turn-of-the-century children's books. Tracking the popularity of Billings's conception of Stowe's Tom and Eva in chapter 1, "Picturing Uncle Tom with Little Eva: Reproduction as Legacy," is a way to examine how perceptions of African American men changed after slavery was abolished. Although Eva remained an idealized child, Tom, once a virile father, grew old, stooped, and white-haired. Tom seemed dependent on the tiny girl. Once he had read to her from his own treasured Bible, but later she supervised him as he scratched

out letters on a child's toy chalkboard. In looking at the many reissued and reconfigured images of Tom and Eva, it is clear that visual culture was a space of racial power negotiation that corresponded to shifting social, political, and economic conditions. Why this became the most frequently reproduced image, what it might have meant in the beginning, and how its meaning changed over time is in direct correspondence with the emerging needs of men in power. Remember, it was a woman who first brought Tom to life. Were midcentury viewers disturbed by the intimacy of the "broad-chested, strong-armed fellow" and the young white girl? Then why were there so many pictures of them in such chummy situations?

CHALLENGING PATRIARCHY

The story of Uncle Tom offers a renewed understanding of the phrase "sold down the river," for that was exactly what happened to this devout slave father. When Kentucky planter George Shelby fell into debt, Tom became the property tendered to settle his accounts. Shackled, in the cargo hold of the *Belle Rivière* as it sailed down the Mississippi to a New Orleans slave market, away from his loving family and the only home he had ever known, Uncle Tom still professed faith in a benevolent God. Stowe's portrayal of Tom shows that she believed in the humanity of slaves and that she believed them in possession of souls worth saving. The novel was published at a complex juncture of developing reform movements, any of which may feasibly have motivated her to write a novel that many alternately claim was endorsing abolitionism, evangelical Christianity, and/or women's rights.

In the immediate months after the novel was proven a phenomenal success, Billings produced a second set of images for a gilt-embossed Christmas edition. Within the 127 new cuts, there is almost no aspect of the story these illustrations do not address, making them an interesting partnership of words and pictures. Scholars continue to debate about the rhetorical strategies of the written text. Was it an antislavery plea, a Christian tract, or a woman's way to find a public voice? The pictures spoke directly to the reader using symbolic language of 1852. Both antislavery campaigns and Christian promotions had defined visual strategies with accessible iconography.[29] Billings may or may not have sensed Stowe's investment in one of these agendas, but he was dependent on available iconology all the same.

29. David Paul Nord, "The Evangelical Origins of Mass Media in America, 1815–1835," 23; Phillip Lapansky, "Graphic Discord: Abolitionist and Antiabolitionist Images."

When seen in succession, the pictures tell an interesting story of their own that may in fact complicate the interpretations literary scholars glean from the written story. Whether antislavery, evangelical Christian, or advancement of women's rights, in some way each social reform movement was an incursion into the status quo, a challenge to patriarchal institutions—slavery, the mainstream church, and the political arena.

There is no record that the artist ever met or discussed the book with the writer, yet Billings's prints gave form to Stowe's words in a project ostensibly abolitionist but with far broader implications. For his second set of images, Billings's engraving of "Little Eva reading the Bible to Uncle Tom in the arbor," which Billings biographer O'Gorman calls "the most important image of the first edition," was retained intact along with additional scenes of the two together. A strategically placed Bible on the young woman's lap seems at first glance to be there to dissuade sexual implications. O'Gorman contends that "Billings's images have been characterized as possessing both erotic and sacred connotations." Chapter 2 takes another look at configurations of Tom and Eva in order to ponder the sacred connotations. "[W]hether the relationship between Eva and Tom is seen as sexual or pious," O'Gorman continues, "Billings's images suggest an equality between them that was difficult to accept in the middle of the nineteenth century, north or south."[30] Might writer Stowe, with artist Billings as her accomplice, have been tacitly engaged in an even more subversive undertaking?

Chapter 2, "The Passion of Uncle Tom: Pictures Join Words to Challenge Patriarchy," contemplates the implications of that ponderous Bible open on Eva's lap. Most of the original six engravings showcased familiar abolitionist iconography of kneeling supplicants, imperiled slave families, and slave auctions. These events were reprised by Billings in his second set of illustrations for *Uncle Tom's Cabin,* which were augmented with new kinds of imagery. Perhaps this surfeit of illustrations will enable scholars to settle the debate. Was *Uncle Tom's Cabin* an antislavery novel that used Christian themes to elicit sympathy for the plight of slaves? Or was Tom's piousness Stowe's ploy to promote evangelical Christianity? These questions are asked of the visual text in that 1853 gift book.

RECONSTRUCTING THE MULATTO WOMAN

The Civil War spanned from 1861 to 1865, and the Emancipation Proclamation went into effect on January 1, 1863. Why then would Kentucky-born

30. James F. O'Gorman, *Accomplished in All Departments of Art: Hammatt Billings of Boston, 1818–1874,* 57.

Thomas Satterwhite Noble, a former Confederate soldier and the son of a slaveholder, have painted highly charged events of slavery in the aftermath of emancipation? *Last Sale of Slaves in St. Louis,* a repainted version of *The American Slave Mart* (1865), which was lost to a fire, was both anachronistic and conventional. In this painting, a pretty young girl and a slave mother with her baby are presented as merchandise. They are surrounded by throngs of white men who have convened in front of the courthouse steps for an auction. In his engravings for *Uncle Tom's Cabin,* Billings had employed the visual tradition of using auction scenes to engage abolitionists' sympathy. But that was at the height of the Fugitive Slave Law controversy in 1852. In 1865, slavery was over. Unlike Uncle Tom and his old Kentucky home, which had become nostalgic icons in stage show minstrelsy, the auction block and images of women and children suffering did not make the transition to popular entertainment. For that, *Last Sale* seems a perplexing anomaly. A discussion of *Uncle Tom's Cabin* and its impact on American culture may help place Noble's painting within a cultural context or at least account for the artist's possible attraction to the topic.

Even more provocative is Noble's 1867 painting of fugitive slave Margaret Garner, who attempted to escape with her family during the winter of 1856. Garner will be familiar to contemporary literati as the inspiration behind Toni Morrison's Pulitzer Prize-winning novel *Beloved.* Noble's painting, aptly titled *Margaret Garner,* depicted Garner's apprehension by local marshals, just after she had slit the throat of one of her children. During her murder trial, she was described by a reporter as being a mulatto of one-fourth to one-half "white blood," five foot three inches tall, with "delicate" and "intelligent" eyes and forehead.[31] Thus, Garner can be seen as a living embodiment of two of Stowe's light-skinned female characters: Eliza and Cassy. On her dramatic getaway across the frozen Ohio River, Margaret followed the same path that the fictional Eliza had traversed four years earlier. And Cassy, Simon Legree's slave mistress, had killed her infant by drugging it with laudanum rather than see it grow up a slave. Thanks to Tom's religious counsel, Cassy's Christian faith had been restored and with it came the strength to escape from slavery. The flesh-and-blood Margaret was not as lucky as the imaginary Eliza or Cassy. Did these two fictional women inspire the artist? Chapter 3, "From Barefoot Madonna to Maggie the Ripper: Thomas Satterwhite Noble Reconstructs Eliza and Cassy," will explore this question.

31. Edmond Babb, "Third Day of the Trial of the Mother and Her Children," *Cincinnati Gazette,* February 13, 1856, cited in Steven Weisenburger, *Modern Medea: A Family Story of Slavery and Child-Murder from the Old South,* 156.

By attempting to engineer her own destiny Garner betrayed the very tenets of both sides in the slavery debate: she was neither the gentle Madonna of abolitionist propaganda nor slavery's instinctual "breeding woman," a term Thomas Jefferson once used in instructions to overseers. Garner's story became a cause célèbre when she was charged with murder in Cin-cinnati. Local papers decried her as "the heroic woman" who sacrificed her child rather than see it live in slavery, and northerners rallied to support her. The incident happened in 1856; Noble painted it in 1867. For whom would such an event that occurred during slavery still resonate eleven years later? Could it be that perceptions of mulatto women were in flux during this period? Gentle slaves on the auction block such as Emmeline, a girl Billings drew for the second book, and pale Eliza, the barefoot Madonna at Uncle Tom's door, engraved for his first set, had melted the hearts of readers. How were Noble's mulatto women regarded in post-emancipation America?

UNCLE TOM'S CABIN REVISITED

Reconstruction ended in 1876 with the presidential election that brought Ohio Republican Rutherford B. Hayes to power. In the closest race in U.S. history—that is, up until the Bush/Gore election in 2000—Hayes was neck and neck with Samuel Tilden, a Democrat from South Carolina, when an eleventh-hour compromise was reached between the two parties and Hayes was declared the winner. As part of this compromise, Hayes agreed to remove federal troops from the South and to disband the Freedmen's Bureau, effectively concluding Reconstruction. It was at this precise historical moment that Winslow Homer, a painter who became better known for his hunting scenes and seafaring sagas, painted a series of African American women and children. It was then that "Winslow Homer Visits Aunt Chloe's Old Kentucky Home."

In a painting called *A Visit from the Old Mistress*, Homer brought together a group of former slave women with a white woman, presumably their ex-mistress. This painting, and a few others created by Homer, was reputedly based on his firsthand observations of recently freed families in Petersburg, Virginia, in the mid-1870s. Coincidentally, a little-known engraving by Billings for *Uncle Tom's Cabin* betrays a striking resemblance to Homer's oil painting. Both feature a ramrod-straight white woman standing in profile on the far right, facing a black woman with massive arms, posed in a three-quarter stance. The existence of the Billings illustration, and a review of the visual strategies commonly used by other print artists of the time, calls

Homer's manner of working from line models on site into question. From there the broader concerns are why he chose these subjects and whether his choice indicated economic motives superseding aesthetic ones, which art historians enjoy ascribing to painters.

Homer was from Boston, but he had lived in New York City since the 1860s. He socialized with men in business and publishing who were influential in the arts. He was known to attend salons held by Oliver Bell Bunce, the editor and publisher of *Appleton's Journal* and a booster of southern excursions. Bunce regularly advised artists to go south, the better to have more drawings available to publish in his "Picturesque America" series. It was thought that print artists could mitigate national concern about reconciliation with the South by reporting on the region as stable and revitalized, an exotic, appealing place to visit. Homer heeded Bunce's cry and went south to Virginia, where he allegedly witnessed African American social and domestic behaviors that he then painted.

Billings's print of Aunt Chloe and her mistress was a likely antecedent of Homer's *Visit.* The story of Uncle Tom, his devoted wife, and their humble little cabin in the South had insinuated itself into the paintings of other artists before Homer. Probably the most famous, which sold for the highest price, was Eastman Johnson's *Negro Life at the South* of 1859, a large tableau of blacks within an enclosed outdoor space in which they gaily chat and frolic, while gathered around a banjo player. The painting was even referred to as *Old Kentucky Home,* after a song Stephen Foster wrote about *Uncle Tom's Cabin.* Both Johnson and Homer were from New England, both had relocated to New York City, and both were striving to build careers in art. For a while each was a resident in the same New York University Building. Homer would have had reason to hope a scene recalling the popular story might invigorate his fledgling career as a painter.

If career pragmatism motivated Homer, what was it about paintings and prints of rustic black people that northern art patrons found so appealing? *A Visit from the Old Mistress* coincided with the end of Reconstruction, when the nation abandoned freed people, leaving them poor, with little changed from the days of Aunt Chloe and her fatherless children. Pictures of the old plantation, even the quarters, legitimized the mythology of stable racial relationships in fixed hierarchies as the country moved beyond divisiveness and into a period of prosperity and growing international presence.

THE ICONIC PERSISTENCE OF UNCLE TOM

Old South mania was at its zenith when African American painter Henry Ossawa Tanner returned to the United States in 1893 after two years of

study in Paris. While at home in Philadelphia recuperating from cholera, he painted *The Banjo Lesson,* a rare nineteenth-century example of an African American subject by an African American artist. Tanner's genre painting continues to intrigue viewers, and in the same way that Homer's convening of African American rustics has been celebrated as sympathetic, Tanner is presumed to have felt a kind regard for his equally countrified subjects.

This was the era of southern redemption. Recollections of the antebellum past were revised into fond memories with pictures, stories, and staged performances. The Old South coalesced into a collective fantasy of spirited belles, dashing suitors, and venerable patriarchs. The figure of a happy, banjo-strumming slave from blackface minstrel tradition became entrenched in popular thinking about the old plantation. With the increased production of chromolithograph sheet music and the new craze for "coon songs" in the 1890s, a connection between music making and African American buffoonery gained ever-greater visibility, which raises the question of why Tanner would paint a ragged old man and a barefoot youth with a banjo no less.

Tanner's *The Banjo Lesson* has impressed generations of art scholars as a positive alternative, even a subversive turnaround, to other depictions of African Americans. Their theories are plausible but not convincing. If Tanner was bent on rehabilitating the image of black men in the visual arts, couldn't he have chosen another type? His own father, Bishop Benjamin Tucker Tanner, was a respected theologian and an intellectual. His family lived in cosmopolitan Philadelphia among an ample community of accomplished African Americans.

By the 1880s and 1890s, genre paintings, once a potent arena wherein political issues engaged northern patrons, were less in vogue. Quotidian scenes of African American life were regularly enacted in commercial printmaking. As topical as their fine art predecessors, mass-produced prints and product advertisements delineated ethnic and gender standards, boundaries, and aspirations for Victorian America and inscribed status hierarchies for a population of consumers. Tanner's *The Banjo Lesson* may have been in response to popular renditions of a stereotype known as "uncle," well known to audiences of Tom shows, and familiar to American consumers in pictures on product labels, trade cards, and sheet music covers.

A painting created in 1893 by an African American artist of an old man and a boy playing a banjo may seem a far cry from a fictional story about slavery written forty years earlier by a white woman. That in an era rife with pictures of Uncle Tom and little Eva, along with theatrical, musical, and literary scenarios of ex-slaves on the plantation, a connection between this painting and popular imagery inspired by *Uncle Tom's Cabin* can be

posed indicates how influential the novel was on American thought. Chapter 5, "Henry Ossawa Tanner's *The Banjo Lesson* and the Iconic Persistence of Uncle Tom," proposes a strategy for how the artist may have reacted to the plethora of negative caricatures of black masculinity rampant in popular culture.

Uncle Tom's Cabin may have been disruptive on several fronts: political, religious, and social. That it was popular, even loved, made it dangerous to prevailing attitudes and the institutional structures kept in place by them. Eric J. Sundquist has written that "the popular reaction of the 1850s may well have *concealed* the novel's guarded subversive power by containing it within ostentatiously marketable forms that would reaffirm the basic prejudices of Stowe's audience."[32] Pictures joined words to challenge patriarchy in the initial illustrations of *Uncle Tom's Cabin* during the height of Fugitive Slave Law controversy. *"Uncle Tom's Cabin" as Visual Culture* will show how subsequent visual strategies were used to coax Stowe's several layers of subversive potential back within acceptable boundaries.

Marcus Wood asks if Tom infiltrated the popular entertainment market or, rather, if it irresistibly consumed him? As *"Uncle Tom's Cabin" as Visual Culture* endeavors to show, "imaging of black people was involved in a cultural backlash against decades of abolition propaganda."[33] Following emancipation, pictures of figures once read as sympathetic were redefined into an alternative propaganda to reinforce white supremacy and to put limits on African Americans' access to the rewards of citizenship. After the "peculiar institution" crumbled, the platforms from which both sides in the abolition debate had launched political campaigns lost the target of a definable opposition. Most frightening to the propertied populace was the idea of social flux. Quickly, race and color, not class, money, education, political goals, or even gender, became the defining aspects that separated Americans. Dependent on race and color to draw a line in the sand, pictures were, and still are, the sites of cultural battles to influence the minds and hearts of viewers. From 1852 to 1893, and beyond, Uncle Tom was a reliable foot soldier, ever forgiving of his earthly "masters" who betrayed his trust, an apologist for the Lost Cause, and a spokesman for the New South. *Uncle Tom's Cabin* was molded into a fantasy of the antebellum South so vivid it almost seemed true, espousing a surprisingly consistent ideology committed to sustaining social hierarchy, guaranteeing that perceptions of race and place in that stratified world were justified. Artists, whether painters of

32. Eric J. Sundquist, ed., *New Essays on "Uncle Tom's Cabin,"* 5.
33. Wood, *Blind Memory*, 144.

exquisite oil paintings for upper-crust urbanites or lithographers and engravers cranking out prints for the hoi polloi, found patronage by gratifying the goals and societal views of power brokers and helped maintain the white business class in positions of wealth, power, and influence.

From the corners of our culture comes the truth.

CHAPTER 1

Picturing Uncle Tom with Little Eva:

Reproduction as Legacy

In 2002, from coast to coast, the sesquicentennial publishing anniversary of *Uncle Tom's Cabin* became an occasion to reassess the impact of Harriet Beecher Stowe's popular novel on American culture. In California, the Huntington Library was the site of a two-day conference during which noted speakers explored "the broad social legacy" of the novel. An exhibition at the New-York Historical Society called Reading Uncle Tom's Image: The 150-Year Legacy of Harriet Beecher Stowe's Character Reconsidered displayed a variety of historical engravings along with work by contemporary visual artists. Writing for *Black Issues in Higher Education*, Kendra Hamilton applauded scholars for reflecting on the "legacy of the groundbreaking novel," its author, and especially on the central character Uncle Tom.[1] Without a doubt, Tom and his story are worthy of study, but perhaps "legacy" may not be the right framework within which to analyze these phenomena.

Historians frequently speak in terms of *legacy*, what *Webster's II* defines as "something handed down from an ancestor or from the past." The phrase *legacy of slavery* is invoked to explain social situations, such as the persistence of African American poverty or the disparity in achievement

1. Kendra Hamilton, "The Strange Career of Uncle Tom," 22.

test scores between the South and the rest of the nation. These situations result, according to sociologists, from slavery's legacy. This notion is alarming, because it seems to accept poverty and low scholastic marks as inevitable. As legacy, the story of *Uncle Tom's Cabin* becomes a cyclical narrative, with Tom reliving a relationship from generation to generation wherein the African man is slave and the European his master.

Spawned as sentimental fiction, Uncle Tom's story was never solely a literary legacy. From the outset, there were pictures. One of the most beloved and most maligned characters in all of America's democratic arts, Uncle Tom is an enduring icon because his image has been drawn, painted, inscribed, acted out, photographed, and continually refitted to social, political, and economic strategies of the ruling class—powerful white males. This chapter is not about the fictional Uncle Tom character from the written text but about the Uncle Tom of visual culture.

WHO WAS UNCLE TOM?

Few today have actually read Stowe's sentimental best seller to encounter its eponymous hero firsthand. Yet his name has long been evoked with tacit expectations. During the civil rights movement to be called "Uncle Tom" was perhaps the most severe insult one could receive from a fellow African American; it was a derogatory epithet for a fawning sycophant who "yassuh-ed" the white man at the expense of his own dignity. Looking askance back to Tuskegee Institute educator Booker T. Washington and his seeming readiness to accommodate turn-of-the-century white southerners, students of the 1960s era of Black Power/Black Pride asked, "Was he a Tom?" In the 1980s when the African American mayor of Los Angeles was viewed by some as too chummy with "the man" and with corporate interests, he was called "Uncle Tom" Bradley. Amidst allegations of police sexual misconduct in the Tawanna Brawley incident some years ago, a New York minister came to prominence as spokesperson for the young woman. He was dubbed "Uncle Sharp-Tom." Supreme Court justice Clarence Thomas becomes "Uncle Thomas" if his opinion echoes that of fellow justice Antonin Scalia. The sobriquet reverberates.

Obsequious servant, accommodating politician, opportunist—these were not Stowe's Uncle Tom. For antebellum readers, Tom was a noble character and a self-sacrificing father. "Sold down the river," he willingly joined the slave coffle to save his family and community from a similar fate. Captive Tom was a heroic figure, a devout Christian who would not be swayed from his faith even at the peril of bodily harm and eventual death.

He was a man of pious beliefs, which he ultimately died upholding. Within the context of the novel, he stood up to and triumphed over his captor Simon Legree. Tom did not kowtow to the man.

Uncle Tom did not so much pass on a legacy as embark upon a chameleon's path. Tom's descent from noble hero to "Uncle Tom" involved a complex interweaving of fictions, fabricated decade by decade to fit social and political strategies. Thousands of editions of the novel were published over the years, with ever-changing illustrations. Then came the plays, freely adapted from the text, that re-created Tom on playbills and posters. As motion pictures came into being, Tom took form in a new visual medium, embodied by actors. Many, like their minstrel show predecessors, were white men who had darkened their faces with burnt cork in order to play Tom. Uncle Tom, as he has become known, was not created by Harriet Beecher Stowe alone but by legions of popular artists, hacking out images for commercial purposes. Visual texts have changed Stowe's paragon of virtue into an "Uncle Tom."

Compelling this study is what W. J. T. Mitchell has identified as "the conviction that the tensions between visual and verbal representations are inseparable from struggles in cultural politics and political culture."[2] Why Stowe wrote *Uncle Tom's Cabin* and the novel's effect on political events at the time of its publication have been documented. What is less studied is how print imagery generated by the story remained a viable cultural force that influenced perceptions about African Americans.

HAMMATT BILLINGS'S TOM

From the wood engravings for the original 1852 novel to the scores of reissues with appropriated pictures, banners for stage plays, and posters for movies and all manner of souvenirs, promotions, gewgaws, and gimcracks, there may be no segment of American visual culture that has not been visited by Uncle Tom. In the beginning, of course, were the words, interpreted by the modest drawings of a local Boston illustrator. It was probably publisher John P. Jewett, not the author Stowe, who engaged Charles Howland Hammatt Billings (1818–1874) to provide the "six elegant designs," plus title page vignette (Fig. 1-1) and gilt-embossed cover, which were touted in advertisements as an enticement to compensate for the extra costly two-volume book.[3]

2. W. J. T. Mitchell, *Picture Theory: Essays on Verbal and Visual Representation*, 3.
3. O'Gorman, *Accomplished in All Departments of Art*, 47.

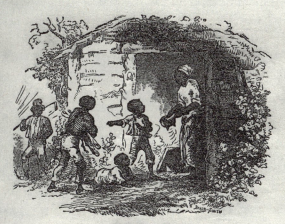

UNCLE TOM'S CABIN;

OR,

LIFE AMONG THE LOWLY.

BY

HARRIET BEECHER STOWE.

VOL. I.

FORTIETH THOUSAND.

BOSTON:
JOHN P. JEWETT & COMPANY.
CLEVELAND, OHIO:
JEWETT, PROCTOR & WORTHINGTON.
1852.

Fig. 1-1. Title page of *Uncle Tom's Cabin,* by Harriet Beecher Stowe (Boston: John P. Jewett, 1852). Engraving by Hammatt Billings. *Collection of the author*

How instrumental Stowe was in selecting images cannot be firmly established, but there are indications that she was sensitive to their effect. She was herself an amateur artist. When she first approached Gamaliel Bailey, the editor of the *National Era*, with the idea for a serial about slave life (what soon became *Uncle Tom's Cabin*), she claimed that her vocation was "simply that of a *painter.*" Her objective in writing the story was "to hold up in the most lifelike and graphic manner possible Slavery, its reverses, changes, and the negro character." As she stated, "There is no arguing with pictures and everybody is impressed with them, whether they mean to be or not."[4] Intriguing use of metaphor aside, there is no conclusive proof that the first-time novelist played a part in choosing Billings to illustrate her novel.

Billings had been chief illustrator of *Gleason's Pictorial*, later called *Ballou's Pictorial Drawing-Room Companion*, an illustrated monthly that had a circulation of one hundred thousand by the mid-1850s. His ten-year career boasted antislavery credentials. In 1850, he redesigned the masthead for Boston-based abolitionist William Lloyd Garrison's newspaper, the *Liberator*, allegedly free of charge. This redesign involved reworking David Claypoole Johnston's second masthead for the paper, an image of slavery present and future, a slave auction on the left, and freed slaves gathered around their humble cabin door on the right. To Johnston's composition, Billings added a central circle in which Christ stands triumphant between a kneeling slave and a fleeing slaveholder (Fig. 1-2). With this he proved an adept promoter of Christian evangelicalism, which many believe was the heart of Stowe's novel. Stowe must have found his work acceptable, for she used him again for later books.[5]

How scenes from *Uncle Tom's Cabin* were selected to become the illustrated "pictures" is not known. For some of them, Billings merely revamped images of kneeling slaves, imperiled families, and implied Christian messages of antislavery iconography. When the *Liberator* debuted in 1831 its masthead had borne the image of a gentle mother with her children at a slave market. Similarly, in his first full-page engraving, "Eliza comes to tell Uncle Tom that he is sold, and that she is running away to save her child" (Fig. 1-3), Billings depicted a slave mother cradling a child in her arms. The full-length figure of Billings's barefoot Eliza standing outside Tom's cabin conjures themes of Christian mothers in flight. That Eliza is light-skinned also puts her in the tradition of antislavery appeals, which used images of women with whom northern women would be most

4. Wilson, *Crusader in Crinoline*, 260.
5. O'Gorman, *Accomplished in All Departments of Art*, 12, 17, 47–48.

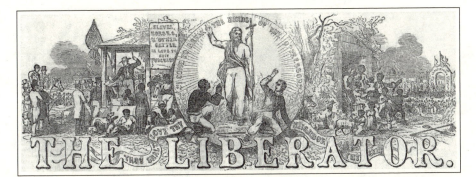

Fig. 1-2. *The Liberator*, April 17, 1857. Masthead designed
by Hammatt Billings in 1850. *Collection of the author*

inclined to empathize. Her covered head, for example, recalls European paintings of the Madonna. And although Harry was described as "a small quadroon boy, between four and five years of age" in the novel, the child Eliza clutches in the engraving seems a mere infant or perhaps a babe in swaddling clothes.

In his second engraving, "The Auction Sale" (Fig. 1-4), Billings utilized another ploy from antislavery prints, portraying pitiful slave families about to be separated. These slaves huddle on the ground in front of white men in top hats, who casually convene while watching an auctioneer point his gavel toward one ill-fated young man. Scenes of slave sales with terrorized families, such as the one on the *Liberator* masthead, were abolitionist mainstays. Billings continued the practice.

Perhaps the most long-lived icon of the antislavery movement was the kneeling supplicant figure. The image of a kneeling slave, much like one Billings added to his *Liberator* masthead, originated in England in the late eighteenth century. It first appeared on a medallion and then later in prints. An 1838 antislavery token (Fig. 1-5) with the caption "Am I Not A Woman and A Sister" is an example. The kneeling posture was understood as a pose of Christian supplication with American viewers. During the Italian Renaissance, for instance, when wealthy donors commissioned artists to make altarpieces for family chapels, they would have the artist include a portrait of them posed in supplication on the side panels. A slave down on bended knee, praying, reinscribed a centuries-old tradition from European art.

George and Eliza Harris became kneeling supplicants in Billings's "The fugitives are safe in a free land" (Fig. 1-6). After arriving safely in Canada, they fall to their knees to thank God for their deliverance. Harry is noticeably older here and wears a broad round hat that might suggest a halo.

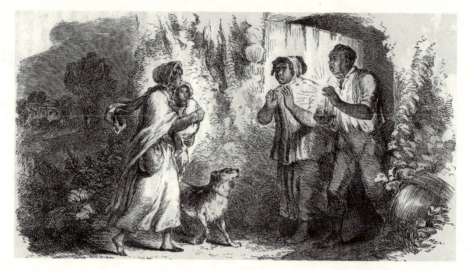

Fig. 1-3. "Eliza comes to tell Uncle Tom that he is sold, and that she is running away to save her child." Engraving, by Hammatt Billings. Harriet Beecher Stowe, *Uncle Tom's Cabin* (Boston: John P. Jewett, 1852), 62.

Two of Billings's remaining three prints, "The Freeman's Defence" and "Cassy ministering to Uncle Tom after his whipping" (Fig. 1-7), were not the kind of images that would have been conscripted for book covers or posters. Not surprisingly, visions of gun-toting escaped slaves such as in the former were less inspiring abolitionist propaganda than depictions of demure mothers or praying families. And nineteenth-century women had difficulty identifying with the wild-haired Cassy, who was strong-willed, shrewd, and not to mention sexually tainted. Even with this degraded woman, however, the slave concubine of Simon Legree, Billings found a biblical connection. Bending over to tend to the wounded Tom, her hair down, Cassy recalls the several women who cared for Christ at various times. In Billings's design, the image of Cassy evokes Mary Magdalene.

Of the initial engravings, "Little Eva reading the Bible to Uncle Tom in the arbor" (Fig. 1-8) became, according to Billings's biographer James F. O'Gorman, "without doubt the most important image of the first edition."[6] Unlike the abolitionist's imperiled slave family or kneeling supplicant, there was no visual precedent for a grown black man in the prime of life cozied up with a tiny white girl, alone within a natural setting. Viewed outside the context of the novel, Tom and Eva in the arbor would have been

6. Ibid., 51.

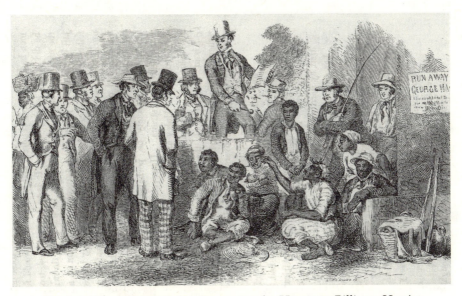

Fig. 1-4. "The Auction Sale." Engraving, by Hammatt Billings. Harriet Beecher Stowe, *Uncle Tom's Cabin* (Boston: John P. Jewett, 1852), 174.

a remarkable sight. Nonetheless, of all of Billings's scenes, this one most captivated viewers. Within the first year, it inspired a painting, songs, sheet music covers, several fine art prints, and all manner of ephemera. Forever after, if an edition of *Uncle Tom's Cabin* included illustrations, there among the pages would be Tom and Eva in a garden. Frequently, they also graced the cover. Theater facades and lobbies where play versions were staged were festooned with their likenesses.[7] Actors playing Tom and actresses costumed as Eva sold photo cards of their characters together. From scores of scenes in the story, generated for more than 150 years, illustrations of Tom and Eva together in gardens or courtyards, huddled over the Bible, have been the most reproduced.

O'Gorman questions how such a portrayal of a black man and young white girl might have been received in 1852. "It would be difficult for the reader to overlook the fact that Little Eva is depicted by Billings with a wasp waist and developed breasts. Nor would the reader in the 1850s fail to remark Tom's attractive features and fine clothing."[8] But was that what viewers saw in 1852? O'Gorman imagines that readers may have been excited by the idea of a relationship between a young woman with

7. Birdoff, *World's Greatest Hit*, 140.
8. O'Gorman, *Accomplished in All Departments of Art*, 54.

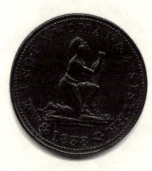

Fig. 1-5. Antislavery token, 1838.
Collection of the author

"developed breasts" and an "attractive" black man. Yet, at that time, to intend the implication of physical intimacy between them would have been highly incendiary. Although widely known to exist, sexual contact (likely exploitative) between males of the master class and female slaves was not acknowledged publicly. Billings could not have presumed to broach the subject of "amalgamation," as interracial sex was called, between a male slave and the tiny mistress.

What, then, did viewers see that they liked so well? The black man together with the white girl had no precedent in antislavery (or proslavery, for that matter) propaganda. That they read a Bible, and thus were Christian devotees, was all that linked them with abolition ploys. O'Gorman suggests that "Billings emphasized the equality between child and man in this intimate moment."[9] Is it equality because the child and the slave share a love of Christianity? Significantly, the caption reads, "Little Eva reading the Bible to Uncle Tom in the arbor," a little mistress fondly sharing her Bible with a slave.

The not-so-subtle visual strategy of making Eva active—she is the one doing the reading and seemingly also the instructing—guaranteed, as Susan Grubar has observed, that "authority accrues to whiteness."

From youthful Huck accompanied by Nigger Jim to the adolescent Scarlett O'Hara costumed by her Mammy, the white youth attended by the black adult spells out a number of disturbing ideological lessons. Not only are blacks somehow childlike in their fawning dependency, but also authority accrues to whiteness, which even at its most vulnerable and ignorant masters blackness.[10]

9. Ibid.
10. Susan Grubar, *Racechanges: White Skin, Black Face in American Culture*, 204.

Fig. 1-6. "The fugitives are safe in a free land." Engraving, by Hammatt Billings. Harriet Beecher Stowe, *Uncle Tom's Cabin* (Boston: John P. Jewett, 1852), 238.

Between Tom and Eva there is no question who is the authority. In his simple devotion, his fledgling literacy, and his attentiveness, Tom is the uninitiated of the pair. Not to mention, he is also a slave.

As well as being a passive listener in his seated posture, the large male is compositionally reduced to the level of the diminutive girl. Robyn Wiegman has observed that black men are repeatedly positioned within textual discourses into "feminine" roles, occupying the same positions that women typically occupy: "In aligning representations of black men with the constructed position of women, dominant discourses routinely neutralized black male images, exchanging potential claims for patriarchal inclusion for a structurally passive or literally castrated realm of sexual objectification and denigration."[11] As a favorite slave on Eva's St. Clare plantation, Tom is a cloistered being, dressed in finery, dolled up by the child, and placed not on a pedestal exactly but on a little perch in the cultivated garden. Any threat of sexual potency is effectively neutralized by visual placement. He is objectified in a manner familiar to the nineteenth-century female viewer, for he inhabits her realm in a space not unlike the

11. Robyn Wiegman, *American Anatomies: Theorizing Race and Gender*, 116–17.

Fig. 1-7. "Cassy ministering to Uncle Tom after his whipping."
Engraving, by Hammatt Billings. Harriet Beecher Stowe,
Uncle Tom's Cabin (Boston: John P. Jewett, 1852), 198.

hallowed steel engraving world of a *Godey's Lady's Book* (Fig. 1-9). Perhaps it is no coincidence that in 1839, early in her literary career, Stowe's stories were published in *Godey's*.[12]

If an image's popularity can be measured by the number of times it was reproduced, then Billings's engraving of Tom and Eva in the arbor was an immediate success. In 1852, the same year that the novel was published, this illustration was used to front sheet music for a song, "Little Eva: Uncle Tom's Guardian Angel," set to words by John Greenleaf Whittier (Fig. 1-10). And the following year, James Francis Conover, the editor of the *Detroit Tribune*, commissioned African American artist Robert Scott Duncanson to create an oil painting of the image of Uncle Tom and Eva (Fig. 1-11).[13]

In these early renditions, Tom looks like Stowe's description of "Mr. Shelby's best hand": "a large, broad-chested, powerfully made man." In an engraving by F. L. Jones, created from a 1856 painting by A. Hunt that was made, according to the caption, "especially for the Ladies' Repository," Tom

12. Joan D. Hedrick, *Harriet Beecher Stowe: A Life*, viii.
13. Ellwood Parry, *The Image of the Indian and the Black Man in American Art, 1590– 1900*, 99; McElroy, *Facing History*, 14.

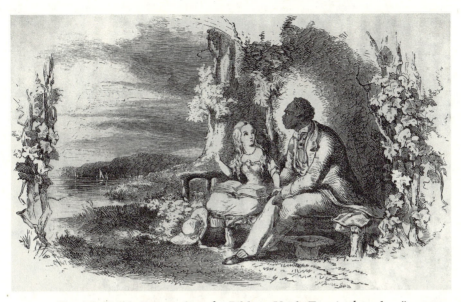

Fig. 1-8. "Little Eva reading the Bible to Uncle Tom in the arbor."
Engraving, by Hammatt Billings. Harriet Beecher Stowe,
Uncle Tom's Cabin (Boston: John P. Jewett, 1852), 63.

is tall and dark, with a broad-shouldered, robust physique (Fig. 1-12). He
and tiny Eva sit together in a lovely garden by a lake. In Jones's version,
Eva's pale skin and bleached dress exude whiteness, and Tom sits passively,
listening to Eva. His vitality (and his virility) is effectively undermined by
her active gestures and her hand that rests on his thigh.

EVA'S TOM

"Little Eva reading the Bible to Uncle Tom in the arbor" should not be
confused with a scene of Tom and Eva in a courtyard, which Billings
drafted later that year. Although only brief interludes in the book, Tom and
Eva's moments together became among the most cherished scenes, widely
reproduced and therefore worthy of study.

With *Uncle Tom's Cabin* a runaway best seller, Jewett commissioned
Billings for more than one hundred additional cuts, to go along with new
renditions of the premiering six, for a 1852 Christmas gift book. With these
new illustrations, Billings expanded some familiar themes. Slave market
scenes that dwelt on feminine misery had proven persuasive in antislavery
propaganda. "The Sale of Emmeline," which featured a young mulatto,

Fig. 1-9. *Godey's Lady's Book.* Engraving, *ca.* 1860s. *Collection of the author*

became the definitive image of an auction sale and was copied by others. Billings evidently was familiar with the neoclassical-style sculpture *The Greek Slave* by Hiram Powers, widely shown in eastern cities since its debut in 1843, for his pose exactly echoes the famous sculpture in reverse. Once he had exhausted the abolitionist prototypes, Billings looked to the written text for archetypes upon which other artists would depend: Eliza's daring escape across the icy Ohio River; Uncle Tom rescuing Little Eva from the Mississippi; Topsy clowning in "Miss Feeley's" duds; and perhaps, based on popular demand, an added outing for Tom and Eva in yet another garden spot. The engraving of Eva placing a wreath of flowers around Tom's neck (Fig. 1-13) first appeared in this second Billings project.[14]

If the scene in the arbor brings the black man and the white girl into close proximity, Billings's courtyard pairing is even chummier, recalling instances of courtship. O'Gorman observes of the second rendition, "Eva who seems to have lost some but not all of the anatomical maturity she possessed in the 1852 illustration, sits on Tom's knee and throws arms and

14. O'Gorman, *Accomplished in All Departments of Art*, 47, 50–52.

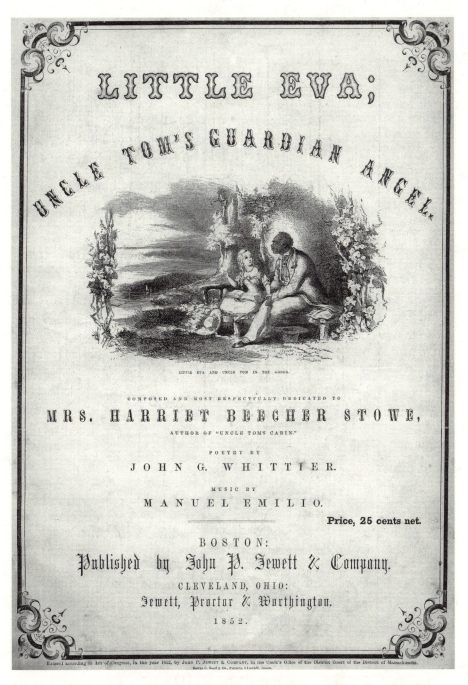

Fig. 1-10. Song sheet cover for "Little Eva; Uncle Tom's Guardian Angel," words by John Greenleaf Whittier, music by Manuel Emilio. Steel engraving, by Hammatt Billings. (Boston: John P. Jewett, 1852). *Collection of the author*

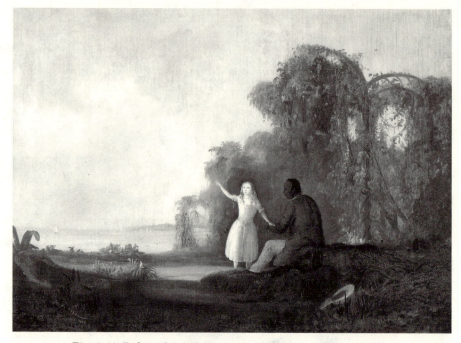

Fig. 1-11. Robert Scott Duncanson, *Uncle Tom and Little Eva,*
1853. *Gift of Mrs. Jefferson Butler and Miss Grace R. Conover.*
Photograph 1987, by the Detroit Institute of Arts

flowers around his neck."[15] Flowers traditionally announce fertility,
youthful ardor in bloom, and Eva twice presents Tom with gifts of these.

The actual courtyard scene in the novel is short and does not focus solely
on the relationship between Tom and Eva so much as it provides an
opportunity for the Louisiana slaveholder St. Clare to chastise his Yankee
relative about northern prejudices. "A gay laugh from the court rang
through the silken curtains of the verandah," Stowe wrote, causing St. Clare
and his cousin Miss Ophelia to look down into the courtyard.

> There sat Tom, on a little mossy seat in the court, every one of his button-
> holes stuck full of cape jessamines, and Eva, gayly laughing, was hanging
> a wreath of roses round his neck; and then she sat down on his knee, like
> a chip-sparrow, still laughing.
> "O, Tom, you look so funny!"
> Tom had a sober, benevolent smile, and seemed, in his quiet way, to be
> enjoying the fun quite as much as his little mistress. He lifted his eyes,
> when he saw his master, with a half-deprecating, apologetic air.

15. Ibid., 54.

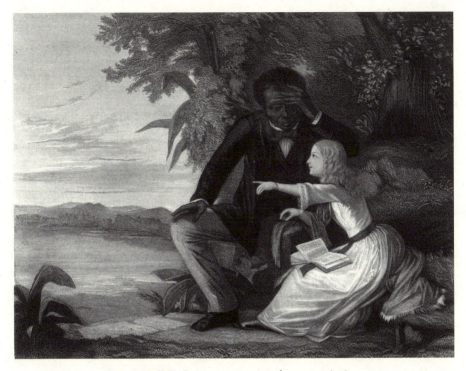

Fig. 1-12. F. L. Jones, engraving from a painting
by A. Hunt, 1856. *Collection of the author*

St. Clare chides Miss Ophelia for squirming at the sight of the child
touching the black man: "You would think no harm in a child's caressing a
large dog, even if he was black; but a creature that can think, and reason,
and feel, and is immortal, you shudder at." The brief scene ends as Eva
"tripped off, leading Tom with her."[16]

If the southern gentleman and his northern kin are the subject of this
passage, then why aren't they highlighted in this image or, at the very least,
why aren't they shown at the upper railing, observing Tom and Eva as
detailed in the text? Did readers disregard the setting, the flowers, and the
playful touching, as if this was nothing more than a pleasant interlude
between a privileged child and a pampered slave in a kind slaveholder's
idyllic home? Were they unconcerned that Tom's hand lays on his mistress's
back in a half embrace and that he is looking dreamily into her eyes, well
away—it must be stressed—from the chaperoning gaze of St. Clare and
Ophelia?

16. Stowe, *Uncle Tom's Cabin* (Boston: Jewett, 1852), 256–57.

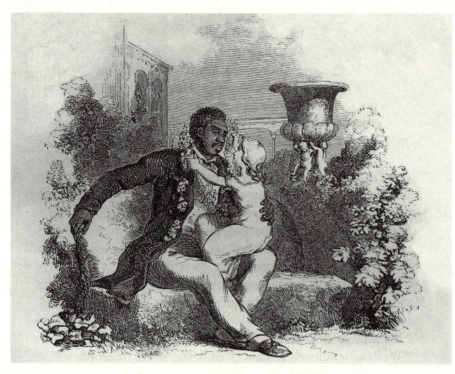

Fig. 1-13. Engraving, by Hammatt Billings. *Uncle Tom's Cabin* (Boston: John P. Jewett, 1853), 217.

As a further paradox, for the 1853 version Billings made subtle changes to his 1852 design of Tom and Eva in the arbor. The 1853 engraving was compacted into a slightly vertical format in order to fit a privileged space atop the text heading "Chapter XXII" (Fig. 1-14). In addition, Tom's skin and his coat appear to be darker; Eva has changed significantly, becoming flat-chested. But if Billings meant to nullify a nubile Eva, giving her a squat figure and blank stare, why then did he keep her hand on Tom's knee?

Billings may have hoped Tom and Eva together in another friendly exchange would be as favorable to the gift-book audience as his arbor from the first set of pictures had been, or this may simply have been one among the many new imprints. In any event, his courtyard scene was used by many other artists as a prototype. In addition to commercial uses, wood engravings in books, and lithographic prints on sheet music, there was a growing industry of printmaking for purely aesthetic appreciation. Lithographs were made to be enjoyed, framed, and mounted on the walls of homes. One lithograph of Tom and Eva, published by E. C. Kellog (*ca.* 1854), found Tom looking especially fit (Fig. 1-15). With a caption recalling

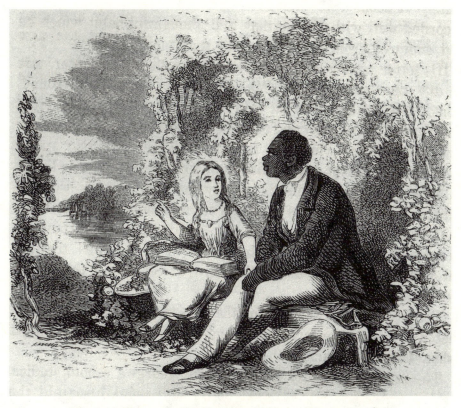

Fig. 1-14. Engraving, by Hammatt Billings. Harriet Beecher
Stowe, *Uncle Tom's Cabin* (Boston: John P. Jewett, 1853), 324.

Eva's response from the text, "Oh Uncle Tom, how funny you do look,"
here she kneels before the seated Tom, pulling him forward as he grasps for
a Bible at his side. She has draped him with flowers. Her right hand now
rests on his breast. St. Clare and Miss Ophelia loom directly over Tom,
perhaps aware that there is cause for concern.

O'Gorman reminds us, however, that later artists made adjustments to
this image, "robbing it of its intimacy and Tom of his dignity." In an undated
lithograph by Nathaniel Currier, Tom no longer wore fine clothing, despite
the text describing him as well dressed, with buttonholes for the posies no
less. "Thus began the transformation of the Stowe-Billings characterization
of a shared humanity between the races into the white supremacist stereo-
type common in later decades," suggests O'Gorman.[17] Ragged clothing and

17. O'Gorman, *Accomplished in All Departments of Art*, 54.

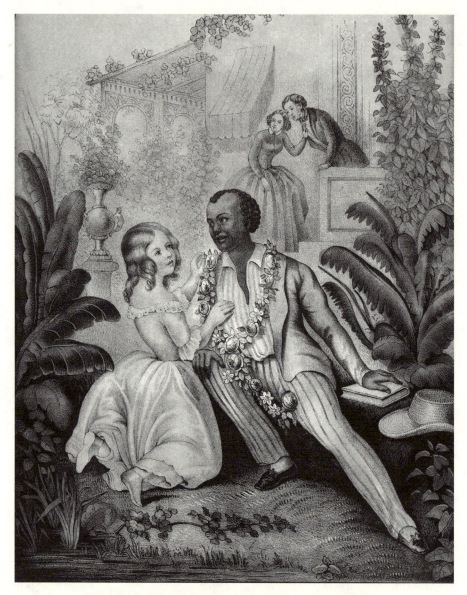

Fig. 1-15. "Oh Uncle Tom, how funny you do look."
Lithograph, by E. C. Kellog, *ca.* 1854. *Collection of the author.*

hand-hewn straw hats of the lowly Tom were a readily understood demarcation from the fine fabrics and bonnets of Eva's leisure class.

A courtyard scene was one of ten full-page wood engravings carved by M. Jackson for another Jewett publication of January 1853. According to the foreword, the thirty-two-page, soft-cover booklet, *Pictures and Stories from*

"Uncle Tom's Cabin," was designed "to adapt Mrs. Stowe's touching narrative to the understanding of the youngest readers." This time, it looked as if Eva had Tom on a leash of flowers, while he gazed amiably back at her, much like the large black dog that St. Clare alluded to (Fig. 1-16). If Tom was Eva's pupil in Billings's arbor and lover (some might say) in his courtyard, in Jackson's rendition, he was her pet.

Other artists almost always placed the couple under the watchful eyes of the adults from the window above the courtyard. "Alternate versions of the scene in the St. Clare courtyard were created," O'Gorman suspects, "probably to avoid the problem posed by showing an embrace between a delicate white girl and a 'large, broad-chested, powerfully made man' of a 'full glossy black' color, the father we remember, of many small children."[18] With Tom and Eva poised at the threshold of intimacy, most Billings imitators were careful to place the couple under the surveillance of the slaveholder and the spinster.

One gets the idea that viewers enjoyed being teased or baited by the implication of what roses exchanged in a courtyard might foretell. Just as St. Clare toyed with Miss Ophelia's northern sensibilities, artists posed provocative pictures of Tom and Eva touching each other and exchanging penetrating glances. Readers could flirt with the couple and what their mingling might suggest, only to contain these errant fantasies by emasculating Tom and eulogizing Eva.

In his survey of blackface minstrel shows—a form of nineteenth-century mainstream entertainment in which northern white men performed as black characters—Robert C. Toll concluded, "Most white Americans act out their need for racial subordination only when they feel their own interests and values are challenged."[19] In the 1850s, a "propaganda battle over slavery" put all that northerners held dear in jeopardy. For northern whites to retain a sense of control over their collective insecurities, the minstrel stage became a place where Euro-Americans could exorcise their anxieties by performing the racial other, a process Eric Lott more recently termed "love and theft." This took form on stage when white men performed their version of southern blacks.[20]

Leonard Cassuto confirms Lott's thesis that blackface minstrel shows were "a staged effort to contain conflicting emotions about blackness and black culture within the medium of performance."[21] Billings and all of the

18. Ibid., 54–55.
19. Robert C. Toll, *Blacking Up: The Minstrel Show in Nineteenth-Century America*, 87.
20. Eric Lott, *Love and Theft: Blackface Minstrelsy and the American Working Class.*
21. Leonard Cassuto, *The Inhuman Race: Racial Grotesque in American Literature and Culture*, 155.

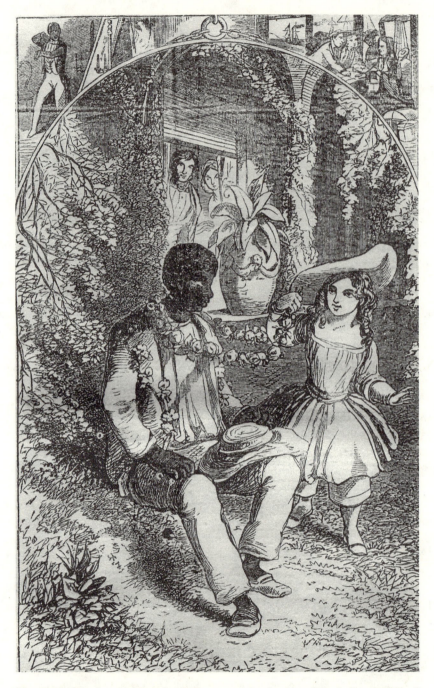

Fig. 1-16. Wood engraving for *Pictures and Stories from "Uncle Tom's Cabin,"* by M. Jackson (Boston: John P. Jewett, 1853), 21. *Collection of the author.*

other visual artists transcribed Tom, enacting "racial subordination," engaging in a form of "love and theft." Anxiety about slavery and white accountability was displaced first by elevating the subjected one and identifying all his fine traits, and then by ruling over the noble character. Authors, performers, and artists all provided an escape valve, giving readers, audiences, and viewers the illusion that they cared deeply for African Americans as fellow beings, assuaging their own guilt, complicity, and responsibility for the peculiar institution. Tom was Stowe's evangelical messenger, witnessing for the Lord, and she dispensed with him after his testifying was done; even his vile death by physical brutality was made to seem as if it were a gift bestowed upon him by Simon Legree.

Tom with Eva on his lap may have been a successful image precisely because the sight was dangerous yet contained, courting the unmentionable and then so unequivocally squelching any chance that a dark, attractive African American man would ever live up to his masculine potential. Tom and Eva together, twice pictured in intimate moments, embodied, as did their minstrel show contemporaries, what Cassuto termed "a complex dialectic that condensed opposing emotions of fascination and dread, acceptance and rejection of blackness within the performing black body."[22] Tom was a Christian. He had saved Eva from drowning and endeavored to save the soul of slaveholder Augustine St. Clare, yet he nevertheless became a mere plaything.

BRITISH TOM

Uncle Tom's Cabin was a worldwide phenomenon. The images of Tom and Eva studying the Bible in the arbor and engaging in playful dalliance in a garden court were known throughout much of the world. The novel was published in thirty-seven languages and reviewed by prominent writers all over Europe. At that moment in the history of the printed book, only the Bible had appeared in so many versions.[23]

Soon after its American debut, *Uncle Tom's Cabin* was published in England and was an immediate success. "Tom and Eva in the Arbour" and "Eva Dressing Uncle Tom" were among twenty-seven whole-page design wood engravings that the renowned English artist George Cruikshank (1792–1878) created for one of the fourteen different versions issued there in 1852. Four more followed in 1853, and several had illustrations. Along

22. Ibid.
23. Brooks, *Flowering of New England*, 420–21.

with the new prints by Cruikshank and others, Billings's gift-book illustra-
tions were copied by artists in Britain well into the 1880s.

In choosing the same scenes that Billings had singled out from the story,
the English Cruikshank took his lead from the American. Moreover, there
are indications that Cruikshank may have literally drawn over Billing's
originals and then later modified his drawings somewhat to fit his own
interpretation of the story. Printing is a process whereby reproductions
result in reversals of drawings, which are made on blocks, stones, or metal
plates, creating a mirror image of the original. Cruikshank's positioning for
"Tom and Eva in the Arbour" (Fig. 1-17) is the reverse of Billings's composi-
tion. He increased the distance between Eva and Tom ever so slightly,
however, and removed Eva's hand from Tom's knee. Furthermore, Cruik-
shank's distinctly English garden setting, with tiled floor and peaked roof,
was more manicured than the wild nature of Billings's backdrop. Eva
perched primly on a bench next to Tom, a big book on her lap, and her feet
supported by a little stool.

Although Cruikshank appropriated the basic design of Billings's prints,
Cruikshank's reproductions were not as sexually suggestive as Billings's.
For example, in Billings's engraving of Eva draping flowers around Tom's
neck, Eva was shown sitting between Tom's legs, but in Cruikshank's
version (Fig. 1-18), the little girl snuggled at his side. With Billings as his
model, however, Cruikshank was not yet alerted to the need for chaper-
ones, as the next wave of draftsmen would be.

To determine how British audiences perceived Tom and Eva requires
some knowledge of that society's standards. Cruikshank notwithstanding,
other artists certainly offered titillating interpretations of the novel. English
pictorial accounts from *Uncle Tom's Cabin* could be outright lascivious
compared to the American prints. In another 1852 rendition of Stowe's
novel, entitled *Pictures of Slavery in the United States*, Eliza's sister-in-law
was shown naked from the waist up while being whipped. Her frontal pose
and full breasts and the voyeur peeking through the doorway indicate that
this image was intended to be erotic (Fig. 1-19). An 1867 English reissue
went to even greater lengths by showing a "topless" Prue being whipped
in front of a leering crowd. In Stowe's novel, Prue was a pitiful old alcoholic
who was left alone in a cellar to die after a whipping; but in this illustration,
the artist chose to draw her as a young and shapely woman.[24]

Marcus Wood suggests that the kinds of images from which Europeans
have derived erotic stimulation is an under-researched area of cultural
study. Even English antislavery imagery tended toward the salacious. The

24. Wood, *Blind Memory*, 184.

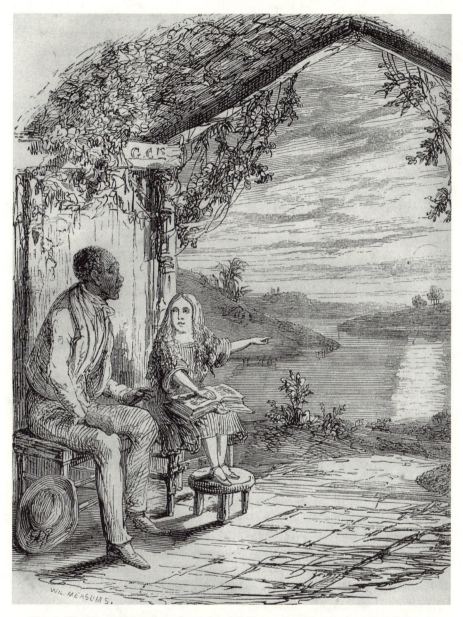

Fig. 1-17. "Tom and Eva in the Arbour." Engraving, by George Cruikshank. Harriet Beecher Stowe, *Uncle Tom's Cabin* (London: John Cassell, 1852), 223. *Collection of the author*

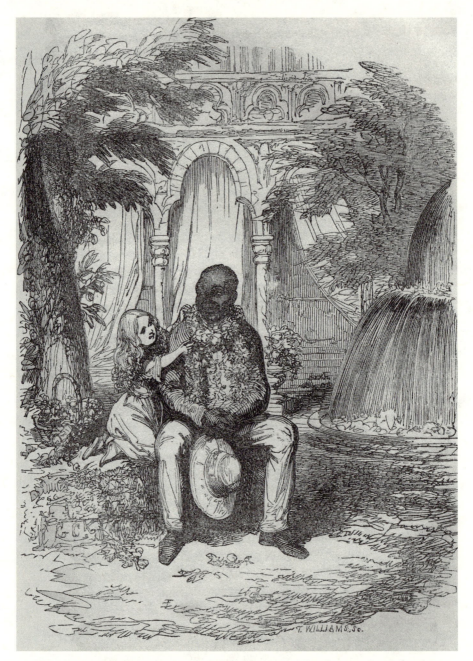

Fig. 1-18. "Eva dressing Uncle Tom." Engraving, by George Cruikshank. Harriet Beecher Stowe, *Uncle Tom's Cabin* (London: John Cassell, 1852), 152.

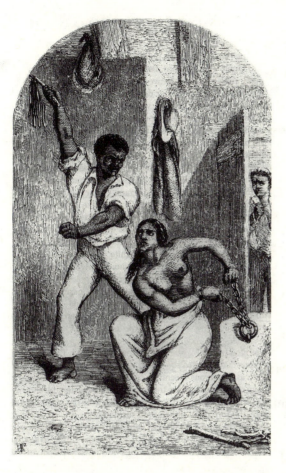

Fig. 1-19. "George's Sister Whipped for Wishing to Live a Decent Christian Life." Engraving. *Pictures of Slavery in the United States* (England: Ingram, Cooke, 1852).

British penchant for images of frontally positioned, bare-breasted slave women being whipped would have been unthinkable in American anti-slavery circles, where attracting women to the movement was a major goal. Scenes that showed the "flagellation of women and children," Wood maintains, "worked their way into the sexual fantasies of Europeans."[25] In fairness, slavery in England had been abolished two decades before *Uncle Tom's Cabin* hit bookstores, so the English reader knew little about the harsh reality of mid-nineteenth-century American chattel slavery. In part, artists capitalized on *Uncle Tom's Cabin* as another opportunity to sate audience tastes for erotica.

English pictures of Tom and Eva were just as widely circulated as their American counterparts. Lithograph posters by Jarrett and Palmer Company

25. Ibid., 190.

especially wowed Londoners, prompting John Ruskin to mention them in *Modern Painters:* "Let it be considered, for instance, exactly how far in the commonest lithographs of some utterly popular subject—for instance, the teaching of Uncle Tom by Eva—the sentiment which is supposed to be excited by the exhibition of Christianity in youth, is complicated by Eva's having a dainty foot and a well-made slipper."[26] Because Ruskin spells out "the teaching of Uncle Tom by Eva," it is assumedly the arbor scene in which the "dainty foot" registered as fetish. Wood concurs, calling this kind of image "sexually charged" to British eyes: "For Ruskin the popular enthusiasm for *Uncle Tom's Cabin* was based in a vicarious and sexually charged emotionalism directed at the image of a small white girl cuddling with a big black man."[27] A lithograph for sheet music published in London in 1852 provides an example. Artist J. Brandard emphasizes Tom's athletic physique and Eva's delicacy. Sitting close to Tom, "cuddling," Eva gently grasps his proffered arm as she casts their joined gaze into the distance (Fig. 1-20).

Yet Wood seems to equivocate his previous statement, adding "Tom's de-sexualization is paradoxically determined by the readiness with which the illustrators of the day flung him and Eva together." If a picture is repeated, does the viewer become inured to it, reading meaning into it regardless of ostensive content? Even so, it was not merely that Tom and Eva were "flung . . . together" so much as how they interacted. Admittedly, British Tom seems more than able to act out the role of a suitor, and the puny Bible resting at the font of Eva's lap is a frail armor at best. Any semblance of sexual prowess in Tom is undermined by his passivity in relation to Eva (Fig. 1-21). Ruskin contends that sentiment for Eva "excited by the exhibition of Christianity in youth" was the subject in the picture. Tom's "de-sexualization" is reinforced by his subordinate status to the child; Tom is elevated while being diminished. A blazoning candle flame is ignited only to be stifled.

Ultimately, the story was the foundation for Tom's tameness and docility and, without doubt, the source of his popularity. Tom was, Wood reasoned, "the ideal Christian house-slave, probably the only type of black male which Victorian society could imagine in physical contact with virginal white girlhood."[28] Or else why would that society, American or British, have delighted to see him with her? Repeatedly.

26. Quote from John Ruskin, cited in Wood, *Blind Memory,* 190. See also Birdoff, *World's Greatest Hit,* 242.
27. Wood, *Blind Memory,* 190.
28. Ibid.

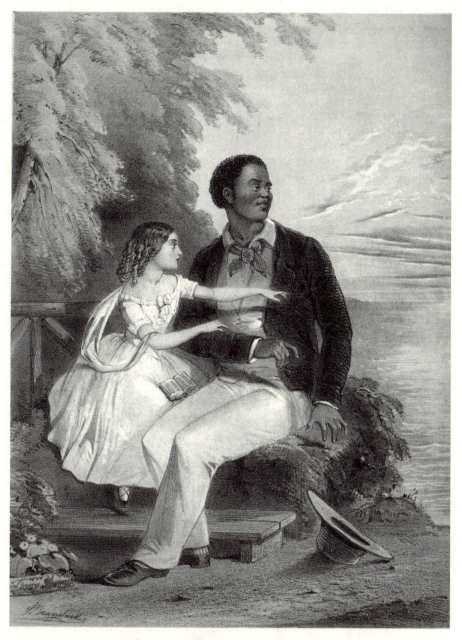

Fig. 1-20. "The Sea of Glass." Lithograph, song sheet cover,
by J. Brandard (London, 1852). *Collection of the author*

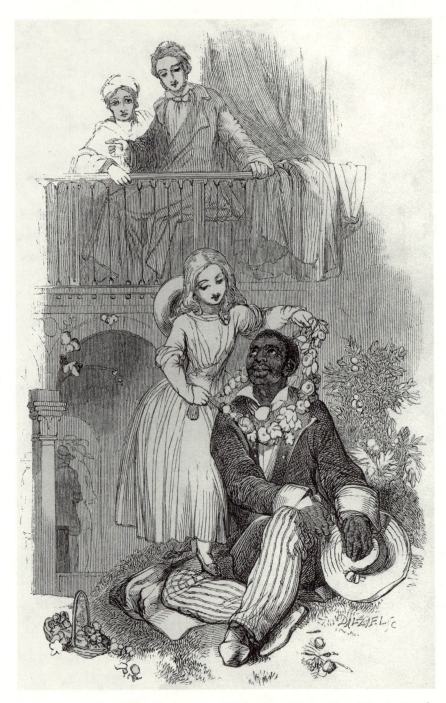

Fig. 1-21. "Eva decorating Uncle Tom with flowers." Engraving. Harriet Beecher Stowe, *Uncle Tom's Cabin* (London: Routledge, 1852), 196. *Collection of the author*

"Uncle-Tom-mania" was unquenchable as entrepreneurs rushed out more illustrated editions, Tom almanacs, songbooks, wallpaper, and antislavery notepaper with scenes from the book. Tom and Eva in the garden were even immortalized in a fine porcelain figurine. The English coined the term *Tomitudes* to describe their penchant for the slave.[29] As testament to Uncle Tom's impact on Britons, the British Museum today owns an extensive collection of "Tomiana."[30]

STAGE TOM

Ever keen to developing trends in popular taste, theatrical impresarios rushed to capitalize on the unprecedented success of Stowe's novel. George C. Howard's premiere production of *Uncle Tom's Cabin*, set to George Aiken's script, was mounted in New York City a mere five months after the book's debut.[31] Within that year, P. T. Barnum had a play—one offering a more positive view of the South—by Henry J. Conway up and running at his American Museum.[32] On January 16, 1854, the Bowery Theater hung a "very large painting of Little Eva crowning old Tom with flowers" on the façade, announcing yet another stage version, with minstrel star Thomas Dartmouth "Daddy" Rice in the role of Uncle Tom.[33] By 1879, there were forty-nine touring Tom shows, as they became known, listed in the *New York Daily Mirror*.[34]

Harry Birdoff began his survey of Tom shows with a description of the large, colorful lithographic sheets that promoters posted in advance of a troupe's arrival:

> With the coming of Spring they blossomed forth—covering barns and fences, and in flaming colors overrunning stone walls; the "three sheet" lithographs could not be read from a distance, but there wasn't a boy who didn't recognize immediately the familiar figures: Little Eva ensconced in old Tom's lap, Eliza pursued across the ice by the hounds, lawyer Marks striking that grandiloquent posture, and Topsy doing a breakdown.[35]

29. Birdoff, *World's Greatest Hit*, 144.
30. Lorimer, *Colour, Class and the Victorians*, 85–86; Hult, "*Uncle Tom's Cabin*: Popular Images of Uncle Tom and Little Eva," 3–9.
31. Birdoff, *World's Greatest Hit*, 24; Gossett, "*Uncle Tom's Cabin*" *and American Culture*, 269.
32. Toll, *Blacking Up*, 91.
33. Birdoff, *World's Greatest Hit*, 102, 132, 140.
34. Richard Moody, "Uncle Tom, the Theatre, and Mrs. Stowe," 29–33, 102, 103.
35. Birdoff, *World's Greatest Hit*, 1.

Birdoff's *The World's Greatest Hit: "Uncle Tom's Cabin"* was written in 1947, almost a century after the story was first published. Through the decades, certain scenes and tried-and-true characters had remained favorites, while others had faded from memory. Of all the scenes and all the characters, "Little Eva ensconced in old Tom's lap" was uppermost in Birdoff's recollection. From 1852 to 1947, Tom and Eva in the garden not only endured but became the quintessential enactment of the story.

Posters featured reenactments of dramatic scenes from the novel, such as "Eliza pursued across the ice by the hounds." Others highlighted the story's funnier moments and characters: "Topsy doing a breakdown" or "Lawyer Marks" striking a "grandiloquent" pose. Lawyer Marks was a rather insignificant character in the novel who had become an audience favorite through actors' bombasts onstage. In the journey from page to stage, there had been other changes. When Eliza escaped over the icy Ohio River in *Uncle Tom's Cabin* the novel, there were no dogs in hot pursuit, but the notion of slavering, bloodthirsty hounds lapping at the heels of runaways was fraught with heart-stopping thrills. On the stage, the beasts of choice were not even the lop-eared bloodhounds of legend but huge mastiffs or Great Danes. Packs of them snapping across the foreground of the posters headlined the production. The monstrous dogs were so popular that they were featured on the advertisement cards for Jay Rial's production of the 1880s (Fig. 1-22).

Nor had the novel's Topsy danced a breakdown per se. This dance, along with the cakewalk, stump speeches, and pathetic songs, were crowd-pleasers in blackface minstrel shows.[36] While Tom shows took on aspects of minstrel shows, blackface stars began performing in "Toms." Foot-tapping, cork-smeared Topsys trod the boards, and pontificating Lawyers Marks chewed the scenery in the so-called legitimate theaters just as they did in the bawdier minstrel houses.

With no theatrical tradition to uphold or revive in performing the inaugural Tom show, the Howard production may have found visual inspiration in Billings's pictures. The choice to end each of the play's eight parts with a tableau resembles how Billings encapsulated segments of the written story into the stop-action moment of a print. These staged tableaux functioned similarly to book illustrations, with actors holding a group pose momentarily, fixing an image from the action into the minds of the audience. For example, stage directions at the end of act 2 in the Aiken script read, "George and Eliza kneel in an attitude of thanksgiving, with

36. Ibid., 292–305.

Fig. 1-22. "Jay Rial's Ideal *Uncle Tom's Cabin*." Color
lithograph, trade card, *ca.* 1880s. *Collection of the author*

the Child between them," echoing of course Billings's illustration of the
Harrises reaching Canada in the original novel.[37]

"Little Eva ensconced in old Tom's lap," first engraved by Billings for the
novel, was a favorite scene on posters and other stage advertisements from
the start. In the Howard-Aiken adaptation, Howard's daughter Cordelia
played Eva. "Little Cordelia Howard," the ads trumpeted, "The child of
Nature." Cordelia became the star of the show. As a result, Eva's few scenes
from the original story, most with Tom, were prolonged to showcase "little
Cordelia." Many Tom shows ended with Tom and Eva reunited after his
death in the heaven of an eternal garden. The poses performers of Tom
and Eva struck for promotional photographs recapped climactic staged
moments (Fig. 1-23).

Care was taken to produce memorable artwork for the theatrical produc-
tions in competition with dioramas of scenes and the magic lantern shows
elsewhere. While the Aiken-Howard version was at the National Theater,
manager Captain Purdy spent two thousand dollars on a ten thousand-foot

37. George L. Aiken, *Uncle Tom's Cabin; or, Life among the Lowly: A Domestic Drama
in Six Acts*, 37; Birdoff, *World's Greatest Hit*, 5.

Fig. 1-23. "Uncle Tom and Little Eva, in Stetson's *Uncle Tom's Cabin*." Photo card, *ca.* 1890s. *Collection of the author*

panorama. Purdy also used tinted lithographs in promotions. Alanson Fisher was paid $565 to paint a four-by-three-foot portrait of Stowe mounted within a gilt frame. At Barnum's American Museum, the script was simplified, but the visual aspect was embellished to include especially sumptuous scenery. "A grand panorama by C. Lehr" was an added draw for audiences. With theater lobbies draped in Spanish moss and cotton bolls, Tom shows became veritable theme parks of slavery. On display would be such things as slave whips stained with blood, posters offering rewards for runaways, and slave shackles.[38]

If the printed image of virile Tom snuggling delicate virgin Eva was cause for caution, what a sight the flesh-and-blood stage Tom and Eva must have been. In the original Aiken-Howard adaptation, it was the producer's own darling daughter bouncing on Tom's knee. Stage performances confounded by this dicey situation solved the dilemma in several ways. For example, in the earliest stagings of *Uncle Tom's Cabin*, white actors performed all roles. Under the grease and ash, Tom was not really a black man. And in other productions, Tom grew old, fast.

In the Howard-Aiken production, Tom was played by G. C. Germon. He had been reluctant to take the role, presuming it would be what he called a "Jim Crow darkey" similar to a minstrel show. In these early performances, Tom seems to have been played as the physically robust father whom Stowe first imagined. That a July 27, 1853, *New York Daily Times* review called Germon's characterization "a strong, black, labouring man" indicates that he successfully avoided a minstrelsy stereotype. Germon played Tom from July 18 to August 22, 1853.[39]

Tom was played next by J. Lingard, a white actor who was evidently less reluctant to play the familiar stage "darkey." Lingard's Tom was perceived as an older man when the performance was reviewed for *New York Atlas* on October 16, 1853. "The character of the meek, pious, and subdued old negro . . . was ably delineated," it read, describing Tom as a "pathetic" man.[40] Meanwhile at the Bowery, Thomas D. "Daddy" Rice—the very performer who had in 1828 originated the blackface character Jim Crow, the rustic old slave with the quirky jumping dance—was expected to perform Tom as an old man.[41]

38. Birdoff, *World's Greatest Hit*, 100–103, 86, 320.

39. Gossett, *"Uncle Tom's Cabin" and American Culture*, 278–79. Playbills alternately spell the actor's name as Germon or German.

40. Ibid., 279.

41. Birdoff, *World's Greatest Hit*, 132.

Thomas F. Gossett has offered other possible reasons that Tom aged onstage.[42] People lived fewer years in 1852, and standards for being considered old may have been "more arbitrary." To support this he cites A. M. Woodward's review of the novel, which describes Tom as "an old man, not less than forty-five, and probably fifty years of age." Although a slave such as Tom might feasibly have been fifty, to have been a prized field hand at that age was improbable. Sold by Shelby, purchased first by St. Clare, and then by Legree, Tom was a valuable commodity. Moreover, had Tom waited to father his toddlers so late in life, it would have severely curtailed increasing the master's stock. Nevertheless, Gossett maintains that Tom's qualities of "meekness, patience, and calm fortitude" were not the virtues a young man was expected to have.

Actor Germon had been wary of attempting a role in blackface. Several decades worth of minstrel-stage lampooning made him question whether Tom would be taken seriously. According to Gossett, this was the most compelling reason for making the stage Tom old, for in minstrel shows the only black characters "with any dignity at all were portrayed as those 'old folks at home' who remembered days long past on the plantation." If the ancient retainers, loyal old slaves, were the only characters with dignity, it was a spurious honor at best. The Aiken play may have been the first to present an African American character in a serious drama, but Tom was nevertheless portrayed with "far less inherent intelligence and ability" than the white characters were. The "Jim Crow darkey," adds Gossett, was supplanted by the old uncle, a stereotype "all the more powerful because it was conceived in idealism."[43]

By performing Tom as old, there was less likelihood that the intimacy between Tom and Eva would be interpreted as, well, intimacy. As Gossett contends, "had [Tom] been portrayed as a young man he might conceivably have been seen as a sexual threat—a threat, for example, to the absolute purity of little Eva."[44] A white actor hidden beneath charred cork and a powder-dusted wig was not factually an "attractive" or "powerfully-built" black man with "brawny arms." When finally in 1878 an African American performer did portray Tom, that actor, Sam Lucas, was partnered with an Eva who was so fat that when she settled onto his lap, what likely aroused the audience was concern for his safety. The production was not successful.[45]

For all the possible reasons that Tom was performed as an old man in the beginning, once he appeared as such, he remained old in almost all produc-

42. Gossett, *"Uncle Tom's Cabin" and American Culture,* 279.
43. Ibid., 280, 283.
44. Ibid., 280.
45. Toll, *Blacking Up,* 217; Wood, *Blind Memory,* 224–25.

tions of the play from 1853 on. In 1873, for example, when the famous stage actor David Belasco was photographed for his San Francisco performance as Tom, he appeared as an elderly bald man, with only a fringe of white hair. Belasco was then twenty.[46]

OLD TOM

Of all the mitigating factors that may have tamed and desexualized Tom, making him a suitable companion for Eva, aging has ultimately been the most effective. As Tom aged on stage and in pictures, he became an "uncle."

Literary uncles had been around since before the Civil War. Such a character, although not called "Uncle," was in John Pendleton Kennedy's 1832 novel *Swallow Barn*, considered to be the first work written in what became known as the plantation tradition.[47] In Kennedy's book, an old servant named Scipio with "a head of silver wool" expressed nostalgia for the past, for a time in Virginia before the old estates had been "cut up" and people had "gone over the mountain."[48] The primary job of an "uncle" was to speak well of the past, conveniently eluding any mention of slavery.

The titular Tom from Stowe's 1852 novel followed in the footsteps of Scipio. Despite being ripped from his wife and babies, chained and sent off in a coffle with other miserable chattel, let down by even a good master, and beaten, finally to death, at the hands of another, he never spoke ill of any man.

Tom had originally been perceived in the prime of life. Before emancipation, a few other dark-haired, broad-shouldered adult black men had appeared in print. Images of one escaped slave, holding a rifle and standing tall, was inspiring propaganda to justify the war for northern readers of *Harper's Weekly* (Fig. 1-24). Once hostilities ceased in the mid-1860s, the image of the proud, able-bodied black man disappeared. Now that his battle service was over and he was free, that same northern weekly forgot this worthy soldier. Printer's ink flowed into effigy of an elderly former slave who spoke well of "old massa" and who held fond memories of slavery. In an engraving, from the early 1870s, by Richard Norris Brooke for the front page of *Harper's Weekly* (Fig. 1-25), like Tom, an old man sits on a mound of earth out in nature; his shoulders are slumped, and he has stopped playing his fiddle because he has been overcome with memories.

46. Gossett, *"Uncle Tom's Cabin" and American Culture*, 280.
47. Sterling Brown, *The Negro in American Fiction*, 18.
48. John Pendleton Kennedy, *Swallow Barn, or A Sojourn in the Old Dominion*, 11–12.

Fig. 1-24. "Escaped Slave" from *Harper's Weekly*, July 2, 1864, 428, Engraving.

Behind him a winding river, gay dancing figures, and the palm trees of an exotic old South haunt his reverie. Musing on the past, it was "dem good ole' times" of happy bondage this ancient fiddler recalled, not the glory days of prideful participation in a civil war and a quest for freedom. By this time, Uncle Tom had become just such a man. His popularity on stage not

Fig. 1-25. Cover page, "Way down upon the Swanee Ribber" from *Harper's Weekly* (1873). Engraving, Richard Norris Brooke.

only coincided with but also contributed to a market for these kinds of portrayals.

Adah M. Howard's short story "Uncle Ned's Cabin; or, the Little Angel Comforter" featured the now-familiar old uncle on the front page of the *New York Family Story Paper* in 1873. In an imitation of Stowe's story, using an updated rendition of Billings's arbor scene, the "little angel comforter," here called Ida, sat with the gray-haired, slumped old Uncle Ned, pointing toward "the Heavenly Zion" (Fig. 1-26). The name "Uncle Ned" had been famous since blackface minstrel shows were at their height in 1848, when Stephen Foster's "Old Uncle Ned" was being performed by almost every troupe.[49]

As the nation reconciled Reconstruction, numerous songs and song covers featured uncles. A freed man, ragged and miserable, sang "The Dear Old Home We Loved So Well" as he pined for "Dixie" and remembered happier days. Another song sheet featured a feeble oldster groping his way home, singing "I'se Gwine Back to Dixie." Recognized by the tufts of gray hair, stooped-over postures, this profusion of aging ex-slaves left the impression that they were returning to the South to die. Unfortunately, "The Old Home Aint What it Used To Be" mused yet another old geezer on a song cover of 1872 (Fig. 1-27). As North and South regrouped and formed new economic and political alliances, freedmen's bureaus were closed and African American causes and voters became obsolete.

Sterling Brown has termed the literary type a "wretched freedman, a fish out of water" as an example of how "stereotypes . . . have evolved at the dictates of social policy."[50] There was no place in public propaganda for the strong figure of an adult male African American head of household. Unable to thrive without slavery, the wretched freedman yearned for a return of the old ways. North and South joined forces and developed an agricultural peonage system that was supported by a complex web of political, social, and economic limitations. Visual culture responded with images of an idyllic South where the "old folks" remained at home.

Tom had never left. His story replayed the days of slavery. In the ultimate irony, African American characters such as Tom could be loyal slaves in perpetuity. By continually restaging Uncle Tom's life, white actors, producers, and artists found a way to keep slavery viable as an ideology of race and class.

The same aging process that occurred in prints and onstage happened across all of popular culture from the 1870s and beyond. Minstrel shows incorporated Uncle Tom and plantation life into performances laced with themes of nostalgia, reconciliation, and southern redemption. As Toll argues,

49. Toll, *Blacking Up*, 78.
50. Sterling Brown, *The Negro in American Fiction*, 1–2.

Fig. 1-26. "Uncle Ned's Cabin; or, the Little Angel Comforter" from *The New York Family Story Paper* (1873): 1. Engraving. *Collection of the author*

"Romantic and sentimentalized images of happy, contented slaves and nostalgic old Negroes looking back to the good old days on the plantation completely dominated minstrel portrayals of slaves." Minstrel performances of old slaves like Tom became a "comforting facade of romanticized, folksy caricatures." Cast aside were "wiley tricksters and antislavery protesters" from preemancipation days "for loyal, grinning darkies."[51]

After emancipation, Tom survived in print imagery and on the stage as a perpetual slave and a loyal old uncle. Tom the father, husband, and strong field hand was gone; he had died his martyr's death at the end of the novel. Apropos, Tom the venerable, grandfatherly companion of Eva was the figure that lingered in the imagination, not as a dark ghost of slavery past, but as a beloved slave who never was and so could always be.

TWENTIETH-CENTURY TOM

Uncle Tom and his story persisted in popular culture well into the twentieth century. Tom shows were still touring in the 1940s and were played on

51. Toll, *Blacking Up*, 88.

Fig. 1-27. "The Old Home Aint What it Used To Be."
Lithograph, song sheet cover, 1872. *Collection of the author*

occasion into and beyond the 1950s. There have been several motion pictures, beginning in 1903 with a twelve-minute film directed by Edwin S. Porter, in which a white actor in blackface played Uncle Tom. African American actor Sam Lucas was seventy-two when he played Tom in a 1914 film, reconfirming audiences' perception of an elderly slave. Carl Laemmle produced a big-budget, full-length feature in 1927, and *Uncle Tom's Cabin* was reinterpreted on film as recently as 1989.

Tom and Eva's relationship had solidified into an enduring icon. In motion pictures, animated cartoons, and advertising campaigns, wherever Tom and Eva appeared together, superiority acceded to the tiny girl. In several films, Shirley Temple and Bill "Bojangles" Robinson recalled Tom and Eva (Fig. 1-28). *The Little Colonel* of 1935, based on Anne F. Johnson's 1896 novel, featured tousle-headed Temple as a reluctant young Belle and Robinson as her "servant" pal. The 1935 film *The Littlest Rebel* was another faintly disguised rendition of Tom and Eva, where the southern missy cavorts with her best friend, an older male slave named Uncle Billy.[52]

In a 1946 magazine ad for the *Ink-O-Graph* pen, the couple wears contemporary dress: Tom appears in a professorial vest and suit trousers, and Eva is in a little girl's ruffled frock. Although they look up to date, nothing has changed. Proudly, Tom pulls back in the straight-back chair to survey his handiwork, and Eva dutifully stands behind him with her right hand proprietarily on his arm. Tom brandishes the fancy pen, but he makes his marks on a child's toy blackboard (Fig. 1-29). Uncle Tom has been "awritin'" boasts the ad. With white, thinning hair, and furrowed brow, Tom has aged over the years, yet time has not brought equality. Eva is still supervisor. Little missy remains "massa."

Where has Tom been lately? The Tom shows are gone. Pictures of little blonde girls bouncing on African American men's laps, or any man's lap, would give pause to viewers in a time of increased awareness about touching children inappropriately. Still, authority finds ways to "accrue to whiteness" and imagery creates other icons that are demeaning to African American men in subtle ways that pose as fondness, all the while privileging the European American point of view. Think about popular culture and which relationships are continually recreated. *Driving Miss Daisy* is perhaps the best known of actor Morgan Freeman's roles as a genial companion,

52. Kimberly G. Hébert, "Acting the Nigger: Topsy, Shirley Temple, and Toni Morrison's Pecola," 191. On Tom in film, see Donald Bogle, *Toms, Coons, Mulattoes, Mammies, and Bucks: An Interpretative History of Blacks in American Films;* and Richard Dyer, *Heavenly Bodies: Film Stars and Society.* On Eva and Topsy in film, see Lund, "Trouping with Uncle Tom," 329–37.

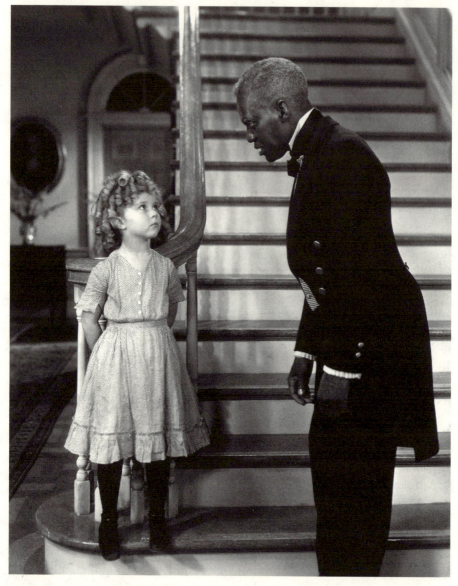

Fig. 1-28. Bill "Bojangles" Robinson and Shirley Temple, promotional photograph for the 1935 film *The Little Colonel*. *Copyright 1935, by Twentieth Century Fox*

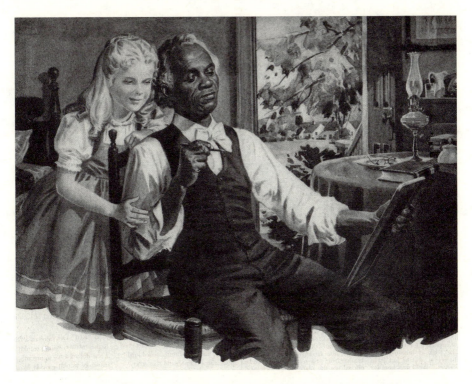

Fig. 1-29. Magazine advertisement for *Ink-O-Graph* pen, 1946.
Collection of the author

but he continues to be cast with young white women as their kindly buddy. Film scenarios for Denzel Washington often reprise the dynamic of a sexually charged, but unconsummated, relationship with a white woman. In *The Bone Collector*, for example, he is a detective paralyzed from the neck down and has an Eva-like Angelina Jolie as his "partner."

If Hammatt Billings's engravings of Uncle Tom and the reproductions of his imitators have passed on a legacy, popular imagery has reinforced America's European ancestors' notions of colonial power relationships. By replaying a scenario in which African-descendant Tom must depend on the master's little daughter Eva, visual culture has sustained European American feelings of confidence and authority. Hammatt Billings's engravings for *Uncle Tom's Cabin* did not so much leave a legacy as begin a strategy.

CHAPTER 2

The Passion of Uncle Tom:

Pictures Join Words to Challenge Patriarchy

Despite being sold down the river, away from his loving family and the only life he had known, Uncle Tom's faith in a benevolent God never wavered. From cruel Simon Legree's hell on earth on the Louisiana Red River, although mortally wounded and dying, Tom still worried for the soul of the "poor mis'able critter" who had inflicted the beatings on him. "Oh, if he only could repent, the Lord would forgive him now." With his last breath he spoke in absolution: "He an't done me no real harm—only opened the gate of the kingdom for me; that's all!" For Harriet Beecher Stowe, Tom's death in her 1852 novel was a triumph, a "Victory in Jesus," in the words of a well-known Methodist hymn, the kind Tom liked to sing.[1] Unlike her contemporaries, many of whom regarded transplanted Africans as mere living chattel, Stowe believed in the humanity of slaves. But, even more revolutionary, she believed that a slave, as well as a slaveholder, could attain divine salvation. One could say Harriet Beecher Stowe was radical.

Uncle Tom's Cabin has always been considered an exposé of American slavery, the peculiar institution that separated families, left young women vulnerable to sexual exploitation, and debased the souls of potential

1. Joan D. Hedrick, "'Peaceable Fruits': The Ministry of Harriet Beecher Stowe," 308; Eugene M. Bartlett, "Victory in Jesus" (1939).

Christians. What scholars have termed a "rhetoric of conversion" also pervades Stowe's abolition-era fiction, making the best seller as much an evangelical testament of Christian faith as an antislavery polemic.[2] But the question is, did Stowe chose Christian themes to elicit sympathy for the plight of slaves or did she use the devout professions of dying Tom as a ploy to promote evangelical Christianity?

This chapter will expand the sphere of discourse usually undertaken in literary criticism to examine another kind of text from *Uncle Tom's Cabin:* Billings's engravings. What do the original pictures suggest is the heart of the story? Instead of looking within the written text for nuances of meaning, art historians read the visual language. By isolating the pictures and analyzing their elemental qualities, an alternative telling of the plot emerges. What might have been uppermost with Stowe and how did her views compare with the significance others found in *Uncle Tom's Cabin*? Was the novel an abolitionist rallying cry or an evangelical treatise? Perhaps the original visual texts can answer this question or at least provide some clues. To what extent did illustrator Hammatt Billings emphasize antislavery or Christian iconography in those first pictures for *Uncle Tom's Cabin*?

HER FATHER'S DAUGHTER

Nineteenth-century women rarely spoke in public, and sentimental novels with their female readership were one of few venues open to a woman's voice. That a woman advanced evangelical Christianity in even this acceptable forum was quite progressive. For Harriet Beecher Stowe, it was literally a break with patriarchy. Stowe's father was the Calvinist minister Lyman Beecher, easily the best-known inheritor of Jonathan Edwards's New England Puritanism of his generation. Calvinist theology maintained that man's good work had no effect on original sin and preordained conversion. With Uncle Tom as her spokesperson, Stowe offered love and devotion as the way to salvation, disregarding Calvinist creeds and dogma.[3] According to this interpretation of scripture, one could choose to be Christian without a sign from the Almighty.

2. Stephen R. Yarbrough and John C. Adams, *Delightful Conviction: Jonathan Edwards and the Rhetoric of Conversion,* 85–93; Stephen R. Yarbrough and Sylvan Allen, "Radical or Reactionary: Religion and Rhetorical Conflict in *Uncle Tom's Cabin,*" 57–67.

3. Gayle Kimball, *The Religious Ideas of Harriet Beecher Stowe: Her Gospel of Womanhood,* 35.

If God held the power of "election and transfiguration," bestowing salvation only on the chosen, whom the Father notified in advance by a conversion experience, then, through Christ's suffering and love, lesser mortals could still be saved. By accepting the Son as their savior and in living his example, the kingdom of heaven was within reach of voluntary converts.[4] Stowe's popular story of Uncle Tom doing just that was unprecedented in the annals of sentimental fiction. Her main character was not only a slave but, moreover, a devout Christian who believed he would share eternity with Christ.

Having adapted the conversion experience paradigm to her own enterprise, Stowe later claimed that God wrote *Uncle Tom's Cabin*. Like the prophets of old, she had had a vision, and the inspiration for the Christian slave came to her in an epiphany while she sat in church. She foresaw Tom's death. Her vocation was "simply that of a *painter*," she explained when she pitched the story to *National Era* editor Gamaliel Bailey.[5] In writing a few episodes for the paper, Stowe hoped "to hold up in the most lifelike and graphic manner possible Slavery, its reverses, changes, and the negro character, which I have had ample opportunity for studying." As she stated, "There is no arguing with pictures and everybody is impressed with them, whether they mean to be or not."[6] Stowe's *National Era* serial took on a life of its own, eventually becoming a multichapter book, in which "pictures" gave visual form to her progressive theology.

If the author's idea for the novel came from God, the artist's pictures were inspired by Stowe's text made manifest using religious iconography from fine art of the past and antislavery prints currently in circulation. Billings's renderings disclosed just how potentially unruly Stowe was. Not that his drawings were shocking or even surprising. Quite the contrary, if anything, Billings's artwork offered a mid-nineteenth-century guide to prevailing pictorial conventions. What was new was not the form of these images but the content—this time a slave became a religious supplicant, intercessor, speaker of the word, and, ultimately, a Christian martyr.

ANTISLAVERY ICONOGRAPHY

When Stowe contacted Bailey she expected her story about a Christian slave might run but a few weeks. Before she was finished, *Uncle Tom's Cabin*

4. Ann Douglas, "Introduction," 25.
5. Stanley Harrold, *Gamaliel Bailey and Antislavery Union*, 142–43.
6. Wilson, *Crusader in Crinoline*, 260.

had appeared in forty-one installments from June 1851 to April 1852.[7] Readers loved it, eagerly anticipating each new segment, sharing copies of the weekly publication with friends and fretting over what would happen next. Despite the phenomenal popularity of the series, book publishers nevertheless shied away from risking an investment in the controversial topic of slavery. The recently enacted Fugitive Slave Law required all citizens to report runaway slaves, inadvertently making even the most reluctant northerner complicit in perpetuating human bondage. Political battles waged over whether newly enfranchised territories in the West would be slave or free. Fortunately for Stowe, Boston publisher John P. Jewett's wife was a big fan of the serial and may have encouraged him to take on the challenge.[8] Illustrations were likely added to justify a higher price for what had become an unwieldy two-volume length.[9]

Local graphic artist Hammatt Billings was hired to create six full-page wood engravings and one title-page vignette for the new book. As the principal illustrator for the weekly *Gleason's Pictorial*, its successor *Ballou's Pictorial Drawing-Room Companion*, and the annual *Boston Almanac* and a contributor to the books of Ticknor and Fields and other Boston publishers, Billings was a likely choice to illustrate Stowe's story.[10] In 1850 he had redesigned the masthead for fellow Bostonian William Lloyd Garrison's antislavery newspaper the *Liberator*. That he took no fee for work, which would have paid about twenty dollars, may suggest that he held anti-slavery sympathies. Despite the fact that Stowe considered herself an amateur artist, there is no record of Stowe and Billings ever having a conversation about the project. Stowe does seem to have found Billings's work acceptable, for she used him again to illustrate later novels.[11]

Antislavery imagery in the United States had long relied on images with Christian associations, and four of the six original Billings illustrations show this influence. For example, "Fugitives safe in a free land" captures the moment when runaways Eliza and husband George Harris, with their child, reach Canada (Fig. 1-6). As a pious family, they kneel together, thanking God for their freedom. Probably the best-known image in the antislavery arsenal had been a kneeling figure. Created in 1787 as an emblem for the English Abolition Society for use on its banners, a half-clad African slave on his

7. Smith, "Serialization and the Nature of *Uncle Tom's Cabin*," 69–70,

8. Wilson, *Crusader in Crinoline*, 259–60, 269.

9. O'Gorman, *Accomplished in All Departments of Art*, 47; Gossett, "*Uncle Tom's Cabin*" and American Culture, 164.

10. David Tatham, *Winslow Homer and the Pictorial Press*, 31, 37–39.

11. Wilson, *Crusader in Crinoline*, 247; O'Gorman, *Accomplished in All Departments of Art*, 47.

knees became a fashionable medallion when English ceramist Josiah Wedgwood reproduced the image on a mass-produced cameo. The roundel format required for a medallion made the figure's constricted fetal shape an effective design solution. Curiously, in England, the kneeling slave had not seemed to be a religious image but a "negative emblem of white superiority" bowed to summon the noblesse oblige of a charitable ruling class.[12] Benjamin Franklin, the president of the Pennsylvania Abolition Society, received shipments of the medallions, which he distributed the next year amongst friends.[13] Once across the Atlantic, the slave emblem entered a society deeply affected by this posture of reverent supplication. "Am I Not A Woman and A Sister?" asked the caption encircling the earth-bound figure on coin tokens and in prints (Fig. 1-5). With hands held aloft, the figure seemed to plead, "Am I not a Christian too?"

Lydia Maria Child's *An Appeal in Favor of That Class of Americans Called Africans* was the first antislavery text to be published in book form in the United States.[14] A steel engraving of a kneeling female slave was the only image in the book, but it was showcased as the frontispiece. Adapted from an 1827 painting by Henry Thomson of a young African kneeling in prayer, the image had previously been used to illustrate a central incident in a short story entitled "The Booroom Slave" by a Mrs. Bowditch.[15] The kneeling slave woman, hands clasped, searches the heavens and asks, "What fate reserved me for this Christian race?"[16] Formerly a writer of popular domestic advice books such as *The Frugal Housewife*, Child was adept at addressing the concerns of a female reader. With the young slave dressed scantily by nineteenth-century dictates, the image suggests she is of "primitive" origins but in an inchoate stage of Christian conversion. In stressing the piety of the slave, Child's appeal was crafted to bring women into the antislavery movement.

In 1850 Billings used a kneeling slave figure to augment the masthead designed in 1838 by David Claypoole Johnston for the *Liberator* (Fig. 1-2). To Johnston's vignettes—a slave auction (left side) and the vision of emancipation (right side)—Billings added a central oval within which the kneeling slave looked up to the standing, radiating figure of Christ. The kneeling

12. Hugh Honour, *From the American Revolution to World War I*, 64.

13. Benjamin Quarles, *Am I Not a Man and a Brother: The Anti-Slavery Crusade of Revolutionary America, 1688–1788*, vi.

14. Blanche Glassman Hersh, *The Slavery of Sex: Feminist-Abolitionists in America*, 13.

15. Honour, *From the American Revolution to World War I*, 130.

16. Lydia Maria Child, *An Appeal in Favor of That Class of Americans Called Africans*, frontispiece.

supplicant, with roots in Christian practice, coincided nicely with abolitionists' claim that slaves could be devout human beings. An icon of antislavery, the kneeling supplicant was also made-to-order for Christian evangelicals.[17]

KNEELING SUPPLICANTS

The kneeling supplicant that northerners perceived in the English Abolition Society emblem traces from even earlier European origins. Italian Renaissance paintings were abundant with genuflecting figures: an Ethiopian wise man bows before the Christ child in a nativity scene, for example. Wealthy Florentine patrons were posed in supplication on side panels of sacred scene altarpieces for family chapels. These generous acts of financial investment and devotion may or may not have affected their progress toward the hereafter, but their devout postures certainly gained them esteem in the here and now of fifteenth-century Italy.

Despite its Catholic roots, kneeling continued to signify allegiance to God for American Puritans. Only affluent Americans could afford expensive books with engraved reproductions of European fine art, but even the middling classes were versed in Christian iconography. Since the late eighteenth century, books with Christian images were used to teach Americans how to spell. For instance, in the *New England Primer* (1780) letters corresponded to biblical examples such as Queen Esther for the letter *Q*. Beginning in 1820, children's literature and schoolbooks were often profusely illustrated. David Morgan credits this rise in picture pedagogy to two far-reaching social developments: the revivalism of evangelical Protestantism and a growing movement to establish publicly funded common schools. Images were tools for inculcating virtue, and when used in concert with words, they helped students learn to read written texts. The American Tract Society and the American Sunday School Union distributed illustrated tracts, pamphlets, and books to the faithful and to potential converts, children and adults. The evangelical Christian Bible and tract societies pioneered mass-circulation print technology. By the 1830s, the American Anti-Slavery Society had adopted the same methods to advance their cause.[18]

17. O'Gorman, *Accomplished in All Departments of Art*, 48.
18. David Morgan, "For Christ and the Republic: Protestant Illustration and the History of Literacy in Nineteenth-Century America," 52–57; Nord, "Evangelical Origins of Mass Media," 23.

The tactics of evangelical Protestants wanting to recruit Christians and the advocates of common schools' intent to raise up good citizens for the Republic were much the same. For example, in an 1844 school primer, George Washington was portrayed much like a kneeling supplicant. He faced readers, arms wide and beckoning, a good shepherd summoning the flock. The accompanying text promised, "Prayer is the simplest form of speech." The Republican ideal of doing good works for the destitute was shared by both civic- and Christian-minded reformists. According to Morgan, both of these groups shared a "commitment to the collective good." By placing his slave in a kneeling posture on his masthead design, Billings enlisted a figure with civic appeal as well as Christian association. This was a perfect choice to entice future abolitionists to the good work of freeing the slaves.[19]

The connection between evangelical Christianity and the antislavery movement has been well researched. "[A]bolitionism may have been the last successful reform movement in the United States fueled largely by a progressive Christianity," observed Richard Yarborough in his analysis of *Uncle Tom's Cabin*.[20] That it was at this juncture, twenty years into a run that had lasted more than three decades, that the praying slave gained primacy on the front page of the *Liberator* indicates how important Christian principles were to abolitionists by the 1850s. Editor William Lloyd Garrison and wealthy brothers Lewis and Arthur Tappan of New York, the founders of the American Anti-Slavery Society, were evangelical Christians. By the 1850s, so too was a growing rank-and-file membership among the abolitionist community.[21]

BAREFOOT MADONNA AND REPENTANT MAGDALENE

Another antislavery figure with even deeper roots in Christian iconology and a broader experience in American antislavery imagery was the young slave mother who could evoke images of the Christian Madonna. In addition to showcasing the potential Christianity of slaves, abolitionists were keen to the threat slavery posed for mothers and their children. When the *Liberator* debuted in 1831, the first illustration to top the front page was of a slave mother and her children (Fig. 2-1). The tiny cut, also by Johnston,

19. Morgan, "For Christ and the Republic," 54.
20. Yarborough, "Strategies of Black Characterization in *Uncle Tom's Cabin*," 79.
21. James Brewer Steward, *Holy Warriors: The American Abolitionists and American Slavery*, 50–51, 78.

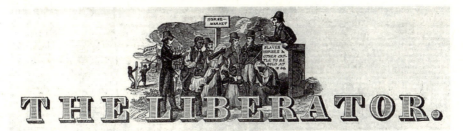

Fig. 2-1. *The Liberator,* June, 22, 1833. Masthead designed
by David Claypoole Johnson. *Collection of the author*

shows a slave auction in progress; the mother huddles with her two
children before an auctioneer holding a gavel. "[S]laves, horses and other
cattle to be sold at 12:00," reads a sign. The mother's head is covered in a
soft scarf, evoking images of Madonna and child icons from centuries of
Christian art, while reminding *Liberator* readers that slavery separates
families.

The catalyst that sets Stowe's story in motion is the sale of Eliza's child.
In chapter 1 the reader meets Eliza, a young quadroon who is possessed of
"refinement," "softness of voice and manner," and Christian upbringing.[22]
Through the vagaries of improvident speculation, her master, a Kentucky
planter named Shelby, has become indebted to a crude slave trader named
Haley. As the book begins, the loathsome creditor comes to collect. To settle
the account Haley insists upon having Eliza's little boy Harry and Uncle
Tom. After overhearing talk of this transaction, Eliza resolves to flee.

For the first full-page picture in that premiere *Uncle Tom's Cabin* of 1852,
"Eliza comes to tell Uncle Tom that he is sold, and that she is running away
to save her child" (Fig. 1-3), Billings seized the moment of pathos and
imbued it with Christian significance. His choice of slave mother and child
reminded viewers of the iconic tradition of Virgin and child: a loose shawl
drapes Eliza's head and she cradles the boy in her arms. Eliza was a
Christian mother, a barefoot Madonna, Mary in her flight into Egypt, while
Harry, who was described in the text as "a small quadroon boy, between
four and five years of age," was her baby Jesus or the future prophet Moses.

And there were other women in *Uncle Tom's Cabin* with biblical corollar-
ies. Of all the slave characters in the book, Cassy posed the greatest obstacle
for engaging sympathy of the genteel ladies who read sentimental fiction.
The system of American slavery had reduced a once-sensitive and pious

22. Douglas, *Uncle Tom's Cabin,* 54.

young quadroon to the mistress of slave master Legree, a drunken, disgusting defiler of women. Her crimes had been many—not only adultery but also infanticide. After two of her children had been sold away, she determined that a third never would be. A generous dose of laudanum delivered her two-week-old baby from the deplorable life of a slave.

Based on the depth of her corruption, Cassy may have been Stowe's most emphatic expression of evangelical Christianity, and Billings appears to have fully understood her role in this novel about conversion and redemption. If Eliza resembled the Madonna, Billings's Cassy favored another woman in the life of Christ. With "Cassy ministering to Uncle Tom after his whipping," he cast the downtrodden slave as a penitent Magdalene comforting the battered Christ-like Tom (Fig. 1-7). Here Billings's representation is indebted to Christian iconography from fine art. Crouched on the floor of the rude shelter, holding drink for Tom, Cassy resembles the candlelit Magdalene of seventeenth-century French painter Georges de La Tour. Her disheveled hair brings to mind the tattered figure by fifteenth-century Italian Renaissance sculptor Donatello.

"[W]ith her wild eyes and melancholy voice," Cassy seems to Tom "an embodiment of the temptation with which he had been wrestling." She tells him, "There isn't any God." But his steadfast Christian faith reawakens Cassy's ability to love and to hope, instigating her redemption much like Christ did for the original Magdalene. The redeemed Cassy, a testament to the power of Christian conversion, is Tom's great achievement. A woman, who is full of sin, a fornicator and a murderer, yielding to Tom's plea, she stops her plan to kill the godless Legree with an axe. Tom's faith gives her the strength and ingenuity to escape her life of degradation. By portraying Cassy not in triumphal escape from Legree's plantation nor as a powerful woman taking charge of her own destiny, but resembling Mary Magdalene, the once-depraved woman becomes devout again, Billings affirms the book's evangelical message. Stowe is not just trying to save slaves: she is saving souls.

TOM AND EVA: CHRISTIANS BY "NATURE"

Because it was unprecedented in antislavery or religious iconography, "Little Eva reading the Bible to Uncle Tom in the arbor" remains for many today the book's most puzzling, if pivotal, scene. Where Billings found incentive to partner slaveholder St. Clare's little daughter Eva with Uncle Tom, and to show them alone together under the leafy bough of an outdoor arbor, can only be from the story itself. It was, of course, Tom's duty to look

after Eva, but he was more than her caretaker or even her companion: sharing a private moment with the young woman in an unsupervised natural setting, he almost resembled a lover (Fig. 1-9).[23]

At first glance, Billings's strategically placed Bible on Eva's lap seems intended to tempt and then to thwart a sexual reading. And as documented in chapter 1, the pictures of Tom and Eva have a sexual charge, the quelling of which may be one reason the image was so popular. It is interesting to note that when Billings made additional cuts for an 1853 edition, he added quite a few more scenes of close contact between Tom and Eva. His reliance on this union points toward other intriguing possibilities about what Stowe was saying in the novel.

Physical closeness—Eva holding Tom's hand or touching his leg—could be a subterfuge to deflect what by nineteenth-century mores was an even more subversive behavior. Perhaps the sheer audacity of pairing an adult black male with a young white female caught viewers so off guard that they overlooked that this slave was in fact literate. In practice, slaves were not allowed to read and were sometimes punished for trying to learn. Not only was Tom reading, he was witnessing for Christ. White men had the ordained privilege to speak the Christian word; slaves did not. Tom and Eva's act of reading the Bible together undermined patriarchal authority. Billings interpreted Stowe mounting an incursion into the realm of white male privilege by making Tom an odd contradiction of virile slave and sensitive male, tamed by Christianity and restricted within domestic boundaries.

Literary scholar Elizabeth Ammons developed the theory that Stowe feminized Tom, giving him piety and other virtues ascribed to women "in the unorthodox cause of challenging, not accommodating, the patriarchal status quo."[24] Billings collaborated to an extent by reducing Tom, through slumped posture, to the level of the girl in a setting coded as feminine: a cultivated garden. But, according to O'Gorman, "if this version made Tom sexually harmless it also made him spiritually potent."[25]

Perhaps Stowe feminized Tom just enough to mitigate that she had assigned him tasks accorded only to white men. Women may have been the moral exemplars in the home, but fathers read the Bible aloud to their families and men spoke of God's grace in prayer at the family dinner table. In her *Key to Uncle Tom's Cabin*, written the next year, Stowe downplayed the subversive aspect of Tom's proselytizing by identifying his predilection

23. Hébert, "Acting the Nigger."
24. Ammons, "Heroines in Uncle Tom's Cabin," 153.
25. O'Gorman, *Accomplished in All Departments of Art*, 56.

to speak the word of God as part of his African heritage. She wrote, "the divine graces of love and faith, when in-breathed by the Holy Spirit, find in [the Negro's] natural temperament a more congenial atmosphere."[26] According to biographer Joan Hedrick, Stowe's ideas were inspired by Alexander Kinmont, whose 1837–1838 lectures she likely attended when the Beecher family resided in Cincinnati: "[A]ll the sweeter graces of the Christian religion appear almost too tropical and tender plants to grow in the Caucasian mind; they require a character of human nature which you can see in the rude lineaments of the Ethiopian."[27] Stowe echoed Kinmont's theory in chapter 38 of *Uncle Tom's Cabin*, "The Victory": "It is the statement of missionaries that, of all the races of the earth, none have received the Gospel with such eager docility as the African."[28] She may have thought it prudent to mollify slightly her challenge to patriarchy by characterizing Tom as a Christian by "nature," not as an interloper interceding into the domain of white male privilege.

The remaining two pictures in the first edition contained no Christian references, however, the theme of a family in danger is present in both. One of these pictures, "The Auction Sale," adapted from the *Liberator* masthead, would have a lasting influence on other illustrators and publishers.[29] The other shows the Harris family's dramatic escape.

BILLINGS'S "BIBLE"

With three hundred thousand of that first edition sold by year-end, Billings's prints in *Uncle Tom's Cabin* were among the most widely circulated pictures in the country. Rushing to capitalize on the book's popularity in the United States, Jewett commissioned Billings to draft new engravings for a special second edition, a gift book for Christmas 1852, but imprinted with the publication date 1853. This edition was priced at fifteen dollars: ten times the $1.50 cost of the original version.[30] Although some of the earlier pictures had been revamped, his illustration of Eva and Tom in the arbor remained much the same, and he drew more for a total of 127 cuts. While several of the first illustrations had evoked biblical associations, with this second version Billings's use of Christian iconography became

26. Arthur Riss, "Racial Essentialism and Family Values in *Uncle Tom's Cabin*," 518–19; Harriet Beecher Stowe, *Key to Uncle Tom's Cabin*, 41.
27. Hedrick, "'Peaceable Fruits,'" 209–10.
28. Douglas, *Uncle Tom's Cabin*, 559.
29. O'Gorman, *Accomplished in All Departments of Art*, 51.
30. Ibid., 47; Gossett, *"Uncle Tom's Cabin" and American Culture*, 164.

more literal. The fancy gift book even looked like a Bible. The cover was pebbled deep crimson and adorned with a gold-embossed imprint of Christ (Fig. 2-2); the pages were gilt-edged; and tiny imprints of angels, praying figures, and doves decorated the chapter endings. Jane Tompkins documented Stowe's "countless quotations from Scripture" that ranged throughout "in the narrative, in dialogue, in epigraphs, in quotations from other authors; . . . in the Protestant hymns that thread their way through scene after scene, in asides to the reader, apostrophes to the characters, in quotations from religious poetry, sermons, and prayers."[31] Billings employed a similarly textured use of visual quotes, the kind one might find embedded in an illustrated Bible. In the tradition of medieval gospel books, the written text of each chapter began with a decorative letter related to the theme; chapter title pages all had a picture illustrating the topic. For example, the chapter in which the Harris family reaches Canada was called "Liberty." Billings created a new image of the praying family to fit the compressed format above the chapter title. On the same page beginning the first paragraph in a tiny vignette a bird just set free surrounded the letter *A*. The immediate visual impression of the page resembled an illustrated Bible.

The Bible held a special place in antebellum American homes. According to Colleen McDannell, "Bound in leather and fastened with a golden clasp, family Bibles were displayed on parlor tables as signs of domestic piety and taste."[32] Beginning with Isaiah Thomas's illustrated English Bible of 1791, by the 1850s close to half of all Bibles published in America had illustrations, and many also had stamped decorations done by hand tools on their covers or embossing done by metal blocks. Publisher Jewett astutely chose to publish a larger format, gold-embossed, amply illustrated edition for the holiday market. This volume was worthy of being placed on the parlor table next to the family Bible.

A decade earlier, Harper and Brothers had published an *Illuminated Bible,* with more than sixteen hundred pictures, that was believed to be largely responsible for the "illustration mania" in books and periodicals that began about this time.[33] Paul Gutjahr compares Harper and Brothers's *Illuminated Bible* of 1841 with earlier Bibles published by Isaiah Thomas and Matthew Carey of Philadelphia to conclude that imagery had increased and had changed in style. The English Bible with fifty copperplate illustrations

31. Tompkins, *Sensational Designs,* 133–34.
32. Colleen McDannell, *Material Christianity: Religion and Popular Culture in America,* 68.
33. Morgan, "For Christ and the Republic," 65.

Fig. 2-2. Embossed cover of Harriet Beecher Stowe's *Uncle Tom's Cabin* (Boston: John P. Jewett, 1853), by Hammatt Billings. *Collection of the author*

aspired to emulate high art in its rococo style.[34] Gutjahr describes the Carey Bible of 1816 as "often sexually provocative" with as many as seventy pages of illustrations.[35] Harper's imagery suggests a transformation was taking place in readers as the once male-dominant, Calvinist point of view was evolving into a feeling-based, evangelical Christianity. Harper's illustrations show women as principal spiritual standard-bearers instead of victims of violence as had previously been the case.[36] With child mortality rates high, and the task theirs to raise virtuous children, nineteenth-century women identified with pictures such as Rachel weeping on Harper's title page. This trend coincided with Stowe's reliance on characters such as Tom who displayed qualities women could relate to. Perhaps it was this charge to inculcate virtue in the young that inspired Billings to insert an expensive steel engraving of Eva as a frontispiece.

Gutjahr cites *Uncle Tom's Cabin* to show how evangelical Christians found narrative means to promote Christianity: "Uncle Tom and Eva in *Uncle Tom's Cabin* embodied the Savior's compassionate lifestyle of sacrificial love." Through pictures "assigning his core attributes to commonplace figures such as little girls . . . and even slaves. . . . Christ's divinity became human, and the promise was held out that humans could become more divine."[37] The illustrations closely followed the written narrative and took on the didactic tone of the words, making the story, literally, readable from the pictures.

Billings used the Bible as a symbol of devout gentility to remind the reader of the slave Eliza's virtue. Just before she learned of the sale of her son, her husband, George Harris, who lived on another plantation, had told her that he planned to escape from his cruel master. "I an't a Christian like you," he said, "I can't trust in God." This scene forecast a similar conversation Tom would have with Cassy. Eliza, as Tom would Cassy, cautioned George to have faith, "God is doing the very best."[38] To underscore her conviction, Billings knew that in Eliza's room, be it ever so humble, a Bible must be on the reading table.

The cover of the 1853 edition resembled a Bible, and pictures inside the book conjured biblical stories and symbols. For this second series of illustrations, Billings expanded from his antislavery repertoire of kneeling

34. Paul C. Gutjahr, *An American Bible: A History of the Good Book in the United States, 1777–1880*, 73–74, 48.

35. Paul C. Gutjahr, "American Protestant Bible Illustration from Copper Plates to Computers," 272.

36. Gutjahr, *An American Bible*, 73–74.

37. Ibid., 141, 159.

38. Douglas, *Uncle Tom's Cabin*, 62–63.

supplicants and gentle mothers. Christian prototypes were readily available in the illustrated Bibles and devotional tracts, which by midcentury were in most middle-class homes. In 1853 alone, 733,042 Bibles were issued from the American Bible Society depository.[39] For these hundreds of thousands who owned Bibles, Christian iconography was a well-understood visual language.

Billings tells Tom's story in three distinctly Christian visual narratives. Throughout the first part of the book Tom is an itinerant minister. The text describes an informal prayer meeting he presides over on the Shelby plantation in Kentucky the night before he is taken away. A chapter letter shows him reading a Bible. Traveling down the river with other slaves to the New Orleans market, he clutches a Bible as he consoles a weeping slave woman. A large Bible is open on his lap when he first encounters little Eva St. Clare on the boat deck (Fig. 2-3). It is still in his hands when she brings her father to meet him. This section culminates in a scene that Ammons calls a "figurative baptism [that] signifies their oneness in Christ."[40] When Eva falls overboard, Tom jumps into the water to save her from the river. In Billings's image of this crucial moment, arms reach down to pull them back on board, a halo of helping hands (Fig. 2-4).

The second visual narrative begins with Tom's purchase by Eva's father, Augustine St. Clare. Tom spends this section entirely preoccupied with religious matters. As an intercessor praying for others, he assumes the pose of a supplicant on his knees praying for the conversion of St. Clare. In one picture he prays for Eva to regain her health, and in another he sits at her bedside, as she grows weaker. Later, he grieves as St. Clare lies dying from an untimely wound (Fig. 2-5).

In addition to reprising the engraving of Tom and Eva in the arbor (Fig. 1-13) from the first edition, Billings created additional scenes of intimacy, which emphasized what may be Stowe's most daring challenge to the patriarchal order. Where her white, male patriarchs were weak, Tom was strong. St. Clare was a kind master without the will to accede to southern patriarchal expectations. Lacking the dictatorial, commanding manner of a slaveholder, he abnegated parental responsibility to Tom. Eva instigated the purchase of Tom and now she was under his care. In Billings's pictures, Eva snuggling onto the lap of her father (Fig. 2-6) varied little from her cozy times embracing Tom in the courtyard.

St. Clare neglected his duty to inculcate Christian doctrine, leaving that to Tom as well. Because nineteenth-century women were assigned the responsibility for teaching children morality in the home, scholars have viewed

39. Gutjahr, *An American Bible,* 44.
40. Ammons, "Heroines in Uncle Tom's Cabin," 158.

Fig. 2-3. Engraving, by Hammatt Billings. Harriet Beecher
Stowe, *Uncle Tom's Cabin* (Boston: John P. Jewett, 1853), 186.

Tom's submissive and nurturing sensibilities as feminine traits. According
to Ammons, who called Tom a "heroine," Stowe's was a "shrewd political
strategy." By making Tom "pious, domestic, self-sacrificing, emotionally
uninhibited in response to people and ethical questions. . . . The character-
ization insinuates Tom into the nineteenth-century idolatry of feminine
virtue, sentimentalized in young girls and sacrosanct in Mother." "Stowe's
genius as a propagandist," Ammons continued, was in making Tom, a
black man, "the supreme heroine of the book."[41] Ammons first posed this
idea almost thirty years ago, and her theory served to elevate the character
of Tom and validated Stowe's unprecedented feminist stance. Yet, the Tom
in Billings's images was far more than just a repository of maternal values.

41. Ibid., 159.

Fig. 2-4. Engraving, by Hammatt Billings. Harriet Beecher
Stowe, *Uncle Tom's Cabin* (Boston: John P. Jewett, 1853), 193.

Stowe's words and Billings's pictures united to challenge the white male
patriarch where he lived. Wherever Tom went he became the male head of
household. On the Shelby plantation "Uncle Tom was a sort of patriarch in
religious matters . . . he was looked up to with great respect," and even the
master's son attended prayer meetings in Tom's cabin.[42] On the plantation
of the brutalizing Simon Legree, other slaves looked to him. Cassy called
him "father Tom." During the mid-nineteenth century, the father purveyed
Bible wisdom; "Lord and master" in the home, he delivered the word. In
images of families gathered together, it is the patriarch who reads from the
Bible. Through his devout professions, his counsel, Tom, also fulfilled this
aspect of the father's role. It was with Tom that Eva sat poring over a Bible,
growing stronger in her Christian faith (Fig. 2-7).

Following the deaths of Eva and St. Clare, Tom was again sold. For a brief
interlude he returned to itinerant preaching. As he sat in the slave
warehouse awaiting yet another sale of his person, a Bible protruded from

42. Douglas, *Uncle Tom's Cabin*, 79.

Fig. 2-5. Engraving, by Hammatt Billings. Harriet Beecher
Stowe, *Uncle Tom's Cabin* (Boston: John P. Jewett, 1853), 399.

his coat pocket. He ministered to slave women his first night at Legree's
dark place.

Throughout the last third of the novel, Billings interprets Tom's final days
as a reenactment of the passion of Christ. Because he refuses to renounce his
beliefs and to bow to an earthly master, Legree orders Tom whipped, as if
condemned by Pontius Pilate. Overseers Sambo and Quimbo lead Tom
down his own road to Calvary. After a beating, Tom is comforted and given
drink by Cassy, the Magdalene. Billings reprises from the 1852 cuts the
engraving of Cassy bringing Tom water by a lantern light (Fig. 2-8). It is
here that Tom requests she read aloud from his Bible: "Father forgive them
for they know not what they do," is the chosen passage.

Tom's "trial by pain" at Legree's demand continues. Tom imagines he
sees Christ: "a vision rose before him of one crowned with thrones, buffeted
and bleeding."[43] Billings renders a crucifixion of Tom, lashed to a post,

43. Ibid., 52, 54.

Fig. 2-6. Engraving, by Hammatt Billings. Harriet Beecher
Stowe, *Uncle Tom's Cabin* (Boston: John P. Jewett, 1853), 343.

beaten at Legree's command, while Christ, manifest before his eyes,
sustains him (Fig. 2-9). He dies grieved over in a "lamentation" by Sambo
and Quimbo, whom he has by then converted (Fig. 2-10). The Kentucky
planter's son George Shelby arrives too late to save him but sees to Tom's
burial, an "entombment" (Fig. 2-11). The novel ends with an image of
"resurrection" as multitudes of freed people move in exodus toward a
radiant sky blazoned with the words "Freedom in Africa" (Fig. 2-12).

Christian references appear throughout the book. Decorative letters begin
chapters, with banners saying "Love Your Enemies." Angels ornament
Eva's bed. A dream of Eva as an angel helps Tom through a dark hour. With
a gold-embossed cover of Christ, picture stories of Tom as minister, as
intercessor, and as a martyr reenacting the passion of Christ, Billings's 1853
Uncle Tom's Cabin did not just resemble a Bible, for many it was a veritable
New Testament (Fig. 2-13).

Fig. 2-7. Engraving, by Hammatt Billings. Harriet Beecher Stowe, *Uncle Tom's Cabin* (Boston: John P. Jewett, 1853), 237.

CHALLENGING PATRIARCHY

With Billings's help in crafting Tom as a Christian father figure, Stowe posed several challenges to patriarchy. Her evangelical Christianity was counterposed to the patriarchal elitism of her father's Calvinism, yet not out of step with the religious trends of her time. By advocating the liberation of slaves, she opposed the patriarchal institution upon which southern social, political, and economic well-being depended. But then, she was a northern woman, writing in the wake of the Fugitive Slave Law, which left legions of northerners outraged. Her severest incursion into the purview of European American manly privilege was that she destabilized the figure of male authority within the home.

Tom's first master, Mr. Shelby, had meant well, but he had gotten into financial trouble and had failed to keep his slave families intact. A rude,

Fig. 2-8. Engraving, by Hammatt Billings. Harriet Beecher
Stowe, *Uncle Tom's Cabin* (Boston: John P. Jewett, 1853), 448.

lower-class trader had gained the advantage over him. His second master
was the father of Eva St. Clare, a decent enough white man, who was weak
at heart, indolent, and laissez-faire and thus ineffective under the dictates
of the peculiar institution. He seemed incapable of accepting responsibility
for anything. Tom, a slave who preached the Gospel, performed his
paternal Christian duty for him. And after St. Clare died, the hateful wife
he had indulged became the one to determine the fate of his hapless slaves,
cheating St. Clare out of even a man's right to pass on "property" or, as he
had promised, to free Uncle Tom. By contrast, Tom's third master, Legree,
was an avowedly cruel white man. Although he was the son of a Christian
mother, he was corrupted by the system of slavery and had become mean
and degenerate, an equally inept patriarch. Only Tom claimed "The
Victory," as a chapter title boasted, under a regime that stood in opposition

Fig. 2-9. Engraving, by Hammatt Billings. Harriet Beecher
Stowe, *Uncle Tom's Cabin* (Boston: John P. Jewett, 1853), 517.

to Christian ideals. He successfully converted others, and his good work
and commitment paved the way to his own salvation and eternal life.

HEGEMONIC CORRECTION

Strategies to reassert the white male's rightful place in the social hierarchy
began at once. Unable to alter the words of a widely known best-selling
novel, it was within the realm of visual culture that European American
patriarchal dominance over Uncle Tom was reestablished. In Billings's
original illustrations for the 1852 novel, when Eliza comes to warn Tom of his
impending sale, she rushes to Tom's door embracing her child in a great
sweep of imminent departure. Tom and Chloe react in gasping surprise. Even
the posture of Bruno the Newfoundland seems animated. The Christian

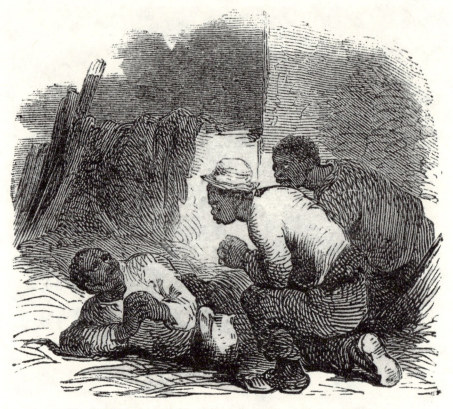

Fig. 2-10. Engraving, by Hammatt Billings. Harriet Beecher
Stowe, *Uncle Tom's Cabin* (Boston: John P. Jewett, 1853), 518.

mother actively seeks her own salvation, physical and spiritual. In the 1853
picture, when Eliza comes to warn Uncle Tom of the impending sale,
everyone faces forward as if in a frieze. Eliza holds the child but seems in
no hurry; Chloe looks lost in thought and Tom buries his face, while the
dog strikes an inquisitive pose (Fig. 2-14). That this scene resembles a stage
tableau is no coincidence. Between the first edition and the Christmas gift
book, stage shows based on the novel appeared in New York City. George
Aiken's script for George Howard's production of *Uncle Tom's Cabin*
premiered in Troy, New York, in September 1852. About that time, Henry
J. Conway debuted a different version in Boston. Both were playing New
York City within a year, and more were soon to follow.[44]

44. Gossett, *"Uncle Tom's Cabin" and American Culture,* 269; Lott, *Love and Theft,*
222–23.

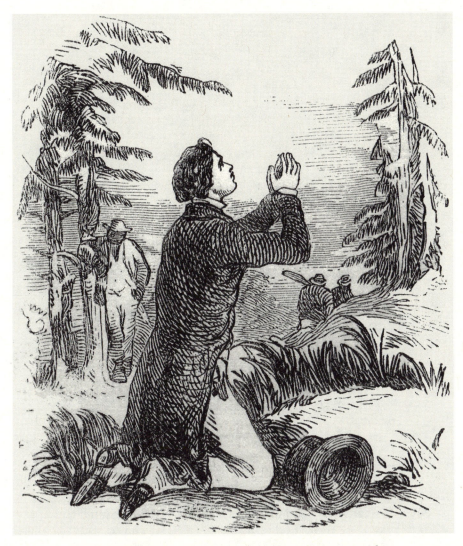

Fig. 2-11. Engraving, by Hammatt Billings. Harriet Beecher Stowe, *Uncle Tom's Cabin* (Boston: John P. Jewett, 1853), 526.

When Eliza crossed the Ohio River on the stage, complete with ice floes and menacing dogs in pursuit, clutching Harry, huddled against the storm, theatergoers were dazzled. In the book there were no dogs chasing her that night on the Ohio. Perhaps the stage shows inspired Billings to add a rendition of the dramatic frozen river scene above the chapter 7 title, "The Mother's Struggle," in his 1853 compilation (Fig. 2-15). In any event, this

Fig. 2-12. Engraving, by Hammatt Billings. Harriet Beecher
Stowe, *Uncle Tom's Cabin* (Boston: John P. Jewett, 1853), 550.

harrowing escape became Eliza's signature moment; it was a favorite on
posters and playbills and was copied by other book illustrators (Fig. 2-16).
Illustrations of Eliza as melodramatic heroine supplanted the gentle
Christian mother who stood outside Tom's door in the original engraving.

While playing up the melodrama, the staged Tom shows also capitalized
on Christian themes in new ways. Before *Uncle Tom's Cabin,* the theater had
been a raucous and bawdy place that was unsuitable for gentlewomen.
Theatergoing in American culture had been primarily a male pastime, and
minstrelsy, especially, depended on sexual innuendo and rowdy behavior.
Christy's Minstrels at Mechanics Hall and Wood's Minstrels at Marble Hall
were at the heart of the New York theater district known for sexual
commerce.[45] Prostitutes trolled the throngs of working-class men, in search
of patronage.

45. William J. Mahar, *Behind the Burnt Cork Mask: Early Blackface Minstrelsy and
Antebellum American Popular Culture,* 277.

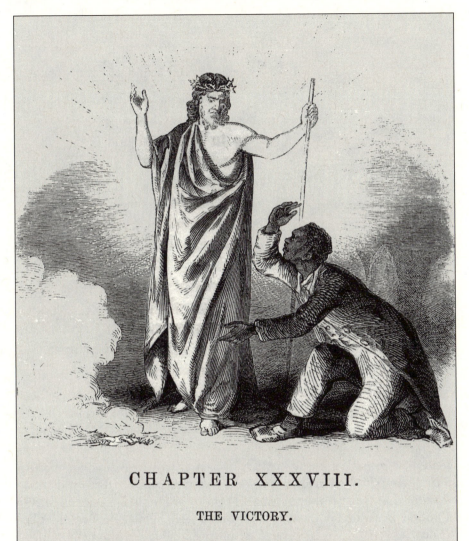

CHAPTER XXXVIII.

THE VICTORY.

" Thanks be unto God, who giveth us the victory."

Fig. 2-13. Engraving, by Hammatt Billings. Harriet Beecher
Stowe, *Uncle Tom's Cabin* (Boston: John P. Jewett, 1853), 486.

Within months of her book's publication, Stowe had been approached
and had refused to grant approval for the story to be staged. Of course,
without copyright protection and because of a tidal wave of entrepreneur-
ial interest, there was no stopping producers and theater owners who

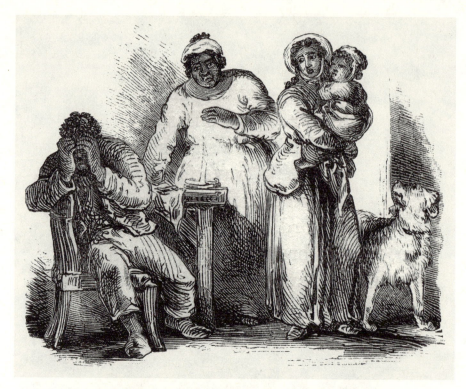

Fig. 2-14. Engraving, by Hammatt Billings. Harriet Beecher
Stowe, *Uncle Tom's Cabin* (Boston: John P. Jewett, 1853), 60.

wanted to capitalize on the novel.[46] In part, it was the Christian ethos of
Uncle Tom's Cabin that made impresarios desire to produce it as a play, in an
effort to legitimize theatergoing and to entice proper ladies to enter a "den
of iniquity," as the National Theater billed itself while showing the play.
While Henry Conway's adaptation played at P. T. Barnum's American
Museum in New York City, Barnum displayed a painting of himself in front
of the theater, Bible in one hand, *Uncle Tom's Cabin* in the other.[47] Alas, the
white male patriarch had seized control of "the word" once again.

46. Lott, *Love and Theft*, 213; Gossett, *"Uncle Tom's Cabin" and American Culture*,
261.
47. Linda Williams, *Playing the Race Card: Melodramas of Black and White, from
Uncle Tom to O. J. Simpson*, 82; A. M. Drummond and Richard Moody, "The Hit of
the Century: *Uncle Tom's Cabin*, 1852–1853," 318; Gossett, *"Uncle Tom's Cabin" and
American Culture*, 270.

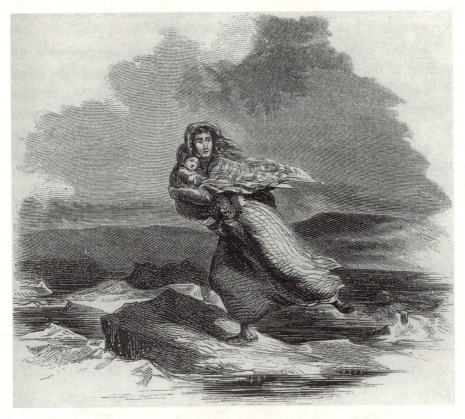

Fig. 2-15. Engraving, by Hammatt Billings. Harriet Beecher Stowe, *Uncle Tom's Cabin* (Boston: John P. Jewett, 1853), 73.

THE GREAT WHITE PATRIARCH

The kneeling African slave on the English medallion had originally been understood as pleading for his life. In American abolition-era images, the pose connoted religious supplication: the figure kneeling at Christ's feet on the *Liberator,* for example, sought mercy. When Uncle Tom knelt to pray it was a position of power, an intercessor addressing God on behalf of weaker mortals.

It may not be a coincidence that perhaps the most post-emancipation kneeling figure was sculpted by Billings's childhood friend Thomas Ball.[48] Finished in 1876, Ball's *Freedmen's Memorial Monument to*

48. O'Gorman, *Accomplished in All Departments of Art,* 62.

Fig. 2-16. "Eliza crossing the Ice." Engraving. Harriet Beecher Stowe, *Uncle Tom's Cabin* (New York: Hurst and Company, [1934]), facing 59.

Abraham Lincoln was erected in Washington, D.C., with a replica made for Boston in 1879 (Fig. 2-17).[49] Ball's famous sculpture bears an uncanny resemblance to the engraving of Tom kneeling at Christ's feet at the top of

49. Kirk Savage, *Standing Soldiers, Kneeling Slaves: Race, War, and Monument in Nineteenth-Century America*, 89.

Fig. 2-17. *Freedmen's Memorial Monument to Abraham Lincoln.* Bronze sculpture, Thomas Ball, 1876.

a chapter in Billings's 1853 edition (Fig. 2-13). Ball put a shackled slave in the same position as Billings's kneeling Tom. Where the illustrator had stood Christ, the sculptor placed Abraham Lincoln. A monument to pay tribute to Lincoln's signing of the Emancipation Proclamation was initially the idea of freed people, but whites quickly took over. Under the guise of collaboration, decisions were made and liberties taken with the representation of the African American figure that served the hegemonic goals of national reconciliation.

In a fascinating study of the project Kirk Savage sums up the racial dynamics of the eventual sculpture: "In this bizarre monument to emancipation, the black man enters sculpture only to re-encode the racial hierarchy established in 'scientific' illustration. Kneeling on the ground, the African-American once again becomes the foil by which we measure the superiority of the white deity above him." Half naked and crouched low, the former slave was right back where he started. Savage exposes how scant African American inclusion was in this project as planning for the monument progressed.

Here is a rare case of a public sculpture creating a potent image that enters the culture at large. As that image travels from monument to book illustration to postage stamp, the honorific power and ideal status of the original medium drain away, and the image comes to seem natural, condensing as it does a whole historical mythology of emancipation. The fact that the emancipated themselves "erected" it—their total lack of participation in the design process glossed over by this conventional rhetoric—then serves as further confirmation of the image's authenticity. As the image is reproduced and recirculated, ever more distant from the

original context of its production, it becomes archetypal, lodged in the collective consciousness even of those who despised it.[50]

Lincoln, hand raised in a Christ-like gesture of healing, towers over a kneeling freedman at his feet. The grouping fixed the black citizen in the same old relationship with the master class, as if Lincoln himself had personally unshackled the still barely clothed, subservient ex-slave (Fig. 2-18).

Sculptor Ball's attitude toward black men is summed up in his own recollection bemoaning his problem of finding a model for the newly freed man: "When I came to the modeling of the nude slave, I had some difficulty in finding a good life model. I had one, two or three times; but he was not good enough to compensate for the unpleasantness of being obliged to conduct him through our apartment." As final ignomiy, for this sculpture he called the "Lincoln Group," Ball modeled the pose of the freedman on himself, completely effacing the black man. For the facial features, Ball gave his kneeling slave a sloping forehead and slightly extended jaw, the blueprint for which would have been readily available in the demeaning rendition of an "African" on any phrenology chart.[51]

The sculpture became an icon of emancipation and was widely replicated. Other artists creating works depicting African Americans and whites together were influenced by its configuration. A vignette of the sculpture was used in one quadrant of the song sheet for "Lincoln Centennial Grand March" (1909) by E. T. Paull, joining Lincoln's log cabin birthplace, his tomb, and Memorial Hall in Washington, D.C., as significant monuments to the president. There were postcards featuring artists' color renderings of the sculpture decorated with flags or bunting. In posters advertising Tom shows and pamphlets for movies, the hierarchy of the beloved statue—a kneeling slave looking up toward a huge cartouche of Lincoln's head—was maintained into the twentieth century (Fig. 2-19). In 1940 the sculpture was reproduced on a three-cent stamp.[52]

This iconic relationship of dominant white man and subservient black man that Savage implies with his book title, *Standing Soldiers, Kneeling Slaves,* was reproduced so often on posters, playbills, and advertisements that it seemed Tom himself was the slave at the feet of Lincoln, kneeling in obeisance to the great white savior. In these print advertisements, Stowe, by then a famous and familiar face, loomed from the upper right corner, like

50. Ibid., 18, 120–21.

51. Thomas Ball, *My Threescore Years and Ten: An Autobiography,* 252–53, 255, 301–2; Charles Colbert, *A Measure of Perfection: Phrenology and the Fine Arts in America,* 23–24.

52. Savage, *Standing Soldiers, Kneeling Slaves,* 120.

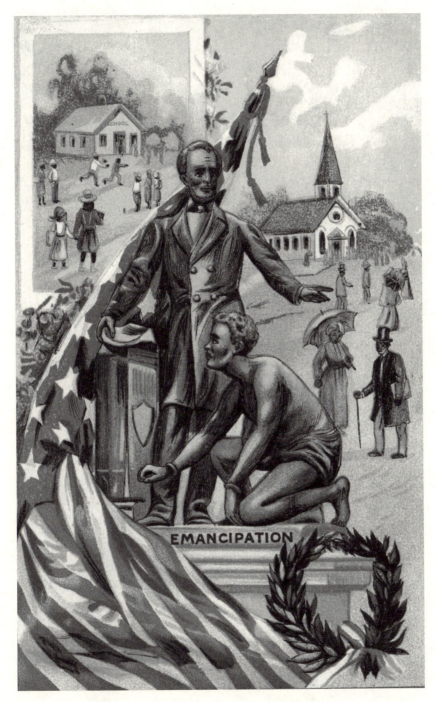

Fig. 2-18. Postcard. *Collection of the author*

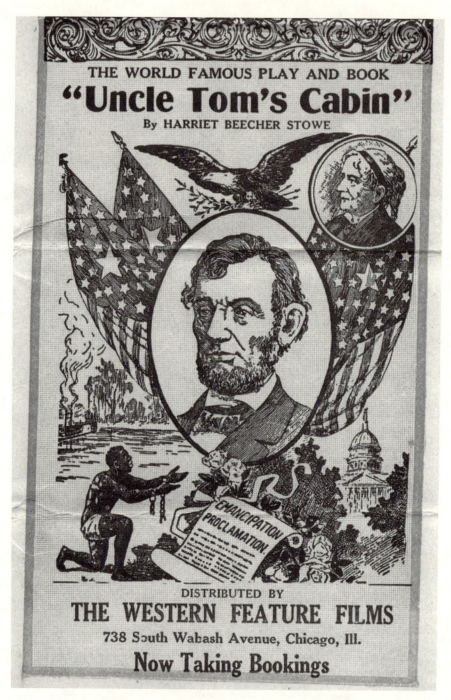

Fig. 2-19. Movie advertisement, *ca.* 1930s. *Collection of the author*

a muse over Lincoln's shoulder. These images conveyed the message that by freeing the slaves, Lincoln assumed the place Christ once held to claim the dominant position for white male patriarchy. The great emancipator dominated the frame as a barely clad ex-slave groveled in front of him. In place of the kneeling slave of antislavery propaganda now there was Uncle Tom. His story was divested of Christian association and returned full circle to the original antislavery icon imported from England almost a century earlier. Carved in stone and reproduced in hundreds of print commemoratives, the African American man remained on his knees begging his superior's noblesse oblige in perpetuity.

APOTHEOSIS

After emancipation, antislavery appeals were, of course, anachronistic, as was the use of Christian evangelism to gird it. Uncle Tom persisted in altered guise, but his Protestant preaching days were behind him. As discussed in chapter 1, in popular representation Tom the vitally alive father rapidly declined into an aged old man. He no longer had the strength to endure the extended suffering of his Christian martyrdom. Few artists after Billings gave Tom Christian attributes and no image ever again analogized Tom's final days as reliving the passion of Christ. Mostly Uncle Tom inhabited the secular realm, a pitiable old slave abused by arch-villain Simon Legree.

African American religiosity was portrayed in popular images as exotic ceremonies that were wildly emotional with frenetic movements. Invariably, worshipers were shown out-of-doors. Stereograph cards depicted blacks "Down in Dixie," conducting river baptisms. Sheet music covers such as illustrator E. T. Paull's "A Warmin' Up in Dixie" (1899) featured hand-waving demonic figures, circling fires in the forest.

In 1938, the Mexican modernist Miguel Covarrubias created lithographic prints for an edition of *Uncle Tom's Cabin.* His Tom prayed with arms raised, in a ritual of movement, suggesting African roots (Fig. 2-20). In this illustration, Tom the minister, prayerful intercessor, Christ-like martyr, was gone; even his Bible was taken away. In scenes with Eva, where once they read the good book together, early twentieth-century advertisements found Tom scratching out letters on a child's toy blackboard (Fig. 2-21). Popular imagery implied that Tom was illiterate, dependent on little Eva to do his reading and writing. "Tom tries to write a letter with Eva's assistance," read a caption of one book illustration. Whatever challenge this pathetic, illiterate old man once posed to the white male patriarch as fatherly guru and

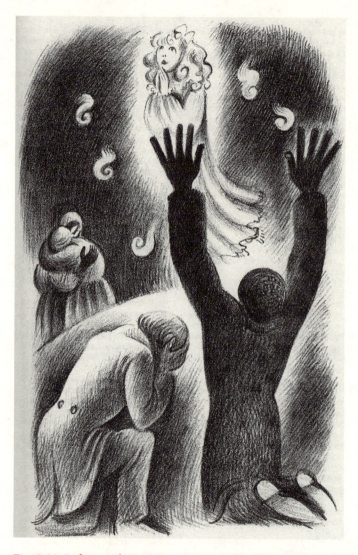

Fig. 2-20. Lithograph, by Miguel Covarrubias. Harriet Beecher
Stowe, *Uncle Tom's Cabin* (New York: Heritage Press, 1938), facing 196.

purveyor of the Christian word faded from memory quicker than the chalk
dust blown from his felt eraser.

As might be expected, the only character in the novel to retain a steadfast
connection with piety was little Eva. White, blonde, evanescent, bathed in
lights, for years she had dominated stage shows. A climactic scene of film

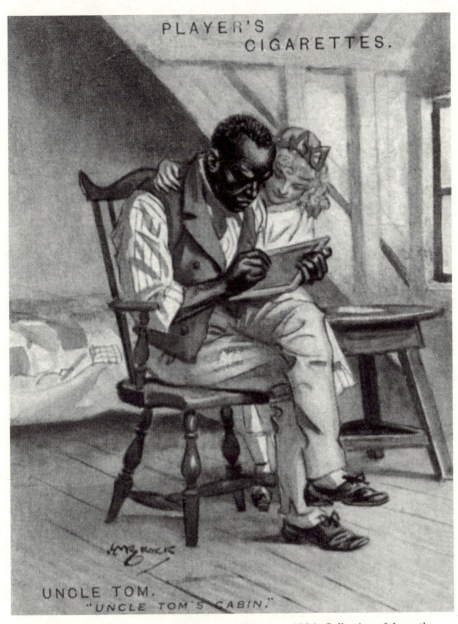

Fig. 2-21. Advertisement card. *Player's Cigarettes*, 1936. *Collection of the author*

Fig. 2-22. "The death of Eva." Engraving. Harriet Beecher Stowe, *Uncle Tom's Cabin* (New York: Hurst and Company, [1934]), facing 282.

adaptations made in 1903, 1914, and 1927 cast Eva as an angel being welcomed into heaven in a glorious apotheosis.[53] Evangeline forever, an alabaster seraph, rising to glory as curtains fell (Fig. 2-22).

53. Birdoff, *World's Greatest Hit*, 395–98.

CHAPTER 3

From Barefoot Madonna to Maggie the Ripper:

Thomas Satterwhite Noble Reconstructs Eliza and Cassy

One may ask why Kentucky-born Thomas Satterwhite Noble (1835–1907), former Confederate soldier, son of a border state slaveholder, began painting slaves after emancipation was a fait accompli. Noble had known the "peculiar institution" firsthand, albeit from a privileged position within the master class. As a result, his choice to embark upon a career as a painter using historical incidents from slavery makes for an interesting study. Were his paintings a way of atoning for his Confederate culpability, a rebel pounding his sword into a paintbrush to appease the conquering North? Or was he hoping to capitalize on his unique geographic perspective as a scion of slave-trafficking Frankfort, Kentucky? Shortly after completing the slavery pictures he was selected to be the principal at the opening of the McMicken School of Design in Cincinnati, the city where so many runaways had first tasted freedom. Between 1865 and 1869, Noble exhibited in northern cities a total of eight paintings with African American subjects. Two of these, *The Last Sale of Slaves in St. Louis* (1865, repainted *ca.* 1870) and *Margaret Garner* (1867), featured mixed-race women, or mulattos, as they had come to be called. From a young female up for auction to the famous fugitive Margaret Garner, his portrayals show the transformation taking place within perceptions of biracial women in postemancipation America. Opinions about mulattos surfaced in a range of theoretical discussions, from

the scientific to the political, as strategists North and South envisioned evolving social policy. How Noble, in his paintings, adapted these historic scenarios to the changing public discourse will be the subject of this chapter.

In the years leading up to the Civil War, slave women only occasionally appeared in American genre paintings; slave men were more in evidence. William Sidney Mount of Long Island, New York, Baltimore's Richard Caton Woodville, and Missouri's George Caleb Bingham were among the artists who added a musician, servant, or dockworker to their depictions of everyday life. On occasion, a dark-skinned maid could be spotted caring for children or serving food. While white male citizens engaged in commerce, read newspapers, held elections, and debated wars, black figures stood on the sidelines of the paintings about these activities as intended reminders of the prevailing political issue of the day: the expansion of slavery into the territories.

After emancipation, artists grew less interested in African American figures. Eastman Johnson, made famous in 1859 when his painting *Negro Life at the South* debuted in an annual show at the prominent National Academy of Design in New York City, portrayed his last African American subject in 1866. Winslow Homer painted freed people in Virginia in the 1870s before settling on the outdoor scenes for which he is best known today. But Noble was unique. His paintings were no fanciful imaginings of social milieus but pictures depicting the reality of slavery.[1]

When Noble painted *The Last Sale of Slaves in St. Louis* and then *Margaret Garner* in the early years of Reconstruction, North and South were reconciling a severed relationship, and both regions faced the dilemma of how to integrate a once-bound labor force into the fabric of a free society. There were economic matters to resolve, but even more difficult, there were social issues created when former slaves suddenly became potentially mobile. All of this had political repercussions.

To understand why a painter such as Noble made the choices he did, it is imperative to remember that his works sold for as much as two thousand dollars. Whether one-of-a-kind oil paintings purchased by affluent men or

1. Boime, *Art of Exclusion*, 1990; James D. Birchfield, Albert Boime, and William J. Hennessey, *Thomas Satterwhite Noble, 1835–1907*; Patricia Hills, "Painting Race: Eastman Johnson's Pictures of Slaves, Ex-Slaves, and Freedmen," 58–159; Mary Ann Calo, "Winslow Homer's Visits to Virginia during Reconstruction," 5–27; Wood and Dalton, *Winslow Homer's Images of Blacks*. Johnson's genre paintings of African Americans include: *Scene at Mount Vernon* (1857); *Negro Life at the South* (1859); *The Freedom Ring* (1860); *Kitchen at Mount Vernon* and *Mating* (1860); *A Ride for Liberty: The Fugitive Slaves* (ca. 1862); *The Lord Is My Shepherd* and the identical *The Chimney Corner* (both ca. 1863); *The Young Sweep* (1863); and *Fiddling His Way* (1866).

mass-marketed prints generated with mercantile or political goals, image production was controlled by those with a stake in the status quo. In America that meant businessmen, industrialists, and landowners. A review of Noble's renditions of slavery along with some of the other paintings and prints in circulation at the time offers clues to what was at stake for these powerful men just after emancipation.

GRAND NARRATIVES

With the painting *Margaret Garner,* Noble revisited Cincinnati of a decade earlier. In 1856 Margaret Garner, a young mulatto slave mother, had fled Kentucky into this northern border city where she was quickly apprehended. Margaret was so desperate, according to accounts, she tried to kill her children rather than return with them to bondage. In a recent study of this sensational case, Steven Weisenburger marvels that such a cause célèbre disappeared from the annals of notable fugitives. Garner's story resurfaced by chance in the 1980s when novelist Toni Morrison happened to read about her in old newspaper accounts. Garner's life became the inspiration around which Morrison crafted her 1988 Pulitzer Prize-winning novel *Beloved.* Weisenburger offers that Margaret Garner got lost among more palatable narratives about slavery.

> Margaret Garner's infanticide spotlighted the plight of female slaves and symbolized slavery's awful, violent power over and within slave families—issues once at the heart of anti- and proslavery arguments but waylaid for generations in the grand narratives about slavery's constitutional challenges leading to disunion.[2]

The reality of her life ran counter to an American creed that valued personal freedom. Margaret Garner the slave and fugitive in no way reinforced a national mythology of honorable white men resolving issues of governance.

And so it was no accident that the story of slave mother Margaret Garner faded from recollections about the antebellum South. Granted, there was little concerning slavery to debate after emancipation; still, the impulse to determine a workable history for a functioning present and future remained. As Marcus Wood has written about the end of slavery in England, "the memory of the slave trade became primarily the memory of

2. Weisenburger, *Modern Medea,* 8, 10.

its glorious abolition."[3] Daring escapes of fugitives became legend because they allowed Americans to celebrate freedom. Ellen Craft masqueraded as a white man traveling with a slave of her own, her darker husband, William, to flee the South by boat. Henry "Box" Brown mailed himself north. Frederick Douglass, Sojourner Truth, and Harriet Tubman remained public figures into the postbellum years. Even failed attempts for freedom reminded white northerners what a great system of governance theirs was. "Tsk tsk," what a shame it was about Dred Scott of Missouri, whom the United States Supreme Court dispatched back to slavery in 1857. But was this not a wonderful nation to have freed the slaves?

Margaret Garner's story is not a pleasant one to tell. The title of Gwendolyn DuBois Shaw's recent book on the art of Kara Walker, *Seeing the Unspeakable,* would make an appropriate title for a Garner documentary.[4] Garner's life is a sad recounting of several crimes: murder, rape, violence, and enslavement. Noble's *The Last Sale of Slaves in St. Louis* is another unspeakable sight, in which human bodies are for sale and babies are taken away from their families. Noble, doing his best to give the scene a veneer of gentility, can not hide the vile reality.

The American creed is built upon ideals of individual freedom, but slavery tested Americans' belief in this system. In touting liberation, northerners spoke for the principles upon which the nation was founded despite the obvious inequity of slavery. Slave narratives were mechanisms for reassurance. Frederick Douglass, for example, fit into an existing "grand narrative" of a nation founded on self-reliance. Douglass was a man of commanding presence, powerful voice, and exceptional intellect, and by celebrating his freedom, northerners could believe in the values their society espoused.

For a more contemporary example, consider the American system of justice where prisons teem with black and brown populations. Is this the result of racial profiling? Poverty? Innate criminality? Inconsistent sentencing laws where selling crack cocaine (the cheap stuff) is a felony but hawking powder cocaine is a misdemeanor? Perhaps endemic racism predisposes juries to see dark men as criminals. Periodically a black man on death row is found innocent. Aided by current technology in DNA analysis, the system, corrupt though it may be, purges itself in regeneration through exoneration. One goes free, while thousands languish in

3. Wood, *Blind Memory,* 8.

4. Gwendolyn DuBois Shaw, *Seeing the Unspeakable: The Art of Kara Walker.* Shaw's title is in reference to Toni Morrison's *Unspeakable Things Unspoken* (1987).

prisons. The rare case proves the grand narrative that justice prevails. Hearing of these cases, the community feels reassured; tension about injustice is vented; and complacency that the system works is reinstated— that is, until the next time.

Fugitive stories of liberation celebrating the feats of the fortunate affirmed national ideals about freedom. In championing the triumphant individual, these stories helped Americans reconcile contradictions between an abstract concept of liberty upon which the republic was based and the actual practice of a perpetual class system that denied the laboring African slave autonomy. In important ways, the antislavery movement was less about releasing hundreds of thousands of slaves from southern bondage than it was about assuaging American guilt. Harriet Beecher Stowe's saga of Uncle Tom struggling as he vowed Christian ideals in the face of demoralizing slavery in the South ended with a caution about what American readers could do. She recommended that her readers should see that they "feel right" regarding the plight of slaves such as Tom. Empathizing with the poor oppressed slave connected the witness with his or her own decency.

For *The Last Sale of Slaves in St. Louis* and *Margaret Garner*, Noble engaged in sentimental propaganda after the fact. Noble's views of slavery performed as tragic obituaries. His backward glance at the peculiar institution tolled a mournful dirge about letting bygones be bygones and reminding northern viewers that they did in fact "feel right" about the outcome of the war. "One nation under God, with liberty and justice for all" had been restored.

ANTISLAVERY ICONOGRAPHY

In choosing mulatto females for his *The Last Sale of Slaves in St. Louis* (Fig. 3-1), Noble convened reliable antislavery icons to immortalize the final slave auction in the country, held on the steps of the same courthouse in St. Louis from which Dred Scott was remanded back to slavery. Born into the planter elite of Lexington, Kentucky, in 1835, Noble likely witnessed slave auctions and similar indignities. Although to the manor born, young Thomas had not been groomed to live the life of a plantation owner. Just before the Civil War, when the artist was in his early twenties, his father, apparently no proslavery ideologue, manumitted and then hired at wages the slaves who worked his hemp plantation. As a youth, Noble briefly studied art in New York. From 1856 to 1859 he spent time in Paris with the painter Thomas Couture, where he gained a solid grounding in

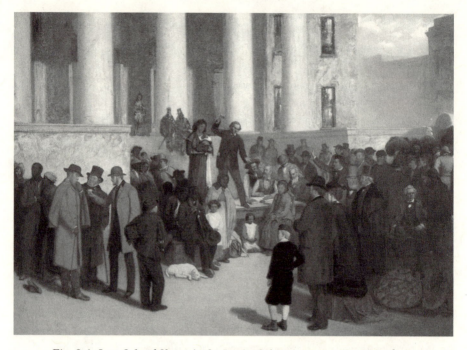

Fig. 3-1. *Last Sale of Slaves in St. Louis.* Oil on canvas, 60 x 85 inches,
by Thomas Satterwhite Noble, 1865 and 1870. *Collection of the
Missouri Historical Society, St. Louis*

European academic painting. Noble's slave auction, originally titled *The
American Slave Mart,* which his granddaughter Mary Garretson called the
first of his "great pictures," toured the North in the mid-1860s, bringing the
aspiring artist critical notice. The painting was displayed in high-visibility
venues where prominent art historian Henry Tuckerman saw it and
documented that "Noble's picture of the 'Slave Mart' has been exhibited in
the rotunda of the Capitol at Washington, and in Boston has attracted much
attention." The war had left the Noble family destitute, however, and
despite his popular and critical success as an artist, Noble could not afford
to marry Mary Hogan of Memphis. When the painting sold that same year
for two thousand dollars to William B. Howard of Chicago, Noble could at
last consummate their three-year engagement. Other African American
themed pictures followed: *Margaret Garner* (1867); *John Brown's Blessing* (*ca.*
1867); *The Price of Blood: A Planter Selling His Son* (1868); and *Fugitives in
Flight* (1869). By 1868, when Cincinnati's culturally minded were casting

about for someone to head a "first-class art school," they wooed Noble, a painter of growing stature, back into their midst.[5]

Tuckerman reviewed the painting again for the *Tribune* while it was on display at a gallery in Chicago during 1867: "About seventy-five figures are grouped around a parti-colored slave girl standing upon the auction block, at the foot of the Court House steps. Her hands are clasped, her head bent forward, and her eyes upon the ground, with a finely brought out expression of sadness in her features."[6] Noble's original of *The American Slave Mart* was lost shortly after in a Chicago fire. It is a replica, painted around 1870 and titled *The Last Sale of Slaves in St. Louis*, that survives today.

Noble's 1865 and 1870 versions varied slightly, although both were constructed around sympathetic female slaves. In the original, a young mulatto, whom Tuckerman called the "parti-colored slave girl," was standing on the auction block; but when Noble repainted the same subject five years later, a young mother cradling a child was in the spotlight.[7] The girl, still present, was seated in front of the platform. Both the young mulatto and the slave mother and her child, at risk of imminent separation, had regularly appeared in antislavery prints, and Noble may have felt they would be familiar to his viewers. A closer look at both portrayals of young slave women is warranted.

In a rare example of this topic in a painting, *Slave Market* (*ca.* 1850), by an as yet unidentified artist, another parti-colored girl once stood on the steps of a public building while an auctioneer waved his tiny gavel sealing her fate (Fig. 3-2). Wearing a pastel gown of soft fabric, the girl extended her hand in a gesture so refined she almost seemed to beckon an escort to help her negotiate a ladylike descent from the porch platform. A crude trader pinched her tender arm instead. Abolitionist writer Lydia Maria Child often referred to similar young women in her ploys to garner sympathy. In an antislavery tract of 1835, she recalled a dinner party where a southern woman had casually told how she sold a "young slave, who was without exception, the prettiest creature I ever saw" to "a gentleman" who had become infatuated with her. Surmising his intent, Child was appalled "That

5. Boime, *Art of Exclusion*, 131; Mary Noble Willech Garretson, "Thomas S. Noble and His Paintings," 117; Henry T. Tuckerman, *Book of the Artists: American Artist Life*, 489. *Fugitives in Flight* (1869), found in an attic in 1993, is presently in the collection at Greenville County Museum of Art, Greenville, South Carolina.

6. "Amusements," *Chicago Tribune*, November 28, 1867, cited in James D. Birchfield, "The Artistic Career of Thomas Satterwhite Noble," 6.

7. Boime, *Art of Exclusion*, 138.

Fig. 3-2. *Slave Market.* Artist unknown, *ca.* 1850.
Carnegie Museum, Pittsburgh, Pennsylvania

such a thing could be done in a free and Christian community," and even worse, that "it could be told of without the least shame."[8]

Probably the most widely circulated image of a young mulatto about to be sold into concubinage was Hammatt Billings's engraving of Emmeline (Fig. 3-3), which was included in the 1853 gift-book version of Stowe's *Uncle Tom's Cabin.*[9] In the story, slaveholder Simon Legree had gone to the New Orleans slave market to augment his human stock. Among his purchases were Uncle Tom and Emmeline. In Billings's illustration of this event, Emmeline stood like a Greek statue, with her hands clasped, her head demurely forward, and her gaze turned downward, just as Tuckerman would describe Noble's slave girl. The auctioneer grasped Emmeline's shoulder from behind as Legree slavered lustfully in front of her. *Uncle*

8. Lydia Maria Child, "The Influence of Slavery with Regard to Moral Purity," 4–6. Harriet Martineau wrote about a southern woman selling her very light-skinned female slave to a white man for fifteen hundred dollars (see Beth Day, *Sexual Life between Blacks and Whites: The Roots of Racism,* 52).

9. Stowe, *Uncle Tom's Cabin* (Boston: Jewett, 1853), 419.

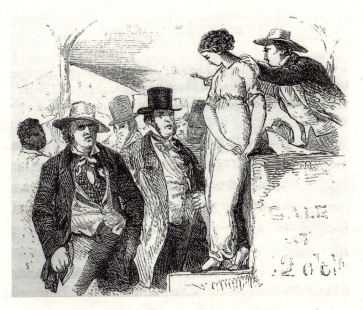

Fig. 3-3. Engraving, by Hammatt Billings. Harriet Beecher Stowe, *Uncle Tom's Cabin* (Boston: John P. Jewett, 1853), 419.

Tom's Cabin was reissued throughout the world, many with illustrations inspired by Billings. That same year, English illustrator George Cruikshank drew "Emmeline about to be sold to the highest bidder" for a London edition (Fig. 3-4).[10]

In addition to young mulattos, there were ample models of slave mothers in antislavery iconography for Noble to consult. When William Lloyd Garrison's the *Liberator* first appeared on January 1, 1831 (Fig. 2-1), its masthead heralded the tragic theme of family separation. David Claypoole Johnston's design of a mother clutching her children before a trader's podium could have supplied a prototype for Noble. All three of the *Liberator's* mastheads featured imperiled slave families: an auction scene on the second, which debuted on March 23, 1838, was also drawn by Johnston, and Billings composed the final masthead in 1850. Billings kept Johnston's auction scene intact but added a central vignette that featured Christ blessing a kneeling slave.[11] As shown in chapter 2, Billings reprised that pair to top a chapter in *Uncle Tom's Cabin*, with Uncle Tom as the kneeling slave.

10. Stowe, *Uncle Tom's Cabin* (London: John Cassell, 1852), 290.
11. O'Gorman, *Accomplished in All Departments of Art*, 48; Donald M. Jacobs, "David Walker and William Lloyd Garrison," 10.

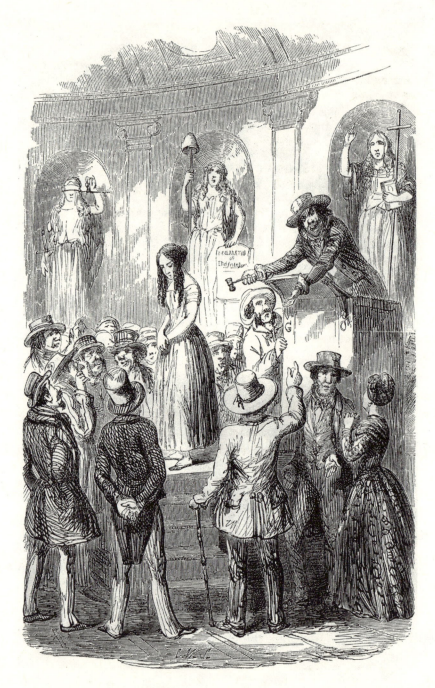

Fig. 3-4. "Emmeline about to be sold to the highest bidder." Engraving,
by George Cruikshank. Harriet Beecher Stowe, *Uncle Tom's Cabin*
(London: John Cassell, 1852), 290.

Noble's slave mother in *Last Sale* resembled another character from Stowe's novel, the young mother Eliza. In Billings's "Eliza comes to tell Uncle Tom that he is sold, and that she is running away to save her child" (Fig. 1-3), she had just learned that her son had been sold to a trader who was leaving for New Orleans the very next day.[12] By draping Eliza with a shawl instead of a tied turban or cotton handkerchief, the more common of slave head wear, Billings might have intended that she resemble a Madonna with child, connoting Christian sensibility in support of Stowe's text. Noble, following Billings's tradition, put his slave mother in a shawl and, like Eliza, her head was bowed and she cradled a babe in her arms.

Stowe's story of Eliza and her husband, George Harris, may have been of special interest to Noble. The night before Eliza resolved to flee Kentucky with her little boy Harry, George, who had suffered unbearably at the hands of his cruel master, escaped. He had once been treated well and with respect until, after being hired out to a bagging factory, he invented a machine for cleaning hemp—which was, as you may recall, the primary crop of the Noble plantation. The influence of *Uncle Tom's Cabin* may also be seen in the site where Noble staged his auction. In the novel the slave sale took place "before the Court-house door," but in St. Louis this kind of commerce was conducted at a private market called Lynch's in the downtown area.[13]

By the time Noble painted *Last Sale* in the mid-1860s *Uncle Tom's Cabin* had been a hit stage show for more than a decade and had been touring throughout the country and in England. Posters for upcoming stage performances dramatized Eliza as a barefoot Madonna with her child, huddled against a raging storm, tripping perilously over ice floes. Even if Noble had not been to a Tom show or had not read the illustrated novel, he must have seen advertisements for them by 1865 when he first painted *Last Sale*.[14]

That Noble was from northern Kentucky, slavery's recent home and close to the Ohio River over which the fictional Eliza ran with her little son in the 1852 novel, makes it likely he was sensitive to the influence Stowe's fiction continued to wield. In 1865, Noble was an artist poised on the border between obscurity and a successful career. In addition to Billings and the printmakers, there were other painters who had successfully depicted slavery whom he might have wanted to emulate.

Perhaps Eastman Johnson's *Negro Life at the South* of six years earlier had inspired Noble's reflection on slavery's past (Fig. 3-5). Both he and Johnson

12. Also see a print by Theodore R. Davis that appeared in *Harper's Weekly* (July 13, 1861) featuring a diminutive slave mother up for sale.

13. Albert Boime, "Burgoo and Bourgeois: Thomas Noble's Images of Black People," 38, 43.

14. Birdoff, *World's Greatest Hit*, 1.

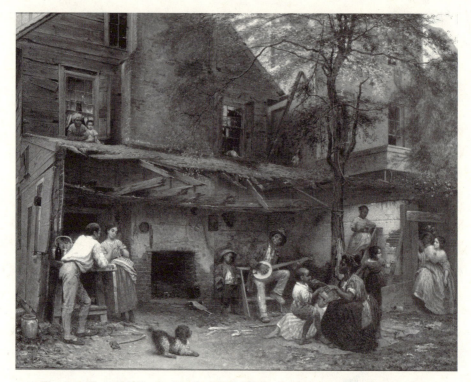

Fig. 3-5. *Negro Life at the South,* 1859. Oil on canvas, 36 x 45 1/4 inches, by
Eastman Johnson, 1859. *The New-York Historical Society, Robert L. Stuart
Collection, on permanent loan from the New York Public Library, S-225*

had been students of the French artist Thomas Couture.[15] *Negro Life* gained
Johnson membership in New York's prestigious National Academy of
Design when it appeared there in 1859. Within the year, it was being called
Old Kentucky Home, after a Stephen Foster minstrel tune written for a Tom
show. In 1867, the owner of the painting, William P. Wright, a cotton broker
with a vested interest in southern commerce, sold it at auction for the huge
sum of six thousand dollars.[16] Noble's *Margaret Garner* was also being
shown at the National Academy of Design that year.

Johnson's painting had made him famous and seemingly rich. Critics
hailed his panoramalike scene of slave life, with its banjo-strumming
musician and the assorted women and children gaily enjoying leisure, for
its reenactment of Stowe's *Uncle Tom's Cabin.*[17] A light-skinned slave and

15. Boime, *Art of Exclusion,* 126, 131.
16. Hills, "Painting Race," 126.
17. Hills, "Painting Race," 126–27. Hills cites a critic at the *New York Daily Tribune*
who called Johnson's painting "a sort of *Uncle Tom's Cabin* of pictures."

her beau to the left of center may have reminded them of Eliza and George in their courting days. Three hundred thousand copies of the best seller were sold in the first year alone, and stage plays, which had been up and running in New York City since 1853, continued to thrive there and as traveling shows. It is possible that Noble, who, like Tom, was from an old Kentucky home, was sensitive to the spell "Tom-mania" had cast on northerners.[18] If there was a market for views recalling the famous novel, as Johnson's success would indicate, who better to tell the story than a native son of the Bluegrass State?

As Albert Boime has said of Noble's *Last Sale*, "Northern businessmen and merchants may have sought out such images to display their liberal sympathies and support of Reconstruction, which benefited them economically."[19] Southern-grown cotton and indigo dyes produced by slave labor had sustained northern textile factories. After the war, black men pounded rails into roads, reconnecting North to South and extending economic prosperity into the West. Nearly destitute ex-slave families became sharecroppers toiling in the fields on the old plantations. By enjoying Noble's iconography of antislavery during the late 1860s, until Reconstruction was well under way, northern businessmen might have deluded themselves that their acquiescence to a war with the South had been motivated by ideals, not merely by political power or commerce.

That Noble took considerable license with his rendition of a slave sale hints at his own pecuniary calculations. Instead of a charged and rowdy crowd, his "middle-class milieu tells us a good deal about the actual public for Noble's picture, northern and liberal and moderate on the issue of slavery."[20] Female viewers may have identified with Mrs. Noble, pictured in the crowd next to her artist husband in his second version of *Last Sale*, her heart no doubt breaking at the sight of the unfortunate slave mother.[21] The northern woman could empathize, secure in "the consciousness of her own virtue," to borrow Karen Halttunen's theory about the effect that "spectacles of suffering" had on nineteenth-century women.[22] Slavery was over; there was little political risk to admitting that the system had been wrong. As Noble provided women of the North with this reminder of the evil practice, remorse for the war was partially soothed. After devastating losses

18. Audrey A. Fisch, "'Exhibiting Uncle Tom in Some Shape or Other': The Commodification and Reception of *Uncle Tom's Cabin* in England," 147.

19. Boime, *Art of Exclusion,* 131.

20. Boime, "Burgoo and Bourgeois," 43–44.

21. Garretson, "Thomas S. Noble and His Paintings," 117.

22. Boime, *Art of Exclusion,* 138; Karen Halttunen, "Humanitarianism and the Pornography of Pain in Anglo-American Culture," 308.

of husbands and sons to the fighting, Noble's painting offered assurance that opposing slavery had been just.

But there were other issues to resolve in this transitional period. Jan Nederveen Pieterse observes that within late eighteenth- and nineteenth-century European thought, as slavery ended in England's colonies and later in the United States, "Race emerged as the buffer between abolition and equality" and offered a means to define and keep "others" separate and distinct.[23] The quest to prove "the Negro" inferior to "the Caucasian" grew fervent as social mixing became possible. Light-skinned girls and gentle mothers, barely discernable from northern ladies, no longer languished in perpetual bondage but mixed within society. Now that the mulatto was free, what would become of her and what would that mean for the grand narrative of American nationhood? If Noble's *Last Sale* looked back to the bad old days when delicate "parti-colored slave girl[s]" were vulnerable to exploitation, his *Margaret Garner* later reexamined the mulatto with an eye to the future.

A BREEDING WOMAN

Margaret Garner was a mulatto woman who escaped from a Kentucky plantation with a baby in her arms over the icy Ohio River into Cincinnati. Ironically, this actual escape happened four years after the fictional slave mother Eliza traversed the same treacherous path in the novel *Uncle Tom's Cabin*. During the winter of 1856, the tumbling water froze solid, forming a natural bridge to transport Margaret out of bondage. Margaret, along with her baby, her three other children, her husband, Robert, and his parents, took refuge in the home of a free cousin to await passage on the Underground Railroad. But unlike the fictional Eliza, who made it into Canada, Margaret's story had no happy ending. After the briefest taste of freedom, local and federal law officers captured the Garner family. Rather than see her children reenslaved, Margaret Garner decided to kill them (Fig. 3-6).

Writing about this tragedy in *Anti-Slavery Tracts*, the well-known abolitionist Samuel J. May described the ghastly sight the marshals encountered when they entered the cabin in which Garner and her family were hiding:

> In one corner was a nearly white child, bleeding to death. Her throat was cut from ear to ear, and the blood was spouting out profusely, showing

23. Pieterse, *White on Black*, 59.

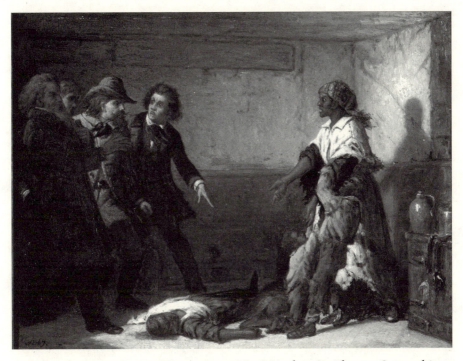

Fig. 3-6. *Margaret Garner.* Oil on canvas, 20 x 16 inches, by Thomas Satterwhite
Noble, 1867. *National Underground Railroad Freedom Center, Cincinnati, Ohio*

that the deed was but recently committed. . . . A glance into the apartment
revealed a negro woman, holding in her hand a knife literally dripping
with gore, over the heads of two little negro children who were crouched
on the floor.

Perhaps with a nod to Stowe's Eliza, or to another slave character from
Uncle Tom's Cabin, Cassy, who poisoned her infant daughter, May added,
"For once, reality surpassed the wildest thought of fiction." Margaret had
slit her baby girl's throat and had left knife wounds on the faces of her two
sons. When the authorities arrived, she was holding a shovel over the head
of her three-year-old girl.[24]

Five years after it was passed, the Fugitive Slave Law still caused
northerners emotional distress when it gave legal sanction to slaveholders

24. Samuel J. May, "The Fugitive Slave Law and Its Victims," 50–62; Weisen-
burger, *Modern Medea,* 73.

reclaiming runaways in free territory.[25] As a result, this astonishing incident captured national attention. The case centered on whether Margaret might be classified as free, because she had once traveled into Ohio, a free state, as a child. If so, she would be tried for murder in a federal court. Alternatively, if she and her family were merely chattel of the slave owner Archibald Gaines, she would be subject to Kentucky state law, where her crime was not murder but destroying property. The three-month legal battle to have her tried in the North ended unsuccessfully in the eyes of abolitionists. She was found to be a slave miscreant, not a free murderer, and so was returned to Gaines.

Eleven years later, a commission from businessman Harlow Roys of New York City gave Noble the chance to reconsider the dramatic incident. It was a personal triumph for the artist. In addition to money from the purchase, Noble attained professional stature with *Margaret Garner* and was elected a member of the National Academy of Design in 1867. Why a New York City businessman would want a picture of the notorious if pitiful slave woman who had killed her child a decade before is a question worth considering.

In a recent article on Noble's *Margaret Garner,* Leslie Furth contends that Noble was responding to the changed climate of postemancipation social concerns by making Garner "a graphic rehearsal of perversity in the face of black autonomy."[26] Was Noble reminding viewers that mulatto women could be dangerous and that they were best kept apart? If so, that would support Pieterse's theory that "racial thinking" grew in relation to the success of the abolition movement.[27] Once abolition had succeeded, racial distinctions emerged to redefine and suppress the sensitive, light-skinned slave woman. Noble's painting, argues Furth, "echoes post-Civil War tensions over the place of blacks in American society."[28] Slavery's once-sympathetic victim became an aberrant mother capable of murdering her babies.

Antislavery descriptions of devoted slave mothers had been an affront to slaveholders who discounted slaves' maternal connections to their offspring.

25. Stanley W. Campbell, *The Slave Catchers: Enforcement of the Fugitive Slave Laws, 1850–1860,* 5. The Fugitive Slave Law was one clause in the Compromise of 1850: "No person held to service or labor in one State, under the laws thereof, escaping into another, shall, in consequence of any laws or regulations therein, be discharged from such service or labor; but shall be delivered up on claim of the party, to whom such service or labor be due." (U.S. Constitution, art. 4, sec. 2, cl. 3.)

26. Leslie Furth, "'The Modern Medea' and Race Matters: Thomas Satterwhite Noble's *Margaret Garner*," 36–57.

27. Pieterse, *White on Black,* 59.

28. Furth, "'The Modern Medea,'" 37.

Author Stowe had mimicked the proslavery view through the words of the rough-mannered slave trader Haley, who wanted to sell Eliza's boy: "'Tan't, you know, as if it was white folks, that's brought up in the way of 'spectin' to keep their children and wives, and all that. Niggers, you know, that's fetched up properly, ha'n't no kind of 'spectation of no kind."[29]

The narratives of former slaves tell a different story. Escaped slave Harriet Jacobs relates that in 1859 she had known that her best hope to enlist the compassion of northern women was through mutual motherhood. An especially poignant moment in her narrative recounts a final night with her daughter before their separation:

> I drew aside the window curtain, to take a last look of my child. The moonlight shone on her face, and I bent over her, as I had done years before, that wretched night when I ran away. I hugged her close to my throbbing heart; and tears, too sad for such young eyes to shed, flowed down her cheeks, as she gave her last kiss, and whispered in my ear, "Mother, I will never tell." And she never did.[30]

Jacobs had endured seven years in a crawl space above her free grandmother's shed before she was able to escape. She later saved her children from slavery. A mulatto herself, Jacobs survived in the North by working in the homes of prominent abolitionist women.

To slaveholders, children were property and women were stock to breed for profit. As was commonly practiced by planters, Thomas Jefferson kept a farm book tally of annual slave births at Monticello. He once wrote his farm manager Joel Yancey to say he valued the child-rearing capabilities of his "breeding" women over their service as laborers: "I consider the labor of a breeding woman as no object, and that a child raised every 2 years is of more profit than the crop of the best laboring man. . . . With respect therefore to our women and their children I must pray you to inculcate upon the overseers that it is not their labor, but their increase which is first consideration with us."[31] Recent discoveries of Jefferson's DNA imprint within the descendants of his slave Sally Hemings revealed that he took a personal interest in increasing his slave family.[32]

29. Stowe, *Uncle Tom's Cabin* (Boston: Jewett, 1852), 49.

30. Linda Brent, *Incidents in the Life of a Slave Girl*, 6.

31. *Thomas Jefferson's Farm Book: With Commentary and Relevant Extracts from Other Writings*, 28–31, 43.

32. Annette Gordon-Reed, *Thomas Jefferson and Sally Hemings: An American Controversy*; Deborah Gray White, *Ar'n't I A Woman? Female Slaves in the Plantation South*, 31.

Margaret Garner, newly pregnant at twenty-three and with four mixed-race children already, was quite a productive "breeding woman." She and her light-skinned children blurred the boundary between white and black; Noble reestablished it. Margaret's appearance and that of her children was significantly altered between news reports of the crime in 1856 and Noble's picture of 1867. Writing for the *Cincinnati Gazette* the day Margaret and the children were brought into court, Edmond Babb described her as a mulatto of one-fourth to one-half "white blood," five foot three inches tall, with "delicate" and "intelligent" eyes and forehead. The intrepid Babb found a way to get close enough to ask Margaret about an old scar on the left side of her forehead. "White man struck me," she replied. In painting Garner with a kerchief covering her brow, instead of a turban, wrapped "a la ole Virginny" upon her head, as Babb had described, Noble may have been hiding this evidence of the slaveholder's brutality.[33]

With generous dabs of burnt sienna and raw umber, Noble darkened Margaret and her boys, camouflaging the obvious white paternity of three of the children. Margaret's husband, Robert, was dark skinned, and they had what was called an "abroad marriage," since he lived on a nearby plantation. During the times when all but their eldest boy, the dark six-year-old, would have been conceived, Robert Garner was hired out and working a great distance away. The whiteness of the dead baby, the three-year-old girl, and the four-year-old boy (as well as Margaret's unborn infant) was thanks to the only resident white man on the plantation—master Archibald Gaines. Perhaps Noble, also of northern Kentucky, had known and sympathized with his neighbor, who had been observed to be greatly bereaved over the infant's death and personally saw to its burial.[34] Margaret Garner, like Sally Hemings, had produced slaves with and for the master. By painting the children with dark skin, Noble ignored the complicity of patriarch Gaines. In his painting there was no "nearly white" baby girl; two dark-skinned boys lay dead on the floor, while two equally dark siblings clung to their mother's ragged skirt.

Abolitionist iconography relied on light-skinned slaves. Whites may have found it easier to sympathize with figures that looked like them. Mulattos were also living testimony of sexual exploitation. By darkening Margaret Garner and her children Noble left behind conventional wisdom about mulatto slaves.

33. Edmond Babb, "Third Day of the Trial of the Mother and Her Children," *Cincinnati Gazette*, February 13, 1856, cited in Weisenburger, *Modern Medea*, 156.
34. Ibid., 75–76.

MISCEGENATION

Noble's Margaret Garner did not resemble the descriptions of her given in news reports. She did not appear to be a mulatto, and the "delicate" and "intelligent" eyes and forehead that the reporter had thought worthy of mention were lost in translation. Light-skinned slaves such as Garner and her children, living documents of male slaveholders' sexual misdeeds, presented a challenge for maintaining social stratification in the post-emancipation period. With less clear-cut boundaries between master and slave, color became a means for designating hierarchy. As a result, *miscegenation*, or mixing of races, a word newly coined in the 1864 presidential contest, became an explosive political and social issue. Sympathetic mulattos of antislavery iconography faded from view. In his study of Margaret Garner, Noble rendered a darker, less refined, and less "intelligent"-looking woman; one that was more compatible with evolving national needs for social cohesion. His was but one of many emerging tactics for distancing the mulatto from mainstream society.

With the country committed to rehabilitating former slaveholders, former slave women were now blamed for their own sexual victimization. Southern memoir writers, such as Myrta Lockett Avary, sought solace by reassessing the "Lost Cause" in a favorable light and pronouncing the female slave unchaste.

> The South did not do her whole duty in teaching chastity to the savage, though making more patient, persistent and heroic struggle than accredited with. The charge that under slavery miscegenation was the result of compulsion on the part of the superior race finds answer in its continuance since. Because he was white, the crying sin was the white man's, but it is just to remember that the heaviest part of the white racial burden was the African woman, of strong sex instincts and devoid of a sexual conscience, at the white man's door, in the white man's dwelling.

The situation grew worse after slavery, Avary insisted, a claim that was reinforced in popular images.[35]

"Wench" roles performed by men on the blackface minstrel stage can be traced back in folk traditions at least to English mummers. As early as 1844,

35. Myrta Lockett Avary, *Dixie after the War*, 395. Also see Louisa Barker, *Influence of Slavery upon the White Population*, 6–8; Ronald G. Walters, "The Erotic South: Civilization and Slavery in American Abolitionism," 177–201; and Bertram Wyatt-Brown, *Southern Honor: Ethics and Behavior in the Old South*, 313–14.

George Christy of Christy's Minstrels was known for his portrayals of what Robert Toll calls "pretty plantation yellow girls," singing songs such as "My Pretty Yaller Gal" (1847).[36] Light-skinned blacks were commonly referred to as "yellow" or "high yellow." On the stage "yellow gals" had been performed for comedic effect, but after emancipation these roles took on added significance. In 1859 Dion Boucicault's stage drama *The Octoroon* opened in New York City. This play popularized the portrayal of the mixed-race female, who came to be called the "tragic mulatto." In this drama, despite her pale appearance, being seven-eighths white, the Octoroon made the only choice open to her: she died in a noble sacrifice to free her white lover from their mixed, thus ill-fated, union. She sang,

> I cannot break thy noble heart,
> So full of love and truth;
> No, better far from thee to part,
> Than I should blight thy youth;
>
> Yes, leave unto her fate, dear George,
> The lowly Octoroon;
> With one whose blood is pure as thine,
> Forget the Octoroon.
>
> One parting kiss, 'tis all I ask—
> Oh! grant me this last boon—
> That in thy sunny smile may bask,
> The dying Octoroon.[37]

The tragic mulatto was admired for her beauty, because she was light-skinned, and for her refined and sensitive nature, as long as she stayed away from white males. The death of the tragic mulatto was a handy plot device to preserve white privilege.

Onstage, Stowe's light-skinned Eliza was portrayed as nearly white. She was married, however, to George Harris, another mulatto, and both of them were expediently dispensed with in a melodrama that found them safely out of the country into Canada.

If death or deportation were not options, then in popular culture the mulatto could be portrayed as sexually uninhibited, and thus unsuitable as a proper marriage partner. Beginning in the 1860s, periodicals featured engravings of African women only partially clad. In an 1860 *Harper's*

36. Dale Cockrell, *Demons of Disorder: Early Blackface Minstrels and Their World*, 55; Toll, *Blacking Up*.

37. Jennifer DeVere Brody, *Impossible Purities: Blackness, Femininity, and Victorian Culture*, 46–49; John Mahon, "I am an Octoroon," H. H. Dodworth (publisher), 1860.

Weekly, for example, an African woman was shown with bared breasts nursing her child.[38] The ties and buttons of her blouse attest that the garment could easily have been refastened, but the daguerreotypist seems to have wanted her breasts, large and pendulous, to be the focus of the composition. Images such as this supported southern propaganda that African American women were naturally uninhibited and responsible for the past sexual transgressions of slaveholding men.[39] Later in the century, when stereograph card viewing became a pastime in middle-class homes, poor African American women were hired to pose for the photographs with breasts exposed, nursing children on porches of rustic cabins.

Sexualizing black women became a dependable way to separate black from white. With slavery abolished, blaming the ex-slave for her own sexual exploitation was doubly effective, aiding northern reconciliation with southern white men while discouraging miscegenation. In 1863, year of the Emancipation Proclamation, Swiss-born natural scientist Louis Agassiz suggested that "[T]he sexual receptiveness of housemaids and the naiveté of young Southern gentlemen" were responsible for the large population of "halfbreeds" in the South.

> As soon as the sexual desires are awakening in the young men of the South, they find it easy to gratify themselves by the readiness with which they are met by colored [halfbreed] house servants; This blunts his better instincts in that direction and leads him gradually to seek more spicey partners, as I have heard the full blacks called by fast young men.[40]

In other words, contact with mulattos could give the man a taste for even darker women, the "spicey partners."

The plentitude of biracial ex-slaves bore witness to how desirable white males had found slave women, yet strategists were contending that the women were the sexual predators. Assessing the post-Reconstruction situation in Virginia, social scientist Philip A. Bruce asserted that miscegenation followed from emancipation because "the negresses are less modest as a class at the present day than they were before the abolition of slavery, since they are now under no restriction at all." Bruce denounced black women who saw "no immorality in doing what nature prompts."[41]

38. "The Only Baby among the Africans," *Harper's Weekly* 4 (June 2, 1860): 345.

39. John D'Emilio and Estelle B. Freedman, *Intimate Matters: A History of Sexuality in America,* 109–10; George M. Fredrickson, *The Black Image in the White Mind,* 79.

40. Stephen Jay Gould, *The Mismeasure of Man,* 48. From a letter written by Louis Agassiz on August 9, 1863.

41. Philip A. Bruce, *The Plantation Negro as a Freeman.*

During slavery, the appalling truth was that children of masters were saleable property. According to the legal decree *partus sequitur ventrem,* children of the antebellum South "followed the condition of the mother." If she were a slave, the child would be a slave, regardless of the race or free status of the father. But after emancipation free mothers produced free children. Mulatto women had been highly sought after and lighter slaves, known as "fancy trade," brought higher prices at auctions during slavery.[42] Even Harriet Beecher Stowe, a minister's daughter, minister's wife, and minister's sister, had known this unsavory fact. In *Uncle Tom's Cabin,* when the slave trader Haley first laid eyes on Eliza he admiringly exclaimed, "[T]here's an article now! You might make your fortune on that ar gal in Orleans, any day."[43] The idea that the newly freed, mixed-blood woman might produce even lighter children who might slip into the ranks of privileged society now had whites scrambling to prevent that from happening.[44]

The blurring of a color line was becoming such an impassioned topic that Noble probably wanted to avoid the subtext of sexual exploitation altogether. To that end, his Margaret Garner was neither light-skinned, seductive, nor bare-breasted. Instead, Noble pursued another form of "other-ing." Heeding the cautions of social scientists and southern apologists, he presented an animalistic African American woman.

MULATTOS: STERILE AND SHORT-LIVED

Between 1856, when Margaret Garner made her ill-fated escape, and 1867, when Noble painted his commentary, the scientific community was increasingly committed to proving that "racial" difference was genetically predetermined. Even before emancipation, members of professional disciplines—phrenologists and craniologists—had scrutinized skull shapes to gauge intelligence based on the physiognomies of ethnic samples. Among these professionals, an evolutionary scale had been developed that ranked whites at the top and nonwhites lower, closer to primates. During slavery their findings on "race" justified the belief that the African should rightly be under the custodial supervision of the European, because the latter allegedly possessed larger frontal brain space. Perhaps in response,

42. James Roberts, *The Narrative of James Roberts,* 26.

43. Stowe, *Uncle Tom's Cabin* (Boston: Jewett, 1852), 45.

44. Martha Hodes, "The Sexualization of Reconstruction Politics: White Women and Black Men in the South after the Civil War," 59–74; White, *Ar'n't I A Woman?* 39, 28–46, 61.

Noble depicted Margaret Garner with an extended mandible and sloping cranium. Had her brightly colored head wrap fallen low over her eyebrows in the absence of gray matter within? The structure of her head was similar to that of the lower primate ("Orang-Outan") shown in the phrenologists' charts (Fig. 3-7): her lower jaw jutted forward and her mouth gaped open to expose her teeth. With Noble's help, Margaret the mulatto became a simian vampire.

Skull studies and images inspired by racially motivated scientific inquiry gave graphic testimony to theories of separate origins for blacks and whites. In 1857 Agassiz contributed an introduction to Josiah Nott and George Glidden's *Indigenous Races of the Earth*, in which they maintained that humankind derived from different species.[45] Agassiz believed that all people were divinely created, but that a "Caucasian" and "Negro" couple would be infertile. By 1863, he was predicting that the "mulatto" would be a "degenerate sterile and short-lived breed."[46]

A year later, in 1864, Paul Broca concurred with Agassiz and Nott and predicted the end of mulattos. The Alabaman Nott had toured the South in the 1840s giving what he called "lectures on niggerology."[47] According to Broca, Nott contended, "Mulattoes are the shortest lived of any class of the human race." Furthermore, "[T]hey are less capable of undergoing fatigue and hardships than either the blacks or whites" and "the Mulatto-women are peculiarly delicate." He argued that because they are subject to a variety of chronic diseases, mulattos "are bad breeders" and less prolific than whites or blacks.[48] If the esteemed scientists were correct, the mulatto was a hybrid, like the mule from which the name derived, unable to successfully reproduce and destined for extinction.[49] White men, the exalted species, had actively produced children with these "bad breeders" during slavery, and now, on the eve of emancipation, they wanted to theorize that the

45. Edward Lurie, *Louis Agassiz: A Life in Science*, 258–59, 261, 264–65; James David Teller, *Louis Agassiz, Scientist and Teacher*, 42. Josiah C. Nott and George R. Glidden, *Types of Mankind; or, Ethnological Researches. Indigenous Races of the Earth* was their follow-up to the better-known *Types of Mankind*.

46. Judith R. Berzon, *Neither White Nor Black: The Mulatto Character in American Fiction*, 18; Fredrickson, *Black Image*, 162; Gould, *Mismeasure of Man*, 42–50.

47. Gould, *Mismeasure of Man*, 69.

48. Paul Broca, *On the Phenomena of Hybridity in the Genus Homo*, 29–33. The Nott essay was a forerunner to the groundbreaking *Hybridity of Animals Viewed in Connexion with the Natural History of Mankind: Types of Mankind*, which became *Types of Mankind* (Berzon, *Neither White Nor Black*, 25).

49. Forrest G. Wood, *Black Scare: The Racist Response to Emancipation and Reconstruction*, 66; Joel Williamson, *New People: Miscegenation and Mulattoes in the United States*. 24.

Fig. 3-7. Engraving. Josiah C. Nott and George R. Glidden,
Types of Mankind; or, Ethnological Researches, 459.

FIG. 345.[559]

Orang-Outan.

Fig. 3-6. and Fig. 3-7. Details

women were sterile. After emancipation such offspring were economically valueless to planters and were a threat to white dominance.

With proposal of the Fourteenth Amendment granting the rights of citizenship to African American men in 1866, the year before Noble painted *Margaret Garner,* freed African American were on the cusp of gaining access to the rights previously held solely by white men. That citizenship might also bring ownership of land, once the exclusive province of white men, was intolerable for many defeated southerners and working-class white

northerners.[50] For those intent on protecting the status quo, there was reason to fear that the sons of free mulatto women might go undetected and gain control of property by marrying white women. During the 1850s there had been a 66.9 percent increase in the mulatto slave population.[51] It had become difficult to distinguish white from black.

Well before emancipation, the fear of mulatto infiltration was being expressed by southern writers. In a review of *Uncle Tom's Cabin* for the *Southern Quarterly Review,* Louisa S. McCord justified slavery using the same mulatto characters through whom Stowe was able to elicit sympathy in opposition.

> The real unfortunate being throughout [Harriet Beecher Stowe's *Uncle Tom's Cabin*] is the mulatto . . . It is the mulatto whom she represents as homeless and hopeless; and we confess that in fact, although far below her horrible imaginings, his position is a painful one. Nature, who has suited her every creation to its destined end, seems to disavow him as a monstrous formation which her hand disowns. Raised in intellect and capacity above the black, yet incapable of ranking with the white, he is of no class and no caste. His happiest position is probably in the slave States, where he quietly passes over a life, which, we thank God, seems like all other monstrous creations, not capable of continuous transmission. This mongrel breed is a most painful feature, arising from the juxtaposition of creatures, so differing in nature as the white man and the negro; but it is a feature which, so far from being the result of slavery, is rather checked by it. The same unhappy being must occasionally exist, wherever the two peoples are brought in contact, and much more frequently where abolition license prevails, than under the rules and restraints of slavery.[52]

McCord called the mulatto "monstrous" and a "mongrel breed" brought into being by abolition but held it check by slavery.

In *Treatise on Sociology,* written during the waning years of slavery, Mississippi-born Henry Hughes continued to caution against race mixing: "Hybridism is heinous. . . . Mulattoes are monsters." The "races" should be

50. Jacquelyn Dowd Hall, *Revolt against Chivalry: Jessie Daniel Ames and the Women's Campaign against Lynching,* 154; Williamson, *New People,* 63. Political scientist Mae C. King looked at the growing fear of miscegenation following emancipation when racial hierarchy was threatened by "any congress between black men and white women and by marriage between white men and black women, but not by out-of-wedlock unions between white males and black females." No inheritance or property rights of offspring were at stake with illicit affairs ("The Politics of Sexual Stereotype," 12–23).

51. Michael Grossberg, *Governing the Hearth: Law and the Family in Nineteenth-Century America,* 137.

52. Louisa S. McCord, "Review of *Uncle Tom's Cabin,*" 117–18.

kept apart at all costs, because, he warned, "political amalgamation will initiate sexual amalgamation. In a society of two races, therefore, ethnical segregation is essential."[53] Hughes advocated a system he termed *warranteeism*, wherein an authoritarian state acting through a master class enforced an obligated class to labor.[54] In the early years of Reconstruction this rationale was only temporarily destabilized; clearly, there were factions North and South committed to maintaining white supremacy.

In the national election season of 1864, David Goodman Croly and George Wakeman, two New York journalists originally from Ireland, sought to gain political capital by attributing to Republicans an unsigned little book that they allegedly wrote. Using the new word they had coined for the main title of their book, *Miscegenation: The Theory of the Blending of the Races, Applied to the American White Man and Negro*, the ghost writers purported to advocate interracial marriage. They touted "the doctrine of human brotherhood" to advance a belief in "the right of white and black to intermarry, should they so desire." The term *miscegenation*, they maintained, came "from the Latin Miscere, to mix, and Genus, race." These two northern Democratic sympathizers knew that in 1863 a proposal advocating "the mixture of two or more races" would cause public outrage against the Republicans, who would be held accountable for the idea.[55]

Another hoax on the Republicans came with a book by L. Seaman entitled *What Miscegenation Is! and What We Are to Expect Now That Mr. Lincoln Is Re-Elected*. On the title page was an illustration of a white woman kissing a black man, shown in profile, with his lips predictably thrust forward (Fig. 3-8).[56] A series of lithographs produced by Bromley and Company of New York for the campaign of 1864 brought out the brazen "wench" seductress of minstrelsy to discredit Republicans. On one, entitled "Miscegenation; or, the Millennium of Abolitionism," chesty, moon-faced women named "Miss Snoball" and "Miss Dinah Arabella Aramintha Squash," repose on a park boulevard in the company of Republican president Abraham Lincoln, Republican senator Charles Sumner of Pennsylvania, and northern journalist Horace Greeley. Depicted on another

53. Henry Hughes, *Treatise on Sociology: Theoretical and Practical*, 239–42; John Mencke, *Mulattoes and Race Mixture: Images, 1865–1918*, 18.

54. Douglas Ambrose, *Henry Hughes and Proslavery Thought in the Old South*, 4–7.

55. David Goodman Croly and George Wakeman (attributed), *Miscegenation: The Theory of the Blending of the Races, Applied to the American White Man and Negro*, 64–65, ii. How successful these reporters were at pulling off the ruse is hard to say, but in 1896, racial theorist Frederick L. Hoffman cited their work as an authoritative text (*Race Traits and Tendencies of the American Negro*, 191).

56. L. Seaman, "*What Miscegenation Is! and What We Are to Expect Now That Mr. Lincoln Is Re-Elected.*"

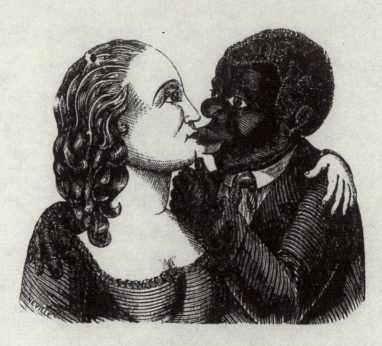

Fig. 3-8. Title page of *What Miscegenation Is! and What We Are to Expect Now That Mr. Lincoln Is Re-Elected,* by L. Seaman (New York: Waller and Willetts, 1864).

of the Bromley lithographs was "The Miscegenation Ball," an affair for white men and voluptuous black women, whose plunging necklines, cinched waists, and elevated hemlines show off a good amount of their ample figures. "One Destiny, Abraham Lincoln Pres[iden]t," proclaims the banner above the ballroom of heel-tapping dancers. Should Lincoln be reelected, the print suggests, this lustful horde of beefy strumpets would have America's white males in their thrall.

Republicans, members of the party of Lincoln, hoped to retain the presidency with passage of the Fifteenth Amendment to the Constitution granting Negro suffrage, and Democrats rightly feared a loss of political power. If, as many feared, black political self-determination led to intermarriage and more mulattos, then white control over property, money, and the political process would be in jeopardy. For these reasons, a broad spectrum of activists sought to limit African American access to the rights of citizenship.

THE HEROIC WOMAN

With so much at stake, the challenge to define Margaret Garner's act in the northern press changed significantly between the trial of 1856 and the painting of 1867, the year African American men were gaining the rights of citizenship. Sympathetic portrayals of mulattos and slave mothers, galvanizing and politically efficacious in the wake of the Fugitive Slave Law of the early 1850s, had fueled an ideological battle with the South. After the Civil War, and especially after emancipation, the social, economic, and political landscape changed. On the eve of the 1868 presidential election, the political rivalry between Democrats and Republicans intensified. Republicans, the majority party in the North, hoped to benefit from recent enfranchisement of black voters, yet were loath to seem overly accommodating of freed people. In fact, it would be Rutherford B. Hayes, a Republican from Ohio, site of the Garner tragedy and trial, who next secured the presidency for his part in ending Reconstruction by abandoning the freed people to the dictates of southern whites. By darkening and demonizing Margaret Garner, Noble performed a similar mission, revising a story in which the state of Ohio had once fought for the rights of an African American woman they regarded with compassion.

In 1856 the northern press had found it useful to present Margaret Garner in a positive light. Three days after the Garner family was captured, the *Cincinnati Commercial* exhorted citizens to fund a monument honoring "the heroic woman, who spared not her own child, when she supposed it must

be returned to bondage."[57] A consensus grew within the city, as locals rallied to protest the return of the fugitive family. While sympathizers supported the Garner family, the proslavery side grew righteously indignant at those they saw as meddlers. Essayist Albert Taylor Bledsoe blamed abolitionists for the death of Garner's baby. To Bledsoe, the Fugitive Slave Law was "that great constitutional guarantee of our rights."[58] By encouraging fugitives, he argued, northern agitators were impeding the law, and it was their fault when harm came to slaves.

Abolitionists also spoke out. During the trial, antislavery feminist Lucy Stone arrived in Cincinnati to support Garner. When Stone allegedly tried to smuggle a weapon to the accused mother, she was herself summoned before the court. Stone did not mince words: "The faded faces of the negro children tell too plainly to what degradation the female slaves submit. Rather than give her little daughter to that life, she killed it. If in her deep maternal love she felt the impulse to send her child back to God, to save it from coming woe, who shall say she had no right to do so?"[59] Is it any wonder men endeavored to deny women access to public forums? Lucy Stone's deliberate statement hung in the air, accusing Archibald Gaines of paternity, breaching a taboo to speak aloud what everyone knew was shamelessly clear. Even in her oft-quoted personal diary, southerner Mary Chesnut could only hint at tacit understanding of the social reality. "You see," she wrote during the Civil War, "Mrs. Stowe did not hit the sorest spot. She makes Legree a bachelor."[60]

Those who fought to keep Garner from the slave master's grasp may have inadvertently sustained the privileges of the very patriarchy that had brought her such despair. In their rush to view the accused as a self-sacrificing mother, "the heroic woman," wanting to keep her children from slavery, members of the Ohio community overlooked the possibility that Margaret's infanticide resulted from her rage at Gaines.[61] Seeing his visage in her "nearly white" baby might Margaret not have thought to destroy it to spite his all-encompassing power? Garner, contended Weisenburger, "acts out the system's violent logic in the master's face, thus displaying anger and revenge against his class, she mirrors his violent politics in profoundly disruptive ways. . . . In such moments the dispossessed mother represents unutterable contradictions that the dominant culture must

57. Weisenburger, *Modern Medea*, 263.
58. Albert Taylor Bledsoe, *Essay on Liberty and Slavery*.
59. Weisenburger, *Modern Medea*, 171–76.
60. Mary Boykin Chesnut, *A Diary from Dixie*, 122.
61. Weisenburger, *Modern Medea*, 44–49.

repress or mask."[62] The notoriety of the Garner case and ensuing courtroom battle made repressing it impossible in 1856. Masking it, however, was perhaps why Noble was commissioned to paint the woman eleven years later, after the furor had diminished and the story could be used to political advantage.

It is doubtful Noble intended that Margaret Garner be seen as a "heroic woman." Boime suggests that Noble's rendering of the confrontation between Garner and the group of men can be compared to European neoclassical tradition, which he knew well from his apprenticeship in France with Couture.[63] In keeping with the European painting convention for heroizing figures and expressing higher ideals, Noble placed Margaret on the right and her pursuers on the left to form the sides of a triangle. He deviated from this tradition, however, by drawing viewers' eyes away from the apex of the triangle down to where the bodies of the dead children lay. His inversion of the grand Greco-Roman tradition contained a troublesome disruption, as if Noble had hung an African mask over a face in a classical frieze. Instead of presenting an honest account of the deranged mulatto and her "nearly white" children, light-colored reminders of the master class's once tolerated abusive power, southerner Noble averted his eyes from the inconvenient but conspicuous truth and chose to make Margaret Garner's crime, her deviant behavior, the focus of his painting.

When Noble's picture was photographed by Mathew Brady and made into a wood engraving for the May 18, 1867, edition of *Harper's Weekly*, it took on even greater complexity.[64] Perhaps inspired by a European troupe on tour that year performing Euripides' ancient tragedy *Medea* in the United States to accolades, the print reproduction of Noble's *Margaret Garner* was captioned "The Modern Medea." Photolithographs of the painting appeared that spring in the *St. Louis Guardian*, the *New York Daily Standard*, and the *American Art Journal*. These newspaper prints may have been an awkward attempt to tout national ideals of liberation, to inscribe this poor fugitive within the annals of other grand narratives of slaves who sought freedom. Through thrice-copied impression—Noble's painting to Brady's photograph to an original then a mass-reproduced print—the mainstream *Harper's* seemed to document an historic event and to give the definitive commentary on this troubling episode.[65]

62. Ibid., 263.
63. Boime, *Art of Exclusion*, 146–47.
64. Birchfield, "Thomas Satterwhite Noble: Made for a Painter," 45.
65. Furth, "'Modern Medea,'" 38, 54.

Was Margaret Garner a latter-day heroine tormented by the same dilemma as Medea in the Greek drama? Rejected by her sons' father Jason, shut out from his world, Medea had murdered them.[66] By implication, this reading proposes that Margaret had been cast off by Gaines and was venting her rage on the children. The suggestion of complicit sexual union coincided with the contentions of southern apologists. As Medea she might be one of those "spicey partners" Agassiz had warned about—a sexual predator unleashing her wrath. Noble's Margaret was no heroic woman. The best she was offered in the artistic reports of 1867 was a performance as the modern Medea, a sexually used and discarded woman.

Leon Litwack wrote that "the obsession with miscegenation and racial supremacy proved to be effective banners around which whites could be mobilized to resist any encroachments on the traditional practices and social usages governing race relations."[67] Reunification of North and South was a growing national preoccupation in 1867. With freed people uncontained and mulattos abundant, the survival of the nation, which was founded on white supremacy, seemed in jeopardy. Noble's picture severed a lineage that joined black and white bloodlines; the cord literally cut by a gory knife wielded by Margaret Garner—Maggie the Ripper. This slave who had temporarily escaped from the iron trap of white patriarchal supervision became, thanks to the Kentucky-born painter and his New York businessman patron, a cornered female animal, her teeth bared in defiance, ready to eat her cubs rather than to nurture them.

In 1856 the story of Margaret Garner had captivated the border-state populace. A beacon for abolitionist sentiments, the desperate act of this "heroic woman" who was frantic to keep her children from the clutches of slavery had been a cause for celebration of national ideals about freedom. Once slavery ended, there was nothing to be gained by sympathizing with her aberrant behavior. As a horrific reminder of the evils that slavery precipitated, she offered some reassurance to the victorious North. Above all, Margaret's deed was a caution. Thomas Satterwhite Noble had exposed the monster that southern apologists warned lurked within the mulatto, presaging the need, many could reason, for soon-to-be enacted policies of segregating black from white.

66. Weisenburger, *Modern Medea*, 263, 8.
67. Leon F. Litwack, *Been in the Storm So Long: The Aftermath of Slavery*, 265–66.

Winslow Homer Visits Aunt Chloe's Old Kentucky Home

When Winslow Homer (1836–1910) painted *A Visit from the Old Mistress* in 1876 he may have been even more influenced by popular culture than scholars have previously acknowledged (Fig. 4–1). Revered as an independent voice, a celebrant of quintessential nativist themes, Homer is best known for his paintings of New England barefoot boys and modest maidens and for his hunting and seafaring scenes.[1] In recent years, with emergent interest in African American representations, Homer's recognition as an artist who had a special empathy for portrayals of humble ex-slaves has magnified. With so many grinning minstrels, corpulent mammies, and geriatric uncles in the mass-produced imagery of his contemporaries, Homer's depictions were comparably "serious and sensitive." In 1878, Homer's "negro studies" were deemed "the most successful things of the kind that this country has yet produced," and scholars today still extol "the dignity, unpatronizing sympathy, and sensitive understanding by which [Homer] represented black life and culture."[2] A reexamination of two of

1. "Artists and Their Work," *New York Times*, April 9, 1880, 5; Sidney Kaplan, *The Portrayal of the Negro in American Painting*; Parry, *Image of the Indian and the Black Man*, 140–43.

2. Calo, "Winslow Homer's Visits to Virginia," 5; G. W. Sheldon, "American Painters: Winslow Homer and F. A. Bridgman," 227; Nicolai Cikovsky Jr., *Winslow Homer*, 46.

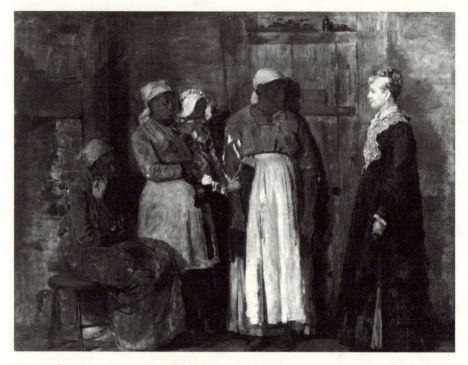

Fig. 4-1. *A Visit from the Old Mistress.* Oil on canvas, 18 x 24 inches,
by Winslow Homer, 1876. *Smithsonian American Art Museum.*
Gift of William T. Evans (1909.7.28)

Homer's oil paintings, *A Visit from the Old Mistress* (1876) and *Sunday Morning in Virginia* (1877), however, finds that these African American genre pictures were consistent with mainstream tastes of his day, even though critics have often argued that they were not. Homer's southern rustics, shown often in the bare interiors of cabins, corresponded to popular imagery and evoked familiar scenes from *Uncle Tom's Cabin.*

After apprenticing as a graphic designer in the urban centers of Boston and New York, Homer pursued painting surrounded by the creative community of artists, publishers, and entertainers in the Northeast. This in a decade that spanned from the end of the Civil War in 1865 to the end of Reconstruction in 1876, during which visual arts, news periodicals, and stage shows took up the cause of North/South reconciliation in earnest. Homer was indebted to the art of illustration and was beginning to make a name for himself as a painter in a time of renewed nationalism.[3] Studious

3. David Tatham, *Winslow Homer and the Illustrated Book,* 113; Francis John Martin Jr., "The Image of Black People in American Illustration from 1825–1925," 80–82; Paul H. Buck, *The Road to Reunion, 1865–1900,* 222.

observer of nature and people though he was, Homer's African American figures in rural settings reveal him to have been very much a man of his time. His work reflects the artistic and business climate that nurtured and sustained him.

Homer's *A Visit from the Old Mistress* bears a striking resemblance to an engraving Hammatt Billings made for the 1853 gift-book edition of Harriet Beecher Stowe's novel *Uncle Tom's Cabin*.[4] Tucked within the chapter called "Kentuck" was an engraving of Uncle Tom's wife—broad-shouldered, hefty Aunt Chloe—facing a thin, straight-postured mistress, Emily Shelby (Fig. 4–2). Billings illustrated a moment in the story after Tom had been sold down the river, destined for a New Orleans slave market. To settle a debt, Kentucky planter George Shelby had handed over Tom to the crude speculator, Haley. In Billings's print, Mrs. Shelby visited Aunt Chloe, her plantation cook, who had been robbed of a husband, in her lonely cabin, bringing condolence to the grieving spouse.

Homer's composition is comparable to Billings's: the figures of Emily Shelby and Aunt Chloe are approximately the same distance apart, and the shape of space between the "old mistress," standing in profile on the right, and the large-figured ex-slave, in a more forward pose to the left, is similar. Homer's pair varies little from Billings's Kentucky mistress and slave cook; except that in Homer's work, the arms of both women hang easily at their sides, instead of being tightly clasped in front of them. In both renditions the slave woman wears an apron and a similar type of head wrap. In the 1876 painting, a fine lace collar and delicate parasol signify improved circumstances for the plantation mistress, while the black woman's clothing, dirty and patched, is indicative of her poverty. The resemblance between *A Visit from the Old Mistress* and the engraving of Aunt Chloe visited by Mrs. Shelby connects Homer, a former illustrator himself, with the visual strategies of commercial printmakers. Ironically, an all-but-forgotten print of Aunt Chloe and Emily Shelby from *Uncle Tom's Cabin* may actually have been the impetus behind a painting by this major figure in nineteenth-century American art.

By continually lauding painters as the more significant artists, art historians have become the guardians of culture, elevating high art over popular culture. Paintings traditionally have been accorded unimpeachable respectability. In nineteenth-century America, paintings hung in genteel venues, obediently regarded by the press. Affluent men paid their hearty price tags, providing what they saw reflected their own value systems. Eventually the collections of these wealthy and powerful men were handed over to museums where the public was encouraged to esteem paintings

4. Stowe, *Uncle Tom's Cabin* (Boston: Jewett, 1853), 321.

Fig. 4-2. Engraving, by Hammatt Billings. Harriet Beecher Stowe,
Uncle Tom's Cabin (Boston: John P. Jewett, 1853), 321.

above the common fray of mass-produced imagery. A practitioner such as
Homer, adept at naturalism, was accepted as sympathetic to his African
American subjects for even choosing to bring them into the exalted realm of
a painting. Nevertheless, a comparison of Homer's paintings and the
popular prints that may have influenced him shows that, despite the
separate conditions of their production, display, compensation, and
provenance, both categories of picture were complicit in reenforcing postwar
views of racial relationships by reinscribing prewar social hierarchies.

BOSTON PUBLISHERS

Homer's first job at eighteen years of age was as an apprentice in 1854,
with the Boston lithographer John H. Bufford. Two years before, also in
Boston, publisher John P. Jewett had made publishing history by selling an

unprecedented three hundred thousand copies of first-time novelist Harriet Beecher Stowe's *Uncle Tom's Cabin* in less than a year. Under Bufford's employ, artists made lithograph covers for songs, such as "The Death of St. Clare (Little Eva's Father)" (Fig. 4–3), that were inspired by the best seller. Bufford also produced lithographs for trade cards and a variety of other promotional items. During the year that he spent under the tutelage of the thriving Bufford, Homer received a solid introduction to the creation and production of these graphic arts. Coincidentally, as Homer began his apprenticeship at Bufford's another Boston artist, Hammatt Billings, had just finished illustrating *Uncle Tom's Cabin*.[5]

Shortly after Billings completed the engravings for *Uncle Tom's Cabin*, he and Homer crossed paths professionally at *Ballou's Pictorial Drawing-Room Companion*, where the younger Homer soon outpaced the journeyman, gradually easing him out. They worked on the same project in New York, illustrating William Barnes's 1869 edition of *Rural Poems*. And both worked for *Harper's Weekly* in the 1860s.[6] It was under *Harper's* aegis, as an artist/reporter covering the Union Army of the Potomac during the Civil War, that Homer first began creating images of southern life and culture. Among that body of work were scenes of military camp life and quite a few African American subjects.

Even if Homer had not known Billings personally, he might have read *Uncle Tom's Cabin*. The book was an unavoidable phenomenon. In the first year of its publication, in Boston alone, three hundred babies were christened "Eva" after the saintly white child who befriends Tom. On November 15, 1852, George L. Aiken's play based on Stowe's story debuted in Troy, New York, and opened at the National Theater in New York City on July 18, 1853.[7] Two other adaptations were mounted in New York within a year, and soon versions were playing in all major northern cities. By the late 1870s, the *New York Daily Mirror* listed forty-nine traveling companies out "Tomming," calling these dramatizations the "bread and butter of the profession."[8] Living in New York during this period, Homer may have even seen a staged performance of *Uncle Tom's Cabin* or, at the least, the posters for one.

5. O'Gorman, *Accomplished in All Departments of Art*, 47.

6. Marilyn Kushner, *Winslow Homer: Illustrating America*, 32n15; Tatham, *Winslow Homer and the Illustrated Book*, 94–98, 298; O'Gorman, "H. and J. E. Billings of Boston," 62n31

7. Gossett, *"Uncle Tom's Cabin" and American Culture*, 164, 269; Hult, "*Uncle Tom's Cabin*: Popular Images of Uncle Tom and Little Eva, 1852–1892," 3–8.

8. Birdoff, *World's Greatest Hit*, 257. A version written by Henry Conway was at P. T. Barnum's American Museum that same year (88–89), while the Bowery Theater presented Thomas D. "Daddy" Rice as Uncle Tom in 1854 (102). For discussion of the antislavery versus proslavery aspects of *Uncle Tom's Cabin* in play versions by Aiken and Conway, see Lott, *Love and Theft*, 56, 211–33, especially 222–23.

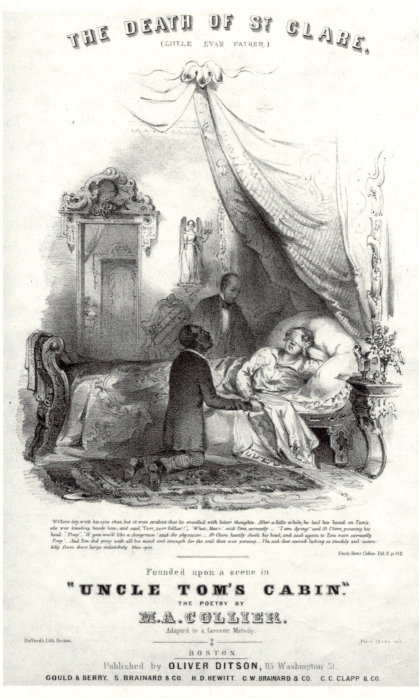

Fig. 4-3. "The Death of St. Clare (Little Eva's Father)." Lithograph, song cover sheet (Boston: John H. Bufford, Lithographers, 1852). *Collection of the author*

OLD KENTUCKY HOME

Some stage renditions of *Uncle Tom's Cabin,* dubbed "Tom shows," were pathos-laden melodramas; others resembled blackface minstrel theater, which had been popular since the 1840s. Blackface minstrel troupes offered humorous skits of scenes from the book along with an evening of musical acts. In both Tom shows and ministrel shows white actors made up in burned cork impersonated black characters. Performers of *Uncle Tom's Cabin* gave songwriters schooled in blackface minstrelsy an opportunity to compose nostalgic ballads. Stephen Foster's "Old Folks at Home" and "My Old Kentucky Home" (1853) and "Oh Carry Me Back to Ole Virginny" (1876) by James Bland, called "the negro Stephen Foster," are among the best known.[9]

Lee Glazer and Susan Key use the term *circularity* to describe the phenomenon of "creating 'a past' from present conditions," as practiced in nineteenth-century popular songs about the southern plantation. In these songs, former slaves cast longing gazes back to the old homestead; yet, paradoxically, they still reside there. The melodic structures of the music and the narrative recollections in the lyrics fuse temporality, reviving an ideal past as sentimental present.[10] When Homer's old mistress wistfully reprised Mrs. Shelby visiting Aunt Chloe, he was performing a similar displacement. The "basic equality and similarity of human condition," that art historians attribute to the fact that a "monumental black woman" and an "aristocratic white woman" inhabit the same plane actually does the ex-slaves a disservice.[11] The slovenly freedwomen are frozen in time, fixtures from the antebellum past tidily dissolved into a perpetual "circularity" where not much changes on the old plantation.

If Homer was revising a scene from *Uncle Tom's Cabin* he was not the first American painter to do so. Scenes of slave life reminiscent of *Uncle Tom's Cabin* yielded rewards for painters before Homer. The career of fellow New Englander Eastman Johnson (1824–1906) anticipated the course Homer's would follow. Johnson was born in Maine, and like Homer, he lived in Boston during the late 1840s. While still a teenager, Johnson too once worked for lithographer John H. Bufford. In 1858, he settled in New York City.[12] The next spring Johnson literally became famous overnight when he

9. Toll, *Blacking Up,* 1974.

10. Lee Glazer and Susan Key, "Carry Me Back: Nostalgia for the Old South in Nineteenth-Century Popular Culture," 1–24.

11. Karen M. Adams, "Black Images in Nineteenth Century American Painting and Literature: An Iconological Study of Mount, Melville, Homer, Mark Twain," 130–31.

12. Sinclair Hamilton, *Early American Book Illustrators and Wood Engravers, 1670–1870,* 1:161.

exhibited *Negro Life at the South* in that city's important National Academy of Design show (Fig. 3-5).[13]

Negro Life at the South remains one of the most recognizable American paintings of all time. Dispersed across a stage-set panorama, close to a dozen African Americans act out a range of daily activities, from the prosaic to the profound, from children cavorting to courtship. The mood is upbeat, set to the music of banjo strumming; the only discordant note is a young white woman stepping into the secluded area through a gateway at what would be the stage left of a theatrical tableau. Was this Mrs. Shelby come to call? More likely, if Johnson was indeed responding to Stowe's novel, the white woman was not white at all, but the light-skinned, nearly white Eliza come to disrupt Tom's happy home with the dreadful news of his sale and impending departure.

When Johnson painted *Negro Life* in 1859, Tom shows had been running for six years. In the year after Stowe's novel was published, while living in The Hague, Johnson had even tried his hand at painting Uncle Tom and Eva.[14] Whether or not he was still thinking of the best seller when he painted *Negro Life*, the similarity between Johnson's theatrical painting and the sentimental melodrama was apparent to many. A critic at the *New York Daily Tribune* called the painting "a sort of *Uncle Tom's Cabin* of pictures."[15] In addition to a host of stage types—banjo player, dancing child, coy lovers—Johnson arranged his figures much like actors before an audience, as if the curtain had just risen for act 1. George C. Howard's original production for Aiken's *Uncle Tom's Cabin* included eight such tableaux, one at the end of each part of the play.[16]

Public association of Johnson's painting with Uncle Tom began immediately. A photo reproduction selling that summer at the Boston Athenaeum, during the second outing for the painting, was captioned "Kentucky Home," the site of Tom's cabin and the title of Stephen Foster's tune, originally written about the novel and later adapted in performance by the Christy's Minstrels.[17] Prints of the scene were later circulated widely on the

13. Sarah Burns, "In Whose Shadow? Eastman Johnson and Winslow Homer in the Postwar Decades," 184–213; Patricia Hills, *The Genre Painting of Eastman Johnson: The Sources and Development of His Style and Themes* 55–60; John I. H. Bauer, *Eastman Johnson (1824–1906): An American Genre Painter*, 17; John Davis, "Eastman Johnson's *Negro Life at the South* and Urban Slavery in Washington, D.C.," 68.

14. Hills, "Painting Race," 122; Hult, "*Uncle Tom's Cabin*: Popular Images of Uncle Tom and Little Eva," 3–9.

15. Hills, "Painting Race," 126–27.

16. Birdoff, *World's Greatest Hit*, 50.

17. Hills, "Painting Race," 131.

cover of the song sheet of Bland's "Oh Carry Me Back to Ole Virginny." When a print was used on a label for tobacco, the white woman was cropped from the scene of happy-go-lucky slaves: the better to promote the joys of life on the old tobacco plantation unhindered by reminders of the master class, no doubt.[18]

Negro Life was a financial success as well. Artist John F. Kensett purchased the painting for twelve hundred dollars the day after it debuted at the National Academy of Design. Within the year, cotton broker William P. Wright became the owner.[19] According to John Davis, Wright's "willingness to loan the painting frequently during his years of ownership can perhaps be interpreted as an attempt to use it as a visual 'advocate' of the New York mercantile policy of tolerating slavery." The six thousand dollars that second owner Robert L. Stuart paid for Johnson's painting in 1868 brought renewed press attention. Stuart, a sugarcane refiner, most likely amassed his fortune on the backs of slaves laboring endless hours on plantations.[20] Four years after the triumph and subsequent sale of *Negro Life* at the high-profile NAD exhibition, Homer established his own studio in the New York University Building where the slightly older Johnson was already situated.[21]

In 1876, the year Homer painted *A Visit from the Old Mistress,* Johnson's *Negro Life at the South* was back in the limelight. Now exclusively known as *Old Kentucky Home,* the painting was exhibited at the Philadelphia Centennial, and it was singled out as a show highlight in the *Art Journal:*

> We welcome most cordially the picture of the "Old Kentucky Home," by Eastman Johnson, painted many years ago. Here is one of the first pictures which gave him reputation, and looking at it now as we looked at it formerly, we find it doubly charming, with its old mossy roof that shielded various Dinahs and Cuffys of all sizes and ages, from the curlyheaded baby at the knee to the white-headed old men and women, with their pleasant, good-humoured faces, their awkward forms, and their odd clothes.[22]

18. Davis, "Eastman Johnson's *Negro Life at the South,* 84. From 1859 to 1876, *Negro Life at the South* was shown in New York City and Boston (1859); Troy, New York (1860); Weehawken, New Jersey (1863); New Haven, Connecticut (1874); and Philadelphia, Pennsylvania (1876).

19. Hills, "Painting Race," 126; Birdoff, *World's Greatest Hit,* 137–38.

20. Davis, "Eastman Johnson's *Negro Life at the South,* 84, 87; Lesley Carol Wright, "Men Making Meaning in Nineteenth-Century American Genre Painting, 1860–1900," 137, 162.

21. Hills, *Genre Painting of Eastman Johnson,* 61–62, 71.

22. "Paintings at the Centennial Exhibition," *Art Journal* (1876): 283.

There were no "white-headed old men" in the painting, but with old Uncle Tom so inscribed in public consciousness, evidently the writer expected he was there. When readers met Tom in Stowe's 1852 novel he was in the prime of life—a father, a good worker, and a valuable piece of property. When Uncle Tom became a stage character he aged, becoming such an identifiable type that a rubber baldpate rimmed with white hair advertised in costume catalogs was known simply as an "Uncle Tom." Yet, in Johnson's painting there was no such figure.

Tom's Kentucky home had catapulted Johnson to fame and fortune in 1859, and it was still producing raves in 1876 when Homer painted *A Visit from the Old Mistress*. As he assembled his own theatrical tableau, another woman entering an African American home, perhaps he hoped the humble cabin setting would work its magic for him too.

THE INTERCHANGEABLE SYSTEM

Homer based his oil paintings on his earlier drawings and on the work of other artists. Peter H. Wood and Karen C. C. Dalton trace some of Homer's paintings from the Civil War and Reconstruction years back to sketches he and others made for weekly periodicals.[23] Nicolai Cikovsky compares Homer's process of appropriation to a mechanical industrial technique invented by Eli Whitney called the "Interchangeable System." In Whitney's new production system, the various parts used to make a clock, gun, or other machine were to be crafted by separate people, each adding a part to the eventual whole. Previously, as practiced throughout the home-based industries of colonial America, one highly skilled artisan crafted the entire item. According to Cikovsky, the 1860s and early 1870s saw Homer improvising, in a manner "more mechanical in its method than conventionally artistic . . . assembling parts, often interchangeable, into larger pictorial wholes—a method less like pictorial composition than of mechanical compositing."[24] For Homer, figures were interchangeable parts that he recombined, often into stock settings.

A young woman facing soldiers on a Richmond street, detailed in the upper right of a two-page montage for *Harper's Weekly* in 1862, may have prefigured "the old mistress" of his 1876 painting (Fig. 4–4).[25] Although this woman of proud bearing resembled Billings's Mrs. Shelby and Homer's

23. Wood and Dalton, *Winslow Homer's Images of Blacks*.
24. Nicolai Cikovsky Jr. and Franklin Kelly, *Winslow Homer*, 66–68.
25. *Harper's Weekly* 6 (June 14, 1862): 377.

Fig. 4-4. "Views from the War" (detail). Wood engraving by
Winslow Homer for *Harper's Weekly* 6 (June 14, 1862): 377.

later mistress, she was already an established, if interchangeable, type by the time Billings created his engraving and Homer painted his mistress. As the abolition-era standard-bearer instructing middle-class women about fashion and proper deportment, *Godey's Lady's Book,* edited by Sarah Josepha Hale from 1837 to 1877, was unrivaled. The magazine had a staggering 150,000 subscribers by the Civil War. Each month "the Book" featured a centerfold engraving of polite, stylish women in parlors or manicured gardens. When framed and mounted on the wall, these "fashion plates" gave well-appointed homes a feminine touch (Fig. 1-9).[26] Homer's "lady" might also have been familiar to Americans from print reproductions of European paintings. Her haughty demeanor recalled late eighteenth-century-portrait conventions of portraying English ladies and lords in the grand-manner style. In any case, Billings did not invent her, and what Homer borrowed from the more senior illustrator was his partnering of the two contrasting types: the white lady and the black cook.

Scholars familiar with Homer's work may note a resemblance between the woman facing the soldiers in *Harper's* and the figures in the 1866 oil painting *Prisoners from the Front* (Fig. 4–5). In this painting, a Union officer takes the spot held by the young woman, while soldiers—Confederate prisoners—face him. That Homer patterned *A Visit from the Old Mistress* after *Prisoners from the Front* has long been the consensus of art historians.[27] Placement in an officer's stead may also account for the mistress's military bearing, registering with a reviewer in 1880 as "the contrast of lofty-toned Virginia respectability with the crushed, rudimentary natures of the slaves."[28] Even though the officer and the mistress are of higher status, they each seem ill at ease and out of place in the presence of the defeated soldiers and the disconsolate ex-slaves. If *Visit* of 1876 was formed to the grid of *Prisoners* of 1866, the officer in *Prisoners* might himself have been an interchangeable part, fitted into a silhouette left by the southern woman in the earlier *Harper's* street scene.

With his *Harper's Weekly* prints, war correspondent Homer first explored Virginia.[29] So it was to familiar territory that he returned during Reconstruction to paint African American subjects. But while the locale might have been recognizable, much had changed within American society. The mid-

26. Isabelle Lehuu, *Carnival on the Page: Popular Print Media in Antebellum America,* 107.

27. Kaplan, *Portrayal of the Negro;* Adams, "Black Images," 130–31; Parry, *Image of the Indian and the Black Man,* 140–43; Wood and Dalton, *Winslow Homer's Images of Blacks,* 95.

28. *The Art Amateur* 2, no. 6 (May 1880): 112.

29. Lloyd Goodrich, *Winslow Homer,* 47.

Fig. 4-5. *Prisoners from the Front.* Oil on canvas, 24 x 38 inches,
by Winslow Homer, 1866. *The Metropolitan Museum of Art,
New York. Gift of Mrs. Frank B. Porter, 1922 (22.207)*

1870s were a time of economic upheaval for the entire country, and the panic of 1873 signaled a period of financial hardship. An 1877 railroad strike was a defining event in an age of labor struggle. Northern industrialists set their sights on reinvigorating the southern economy to help reenergize the nation. A stable, agriculture producing work force, such as slavery once provided, was crucial.[30] Homer's painting offered reassurance that a peasant class remained available.

SUNDAY MORNING BIBLE STUDY

Another Homer painting that shares qualities with prints made for *Uncle Tom's Cabin* and that is an example of his use of an interchangeable figure is *Sunday Morning in Virginia.* (Fig. 4–6). As the title proclaims, the women and children in this painting huddle together reading the good book on

30. Nina Silber, *The Romance of Reunion: Northerners and the South, 1865–1900,* 43–44; Lawrence Powell, *New Masters: Northern Planters during the Civil War and Reconstruction.*

Fig. 4-6. *Sunday Morning in Virginia.* Oil on canvas, 18 x 24 inches, by Winslow Homer, 1877. *Cincinnati Art Museum, John J. Emery Fund*

Sunday in the chimney corner of a humble cabin. The peaceful group of children is being instructed by a young woman, while an old woman stares into the distance. The better clothing of the teacher indicates she is from more privileged circumstances; it is possible that she is a free black who went south to teach ex-slaves after the war. Homer relies on the vocabulary through which antebellum artists presented sympathetic figures in antislavery texts. Like the pale victims of the auction block from the abolitionist era, Homer's young woman is light-skinned and wears clean, modest clothing with a tidy apron. That she instructs a Bible study adds devoutness to her proper womanly attributes.[31]

As had *Visit*, Homer's *Sunday Morning in Virginia* received favorable press. A critic at the time approved "the centenarian negress whose whole attitude. . . . reveals the history of a race in her look of patience and

31. Barbara Welter, *Dimity Convictions: The American Woman in the Nineteenth Century*, 83–102.

acceptance."[32] Reviewers appraised the image of the former slaves fitting nicely into new roles as free peasants. Recent critics propose Homer may have been advocating African American advancement. Because the group is studiously reading, Albert Boime suggests Homer was in opposition to the hostility some Virginians felt toward educating former slaves.[33] Nina Silber contends that northerners believed southern whites were lazy and that they thought by "educating, enfranchising, and working with" blacks, they could cultivate a stable, productive labor force.[34] For Homer's northern Republican patrons, who were aligned against southern Democrats, the prospect of educated blacks exercising the franchise granted them by passage of the Fifteenth Amendment in 1870 would have been tantalizing. Unfortunately, there is nothing in Homer's output to suggest he ever had the least inclination to challenge prevailing attitudes. While his version of a Sunday morning in an ex-slave's cabin varies from similar scenes created by illustrators and other artful tradesmen by virtue of his gift for realism, he made no radical departure from the popular themes of the day. If education was a controversial topic, he mitigated it by the subdued mood of his domestic group and by enacting literacy as an act of Christian worship. In fact, it was novelist Stowe who first envisioned the revolutionary idea of presenting an African-descendant person as literate, when she created the character Uncle Tom.

Before Stowe gave life to Tom, slaves had occasionally been perceived as Christian but rarely as Bible readers. Images of prayerful slaves on their knees appealing to potential abolitionists were mainstays of antislavery campaigns for more than half a century.[35] Illustrator Billings had drawn a slave kneeling in supplication before the figure of Christ in his 1850 design for the masthead of William Lloyd Garrison's the *Liberator* (Fig. 1–2). Even before that, kneeling figures, males and females, had been used on antislavery tokens and in prints, flanked by banners asking, "Am I Not A Man and A Brother?" or "Am I Not A Woman and A Sister?" But Uncle Tom was rare: he read the Bible and he spoke the Christian word. Unusual for a slave, his behavior can be attributed to author Stowe's evangelical Christian conviction that slaves possessed souls worth saving. She made Tom her emissary, a witness for Christ, sharing his faith with all he met.

32. *The Art Amateur*, 112.
33. Boime, *Art of Exclusion*, 106–7.
34. Silber, *Romance of Reunion*, 43.
35. Jean Fagin Yellin, *Women and Sisters: The Antislavery Feminists in American Culture*, 1989.

As discussed in chapter 2, Billings seems to have discerned Stowe's intention when he drafted engravings of Tom bent over a Bible for the 1853 edition of the novel.[36] Other illustrators followed his lead. Renowned English graphic artist George Cruikshank drew Tom reading a Bible by the glow of a hearth fire. Induced by the Stowe/Billings Tom, illustrations of slaves bowing over Bibles in dark corners of cabins became commonplace in the early copies of the international best seller (Fig. 4–7).

Painters also depicted devout slaves reminiscent of Tom. Perhaps seeking to bolster his association with slave genre paintings, Johnson followed up *Negro Life* with *The Lord Is My Shepherd* (Fig. 4–8), *ca.* 1863, the year Homer became his studio neighbor. Echoing the illustrators, this work shows Tom reading Psalm 23, hence the title, by firelight in his meager cabin.[37]

A woman in another Johnson painting, *Dinah, Portrait of a Negress* (*ca.* late 1860s), makes a convincing candidate for one of Homer's interchangeable figures. Dinah sits, her hands clasped over a cane upon which she leans, seemingly lost in thought (Fig. 4–9). Was it coincidence that in 1877 Homer positioned his older woman for *Sunday Morning* in the same pose Johnson gave Dinah? Whether or not he had seen Johnson's *Dinah* or *The Lord Is My Shepherd*, chimney-corner scenes replicating *Uncle Tom's Cabin* illustrations were common by the 1870s. Johnson painted the subject twice; the second was called simply *The Chimney Corner*.

And there were others. Two years before Homer painted *Sunday Morning in Virginia*, Thomas Waterman Wood of Vermont painted the similarly titled *Sunday Morning* (*ca.* 1875). In Wood's composition, a young girl reads to a seated older woman, perhaps portending the old and young partnership Homer would favor in his painting.[38]

Images of aging ex-slaves joined by young children provide another example of what Glazer and Key call *circularity*, of how art can commingle the past and the present. Homer tamed any subversive potential that a scene of African American education might pose for northern reconciliation with the South by opting to focus on a pensive old woman lost in her own memories. Had he brought forward the young learners instead to presage a future beyond the humble cabin, his scene of Bible study might

36. For engravings of Tom with a Bible, see Stowe, *Uncle Tom's Cabin* (Boston: Jewett, 1853), 48, 171, 186, 197, 237, 324, 408, 436; engravings of Tom and other slaves praying are on pages 357, 370, 381, 398, 477, 486, 518, and 550, and embossed on the cover.

37. Honour, *From the American Revolution to World War I*, 201–20.

38. Margaret C. Conrads, *Winslow Homer and the Critics: Forging a National Art in the 1870s*, 128–29; Cikovsky and Kelly, *Winslow Homer*, 96. An engraving of Wood's painting was made for the *Illustrated Catalogue of the Fifty-Second Annual Exhibition, National Academy of Design*, 1877.

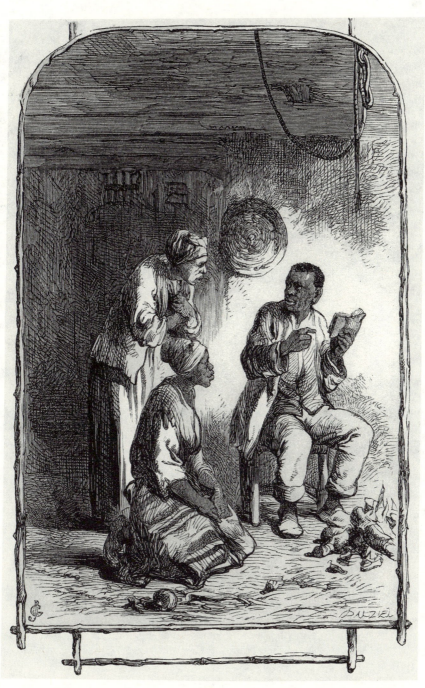

Fig. 4-7. Frontispage, "Uncle Tom teaching the two Negro-women the Bible," for Harriet Beecher Stowe, *Uncle Tom's Cabin* (London: George Routledge, 1952). Wood engraving, by Dalziel Brothers. *Collection of the author*

Fig. 4-8. *The Lord Is My Shepherd*. Oil on wood, 16 5/8 x 13 1/8 inches,
by Eastman Johnson, *ca.* 1863. *Smithsonian American Art Museum.*
Gift of Mrs. Frances P. Garvan (1979.5.13)

Fig. 4-9. *Dinah, Portrait of a Negress.* Oil on academy board,
10 1/2 x 8 1/2 inches, by Eastman Johnson, *ca.* late 1860s. *Private collection*

have been progressive. To the contrary, *Sunday Morning in Virginia* was about continuity. Wearing earth-colored clothes, the solemn sexagenarian still resided where she had lived as a slave, in a cabin much like Aunt Chloe's. As it stands, the talented painter conveyed compassion for the old woman without challenging the status quo, keeping within the bounds for representing blacks laid out by painters and printmakers before him.

OLD PLANTATION REVERIES

From Reconstruction to the end of the nineteenth century, the popular press was full of retrospective ex-slaves, their thoughts drifting back to bygone days. In 1875, two years before Homer painted *Sunday Morning in Virginia*, another ruminating elder musing on the past was the subject of a *Harper's Weekly* cover titled *The Song of the Kettle: Evening Reverie* (Fig. 4-10). Other print artists had plied the trope of circularity. For *Harper's Weekly* in 1872, William L. Sheppard paired an old person with a young one in his two-part composition "Negro Life in the South" (Fig. 4-11), so called, perhaps, with a nod to Johnson's illustrious painting. On the right in the image is an old musician outside his simple cabin playing a fiddle and tapping his raggedy shoes as a younger version of Aunt Chloe smiles from the doorway. A columned portico beckons from the plantation manor rising above in the upper left corner. Michel Foucault could have used the big house as an example of a "schemata of power," reminding viewers that this little scenario was taking place under the watchful eye of the ever-present panoptic master class.[39] Across the page in a companion print, within a sparse interior, barely illuminated by the light sneaking through wood slats of a windowless wall, a stooped old man listens to a boy read. The youngster's bound books cast to the ground and the man's slack-jawed expression betray the futility of advancement for ex-slaves still on the plantation.

Adult black men vanished from visual culture during Reconstruction leaving only boys or geezers in their wake. In that respect, Homer's paintings were not exceptions. Five of his best-known Virginia oil paintings featured black women. There were watercolors centered on boys and one oil painting with an old "Uncle Ned."[40] Homer's old mistress visited a

39. Michel Foucault, *Discipline and Punishment: The Birth of the Prison*, 221.
40. Calo, "Winslow Homer's Visits to Virginia," 9. Homer's paintings that featured women subjects were *A Visit from the Old Mistress* (1876); *Cotton Pickers* (1876); *The Carnival* (1877); *Sunday Morning in Virginia* (1877); and *Upland Cotton* (1879–1895). His *Weaning the Calf* (1875); *Watermelon Boys* (1876); and *Plantation Scene* (date unknown) all featured boys, and his *A Happy Family in Virginia* (1875), which is also known as *Uncle Ned at Home*, depicted an old man with children.

Fig. 4-10. "The Song of the Kettle—An Evening Reverie." Wood engraving for cover of *Harper's Weekly* (September 25, 1875).

Fig. 4-9 and Fig. 4-6. Details.

fatherless household. In the chimney corners where Johnson in the 1860s seated a male figure, Homer in the 1870s found only females. In this, Homer was up to date with trends in popular culture, where adult African American males were either absent or, like Tom, were old men.

The reasons for the disappearance of African American adult males from nineteenth-century paintings and prints are quite simple. Adult black men were now able to vote and to travel around the country, and they were potentially employable in jobs coveted by lower-class whites. Yet, what viewers saw in images were ragged women, dependent children, and aged men, all of whom lack the potential to upset existing hierarchies of power. The original Tom had been a better man than any of his white masters; he had counseled women and children in Christian faith; and the lazy New Orleans master's little daughter had idolized him. After emancipation, the once-subjugated, but now free, adult black man threatened white supremacist notions of patriarchal society. Sambos, pickaninnies, and uncles proliferated, while husbands, fathers, and soldiers were erased from recollections.[41]

41. Goings, *Mammy and Uncle Mose*, 73. Goings notes the disappearance of twenty- to fifty-year-old black males in memorabilia during these years.

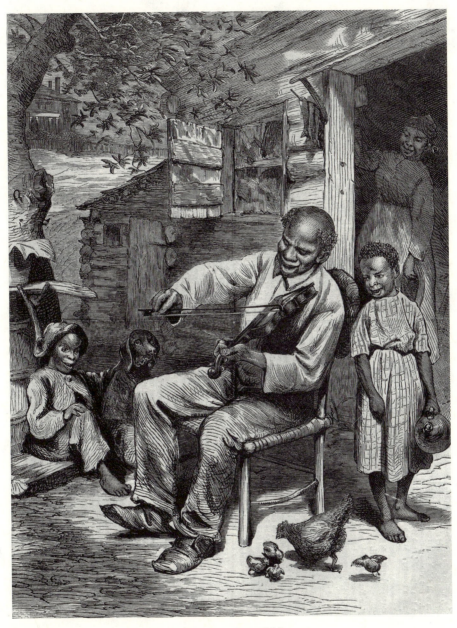

Fig. 4-11. Detail (r)

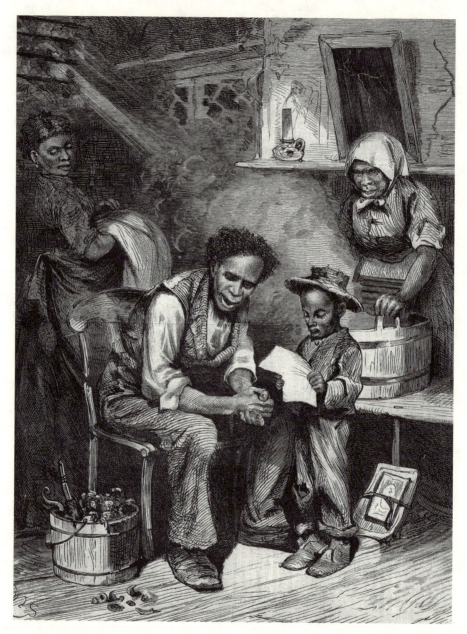

Fig. 4-11. Detail (l)

Over a broad range of popular imagery, the virile African American male in the prime of life, the head of the black household, was exiled. On an 1880s advertising card for the Domestic Sewing Machine Company, for example, "Aunt Chloe" and the girls stand in the doorway of a cabin (Fig. 4-12). No man is present in the home, but a very old salesman graciously bows as a goat chews his shirttail. A sewing machine waits atop his wagon. That these country folks, sans male provider, could have afforded the newfangled item was unlikely, but that probably didn't stop marketers from trying to sell them one. In his autobiography Booker T. Washington observed with chagrin that desperately poor families in Alabama were paying sixty-dollar monthly installments to buy sewing machines, which were likely overpriced and clearly beyond their means.[42]

Another late nineteenth-century visual format that regularly pictured southern blacks was the stereograph cards that brought timely perceptions of African Americans to life in middle-class parlors as social entertainment. Inserted at a twelve- to eighteen-inch remove from the viewer's eyes into an apparatus called a stereoscope, or stereopticon, the double pictures melded into a 3-D image with perceived verisimilitude. On one card in a series, called "Down in Dixie," an African American family, comprised of all women and children, convened on the stoop of the hallowed cabin (Fig. 4-13). Another stereograph series, titled *The Sunny South,* contained similarly predictable pictures of matrilocal black families. The ragged women and their broods featured on these photo cards were doubly offensive because they not only implied that African American males were absentee fathers, unable to function as heads of household, but also gave an impression that black women were promiscuous, having more children than they could properly care for. These skewed families were everywhere in post-Reconstruction visual culture—on trade cards, on sheet music, and on the sundry other photo and print ephemera. By painting this same configuration of black families in *Visit* and in *Sunday Morning,* Homer not only endorsed this popular perception but also gave it the legitimacy of fine art.

An art historian once attributed Homer's Virginia paintings to his "traveling the byways of the South."[43] Although tour books had been around before the Civil War, there was a concerted effort in the 1870s, spearheaded by journalists, to reintroduce northerners to the South to

42. Booker T. Washington, with Max Bennett Thrasher, *Up from Slavery,* 54.

43. Albert Ten Eyck Gardner, *Winslow Homer, American Artist: His World and His Work,* 230; Calo, "Winslow Homer's Visits to Virginia," 10.

Fig. 4-12. Advertising card. Domestic Sewing
Machine, *ca.* 1880s. *Collection of the author*

hasten national reconciliation.[44] *Appleton's Journal* and *Scribner's Monthly*
led the way with illustrated travel and local-color stories.[45] Shortly after it
debuted in April 1869, *Appleton's,* under the direction of Oliver Bell Bunce,
launched a series called "Picturesque America," which was abundant with
images of the South.

For its inaugural story about a southern city, *Appleton's* dispatched artist
Harry Fenn to Charleston, South Carolina.[46] His illustration, *A Road-side
Scene Near Charleston,* was on the front page of the July 1871 issue. His scene
was set within a dense forest of towering trees and included a black
woman, with four shoeless children clothed in dingy garments, who was
preparing food on a makeshift table under the shade of tree branches. It

44. See David Hunter Strother, "Virginia Illustrated: The Adventures of Porte
Crayon and His Cousins," 176–77.

45. Buck, *Road to Reunion,* 222; Michael Quick, "Homer in Virginia," 65. *Appleton's
Journal* began sending writers and illustrators into the South in 1870 and in 1870 and
1871 published two series: one called "Southern Sketches" and another entitled
"Picturesque America." Another series entitled "A Jaunt in the South" ran in
Appleton's Journal in 1873.

46. Sue Rainey, *Creating a Picturesque America: Monument to the Natural and
Cultural Landscape,* 66.

Fig. 4-13. "Down in Dixie." Stereograph card, Griffith
and Griffith, *ca.* 1900. *Collection of the author*

was not a portrayal of Charleston's urban life but of freed people in the
woods taking a breather from laboring.[47]

Contrived after the Civil War in response to the need for reconciliation,
these portrayals of the exotic New South and the mythic Old South of
plantations past were to a significant extent northern-made.[48] Historian
Silber concludes that northerners took an interest in southern travel when,
"no longer preoccupied with wartime anguish and destruction" they were
free to think of the South purely in tourist terms, as a "land of leisure,
relaxation, and romance." Ruins, even of a slave market or a plantation
estate, appealed to the tourist's aesthetic demands. "In the eyes of the
northern traveler," argues Silber, "blacks became less of a problem and
more of a 'picturesque' element on the southern scene."[49] And so, pictures
fell in line with the new thinking.

Appleton's "Picturesque America" series was compiled into a gift-book
edition in 1872, which was, under Bunce's supervision, edited by William
Cullen Bryant. In it were tributes lauding a world where "art sighs to carry
her conquests into new realms" and thousands of nooks lay "waiting to
yield their beauty to the pencil of the first comer." One of those new realms
awaiting artistic conquest was the homesteads of ex-slaves. A picture of

47. "A Road-Side Scene Near Charleston," *Appleton's Journal* 6, no. 120 (July 15,
1871): cover page.

48. Glazer and Key, "Carry Me Back," 22–23.

49. Silber, *Romance of Reunion*, 66–67, 77–78.

"the African element of the population" among the ruins of Richmond, Virginia, was praised: "One cannot help recognizing in this sketch how much more effective in the hands of the artist is dilapidation than tidiness, and a ruin than a perfect structure. The ramshackle porches of the negro tenements here have a higher effect than would a neat row of white-painted houses with green blinds, in a well-kept New-England village." The engraving by Fenn that accompanied the written description showed rickety wood porches of crowded tenements facing a canal, with a burned-out brick structure in the distance, and a barefoot black woman in a tattered skirt scattering feed for chickens along a patch of dirt alley between the slums and the canal.[50]

Appleton's "Picturesque America" was enormously successful as both a weekly series and a fancy fifteen-dollar book. The prints by Fenn, Sheppard, and other prominent illustrators were of high quality, according to William J. Linton, who called them "the best landscapes engraved in this country" in his 1882 history of American wood engraving. Editor Bunce had a special fondness for imagery of the South and he personally selected the stories and the graphics for both the *Appleton's Journal* serial and the book *Picturesque America*. According to Sue Rainey in a recent study of the project, by sending artists and writers to the South "'in search of the picturesque' [*Appleton's Journal*] signaled a return to normalcy." Attracting southern subscribers may also have inspired Bunce's decision.[51]

Following *Appleton's* success, *Scribner's Monthly* countered with a series called "The Great South," written by Edward King and illustrated by J. Wells Champney, which in 1875 also became an elegant collector book. "Imagine yourself transferred from the trying climate of the North," wrote King, "into the gentle atmosphere" of the South. "Your face is fanned by the warm December breeze, and the chippering of the birds mingles with the music which the negro band is playing in yonder portico. The lazy, ne'er-do-well negro boys playing in the sand so abundant in all the roads, have the unconscious pose and careless grace of Neapolitan beggars."[52] If *Appleton's* "Picturesque America" saw beauty in the ruins of indigenous terrain, *Scribner's* "The Great South" exoticized the South, conjuring up grand tour comparisons with the old world.

50. William Cullen Bryant, ed., *Picturesque America; or, The Land We Live In*, 1:80–81; Rainey, *Creating a Picturesque America*, 255.
51. William J. Linton, *The History of Wood-Engraving in America*; Rainey, *Creating a Picturesque America*, 50–51. Also see Tatham, *Winslow Homer and the Illustrated Book*.
52. King, *The Great South*, 380. "The Great South" was serialized in *Scribner's* in 1873 and 1874 and then compiled into a book in 1875. Apparently King's *Scribner's* series was so successful it not only launched that new monthly, but *Harper's* subsequently added articles about the South to their *New Monthly Magazine*.

Picturesque America and *The Great South* were popular and well-received, and they came out right before Homer got the idea to go paint in Petersburg, Virginia. Although Homer was not a contributor to *Picturesque America*, he had a professional association with *Appleton's* publishing company and a social relationship with the influential Bunce. His engravings had appeared in two of *Appleton's* illustrated books: *Song of the Sower* (1870; written by *Picturesque America*'s Bryant), and *The Story of the Fountain* (1871). A Bunce project of 1866, *Festival of Song: A Series of Evenings with the Poets*, counted Homer's first drawing for a gift book among its numerous engravings.[53] That same year Bunce and his partner F. J. Huntington had commissioned Homer to illustrate John Esten Cooke's *Surrey of Eagle's Nest*, a Civil War novel that presented the South in an attractive light.

Bunce held regular gatherings for writers and artists in his home on 21st Street in New York City, some of which were attended by Homer. These "salons" gave Bunce a forum for expounding on his views of the picturesque South and for encouraging writer and artist attendees to travel to the region in search of subject matter. "Our appeal several weeks ago, to our artists to go into North Carolina and Virginia for fresh studies for their canvases, has awakened interest," he wrote in his *Appleton's* "Table Talk" editorial column.[54] Between Bunce's soirees and his zealous written appeals, it is likely that Homer was inundated with encouragement to take on southern subjects. The opportunity to fraternize with reconciliation-minded publishers gave Homer access to business community patrons amenable to the stabilized hierarchy of Virginia freedwomen in their place before a southern matriarch that his paintings seemed to promote.[55]

The man Homer would credit as most responsible for establishing him in his career was Thomas B. Clarke, a prosperous New York merchant in the dry goods business who was from a well-connected New York family. Clarke was infinitely tied to the South because the success of his business was dependent on the southern black laborers who grew and harvested the cotton for his textiles. In 1890, Clarke retired and established an art gallery. He had begun collecting art in 1872 and eventually owned thirty-seven of

53. Frederick Saunders, ed., *Festival of Song: A Series of Evenings with the Poets*, 149. Homer's contribution to this compilation of poems with commentary was a wood engraving titled "Boyhood's Sports," which shows three boys at play, one leaping over the crouched figure of another. A sketch of a similar subject done when Homer was a child has been identified as one of his earliest childhood drawings.

54. Rainey, *Creating a Picturesque America*, 48, 52; Oliver Bell Bunce, "Table Talk," *Appleton's Journal*, August 27, 1870, 264. Journalist Thomas Bangs Thorpe accompanied Fenn on his trip into the South to initiate the series.

55. Sarah Burns, *Inventing the Modern Artist: Art and Culture in Gilded Age America*, 187–217.

Homer's paintings, including *A Visit from the Old Mistress* and others of his African American genre paintings.[56] Northerner William T. Evans, second only to Clarke as the period's most avid collector of American art, owned *Sunday Morning in Virginia* and later bought *Visit*.[57] Homer's flirtation with southern life lasted only several months during the 1870s after which he went on to establish his reputation with other subjects. Nevertheless, his southern views helped propel him along in a career that would span three more decades.

HOMER IN "OLE VIRGINNY"

Homer appears to have heeded Bunce's advice to go south. He made a trip, or perhaps more than one, to Petersburg, Virginia, and he painted *A Visit from the Old Mistress, Sunday Morning in Virginia,* and other southern genre pictures. Mary Ann Calo compiled information from news reports and Homer biographies to confirm that the trip did occur.[58] But since he left neither a diary nor any letters about his experience, what little is known about the mysterious sojourn, and any fieldwork he may have done while there, comes mainly from speculation or anecdotes. Did he really need to work on location if all he wanted was a shabby cabin interior? Certainly these paintings could have been created in the studio, modeled on the graphic work of Billings, or on paintings by Homer or his contemporaries.

If Homer merely sought the acclaimed cabin of an Aunt Chloe, Petersburg might not have been the best place to search. Located well to the north in the Upper South, Petersburg was never a typical old plantation town. During slavery there had been a sizable population of free blacks, with tobacco factories and cotton mills providing ample work. By the time of his alleged visit, blacks in Petersburg lived relatively comfortable lives and outnumbered whites twelve thousand to ten thousand.[59]

Anecdotes told by Homer's early biographer William H. Downes enhanced the painter's standing as a maverick, a persona suited to his later celebrity as a chronicler of manly seagoing and sporting life. Portrayed as

56. H. Barbara Weinberg, "Thomas B. Clarke: Foremost Patron of American Art from 1872 to 1899," 54–63.

57. William Truettner, "William T. Evans, Collector of American Paintings," 50–79.

58. Calo, "Winslow Homer's Visits to Virginia."

59. Suzanne Lebsock, *The Free Women of Petersburg: Status and Culture in a Southern Town, 1784–1860*, 11; Alrutheus Ambush Taylor, *The Negro in the Reconstruction of Virginia*, 34.

a liberal confronting narrow racial attitudes of white Virginians, Downes recounted an incident in which Homer stared down a name-calling "local fire-eater" who had assailed him as "damned nigger-painter." In response to a "Belle" who asked, "Why don't you paint our lovely girls instead of those dreadful creatures?" Homer reportedly quipped, "Because these are the purtiest."[60] Published in 1911, a year after the artist's death, Downes lionized Homer as a gutsy, taciturn Yankee who bested arrogant rebels.

African American Virginians were reputedly displeased with how Homer depicted them. An 1898 *New York Sun* article reported that local blacks took offense at his studies and complained to the mayor of Petersburg. An artist fantasizing Aunt Chloe's cabin, however, would not want it peopled with the "well-dressed negroes" who residents claimed were plentiful.[61] That Homer's worn-out clothing and dilapidated settings were fabrication is given credence by the remarks of Peter Randolph, a former slave. After his postwar travels throughout the North and the South, Randolph returned to Virginia cities convinced that blacks there were well dressed and had comfortable homes.[62]

Many in the North embraced dual fantasies of the South. The exotic South of moss-draped oaks and plantation ruins was imagined in leisurely visual tours reproduced in periodical prints and advertising art. Meanwhile, the antebellum South was revived in sentimental fictions, rhapsodic songs, and theatrical performances. Stage adaptations of *Uncle Tom's Cabin* glossed over the harshness of slavery to emphasize a romantic story of liberation. Fugitive slave mother Eliza's harrowing escape over the icy Ohio became a high point in the drama and a favorite poster image. Even Tom's death was played as a triumphant apotheosis, with the old slave dying a martyr, joining the angelic little Eva in heaven.

By reuniting Mrs. Shelby with Aunt Chloe, Homer's painting made viewers feel good about the end of slavery, while assuring them that the plantation system persisted. Drawing distinctions in physiques—the mistress standing straight and tall, while the ex-slaves slumped, the mistress wearing fine clothing, while the ex-slaves were dressed in rags—and by

60. William H. Downes, *The Life and Works of Winslow Homer*, 85–86; Goodrich, *Winslow Homer*, 58–59.

61. Calo, "Winslow Homer's Visits to Virginia," 20, from a clipping in the Clarke and Downes Scrapbook, 1889–1902, roll 599, frame 83, Whitney Museum Papers, Archives of American Art, Smithsonian Institution, Washington, D.C.; *New York Sun*, March 12, 1898; Christopher W. Knauff, "Certain Exemplars of Art in America. IV. Elliot Daingerfield: Winslow Homer," 128; McElroy, *Facing History*, 80.

62. Marie Tyler-McGraw and Gregg D. Kimball, *In Bondage and Freedom: Antebellum Black Life in Richmond*, 24–25.

Fig. 4-14. "The Thread that binds the Union North to South."
Advertisement card, Clark's Spool Cotton, *ca.* 1880s. *Collection of the author*

depicting the lowly plantation cabin, *A Visit from the Old Mistress* solidified a lateral hierarchy. The high art of painting joined the commercial print, the blackface performance, and the maudlin ballad to reenvision an Old South way of life (Fig. 4-14). When *Visit* appeared at the National Academy of Design in 1880 an *Art Amateur* reviewer wrote, "In all these negro pictures Mr. Homer shows an involuntary depth of observation and philosophy, making his canvases so many authentic documents."[63] Because his was an oil painting in a prestigious exhibition and he had (allegedly) painted it from observation, Homer's version of the diurnal activities of poor Virginia freedwomen was accepted as truth. A homey scene in the idyllic "ole Virginny" of yore, Homer's unreconstructed slave quarters, where a kindly mistress came to call, proved the past benign and the present stable. Not much had changed in the old Kentucky home.

63. *The Art Amateur*, 112.

CHAPTER 5

Henry Ossawa Tanner's *The Banjo Lesson* and the Iconic Persistence of Uncle Tom

After studying art for two years in Paris, African American painter Henry Ossawa Tanner (1859–1937) returned to the United States in 1893 to convalesce after a bout of cholera and to improve his finances. While staying with his parents in Philadelphia, he painted what may be his best-known work, *The Banjo Lesson,* of an old black man seated behind a young black boy who strikes a chord on a banjo. With so few nineteenth-century figure paintings by African American artists for comparison, Tanner's *The Banjo Lesson* continues to fascinate and charm viewers (Fig. 5-1).

The Banjo Lesson has been the most reproduced of all Tanner's works. It was on the poster and the cover for the catalog authored by Dewey F. Mosby and Darrell Sewell for the Tanner retrospective originating from the Philadelphia Museum in 1991.[1] *The Banjo Lesson* was the likeliest Tanner to be reproduced by photographic slide companies until digitalized presentations virtually made slides obsolete. During the 1980s and the 1990s, when Eurocentric art history survey texts were being revised to make them more inclusive, Tanner's painting was the favored nineteenth-century African American example.

1. Dewey F. Mosby and Darrell Sewell, *Henry Ossawa Tanner.*

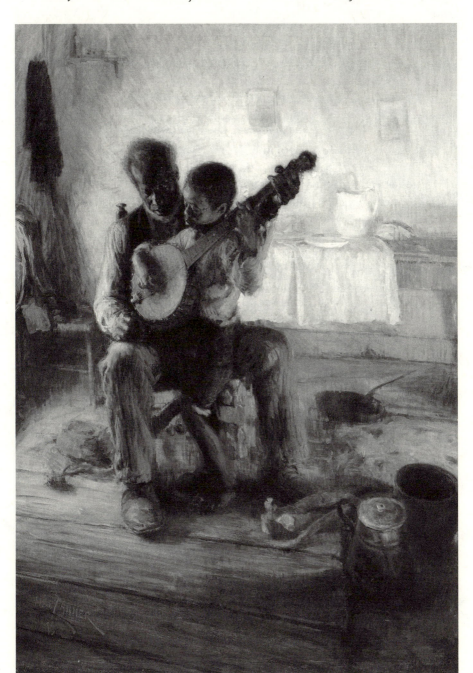

Fig. 5-1. *The Banjo Lesson.* Oil on canvas, 49 x 35 1/2 inches, by Henry Ossawa Tanner, 1893. *Hampton University Museum, Hampton, Virginia*

Scholars valiantly search the painting for signs that Tanner was giving agency to his figures or that his rendition of African American daily life offered an authenticity that those by European American artists lacked. Or was Tanner, like Eastman Johnson, Winslow Homer, and the European American painters before him, just one more striving artist dispensing the humble "darkey" to tempt a wealthy, white patron? Such men did buy *The Banjo Lesson*, as well as *The Thankful Poor*, another genre painting reprising the figures of old man and boy that Homer painted around the same time. His finances were further augmented by an auction of his work that yielded a windfall enough to return the health-restored artist to Paris the next year.

Critical acclaim and financial success came soon after his return to the City of Light in 1894. Tanner's depiction of Christian martyrdom, *The Resurrection of Lazarus*, received a prize at the Paris Salon of 1897 and was purchased by the French government for the Musée du Luxembourg. *Lazarus* established him as a painter of biblical subjects, a category he would favor throughout the rest of his career. A decade later his Christian-themed painting *The Wise and Foolish Virgins* (*ca.* 1907–1907) was in the limelight during another annual Paris exhibition. Back stateside the *Baltimore Sun* touted, "Henry Tanner, An American Negro, May Win This Year's Medal of Honor at the Great Paris Salon." Although the account was ostensibly intended to be a tribute no doubt, the artist later recalled that it was undermined by disrespect. An anonymous black man's photo accompanied the article, as if any "American Negro" would do. Such disregard likely contributed to reasons that the gifted Tanner chose to pursue a career in France.[2]

This chapter will consider how *The Banjo Lesson* compares with other images of African American old men in circulation during the 1890s. Scholars tend to judge Tanner's painting primarily against other oil paintings, but this study will widen the scope to take into consideration nineteenth-century popular imagery in which older male figures abounded. Could it be that a revered fine art painting has something in common with commercial representations of Uncle Tom?

2. Dewey F. Mosby, *Across Continents and Cultures*, 58; Albert Boime, "Henry Ossawa Tanner's Subversion of Genre," 418. My thanks to Dewey Mosby for clarifying the dates of this news article and the Tanner anecdote. The news article was Sterling Heilig, "Henry Tanner, An American Negro, May Win This Years' Medal of Honor at the Great Paris Salon," *Baltimore Sun*, June 14, 1908, 14.

UNCLE TOM AND THE GENRE TRADITION

When Tanner painted *The Banjo Lesson* in 1893, Uncle Tom had been around for forty years. As chapter 1 revealed, Tom was the virile slave father in Hammatt Billings's illustrations for Harriet Beecher Stowe's original editions of *Uncle Tom's Cabin* in 1852 and 1853. Numerous artists illustrated Tom in later book versions and across a range of promotional prints. Tom was crafted in porcelain, in toys, and in an endless array of decorative items; there were even oil paintings based on Stowe's story. In 1853, the year after the novel was published, Robert Scott Duncanson received a commission to paint *Uncle Tom and Little Eva*. And Tom took form on stage as an old man. Actors played the once broad-shouldered father as a bent over, grandfatherly character in numerous Tom shows.

In *The Banjo Lesson,* Tanner's hunched figure sits in a common straight-back chair, his grizzled head nodding like the many Uncle Toms. Granted, this time the youngster is a black boy, not the slaveholder's daughter whom Tom incessantly dotes on in illustrations. Even so, the pair is oddly familiar, as is the setting—a chimney corner in a rustic cabin much like the one in Eastman Johnson's 1863 *The Lord Is My Shepherd* (Fig. 4-8) and in other art renditions.

Slavery ended thirty years before Tanner painted *The Banjo Lesson.* The social and economic climate of the country was quite changed from the antebellum years when genre paintings—views of contemporary life— broached sensitive political topics. *War News from Mexico* (1848), by Richard Caton Woodville of Baltimore, was perhaps the first American painting to touch on the issue of slavery so emphatically. In his composition a black man in a tattered red shirt watches furtively from the sidelines as white men read newspaper accounts about the Mexican War and about the possibility of slavery spreading into California and other states. Albert Boime uses Woodville's painting as an example of how "visually rendered ideas" of artists "inevitably . . . reinforce institutional priorities" via a system of "visually encoding hierarchy and exclusion."[3] The black man, who is seated below the white men on the porch steps of the American Hotel, has no social standing and is excluded from the discussion. He is nevertheless foremost within the picture. The prominence of this slave and his child companion serve as unavoidable reminders that what was at stake in that war about which these white male readers are so preoccupied was whether or not slavery would persist. Woodville's painting was shown at the National Academy of Design in New York. The American Art Union

3. Boime, *Art of Exclusion,* 16.

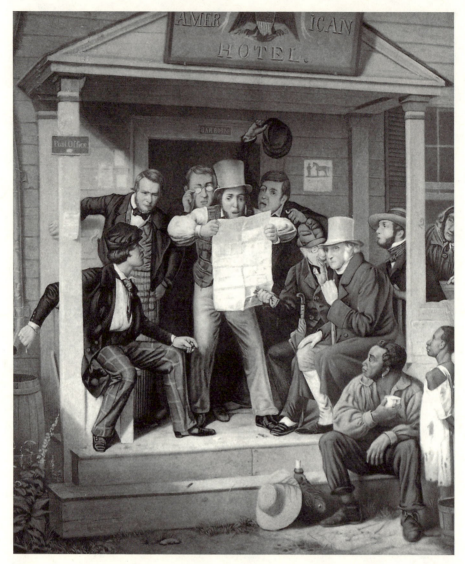

Fig. 5-2. *News from Mexican War Front*, 1851. Hand-colored
engraving, by Alfred Jones after Richard Caton Woodville's
War News from Mexico (1848). *Collection of the author*

acquired the work and made fourteen thousand reproductions for distri-
bution to its members, evidence that it struck a cord with art aficionados.[4]
After gaining their freedom and access to the political process, with
emancipation in 1863 and the passage of the Fifteenth Amendment in 1870,

4. Honour, *From the American Revolution to World War I*, 76, 79.

adult black men all but disappeared from visual culture. As discussed in chapters 3 and 4, paintings of ex-slaves were few after the Civil War. Eastman Johnson, perhaps the best-known painter of African American themes, painted his last in the 1860s. Winslow Homer's oil paintings of Virginia freedmen were composed in the 1870s. Both artists concentrated on women and young people and only rarely included men.[5]

In his study of Tanner's *The Banjo Lesson,* Boime is right in saying that genre paintings were anachronistic by 1893, but he nevertheless sees Tanner's mission as corrective: "[I]n an effort to counter the negative stereotype of the black," by reviving genre he might "transform its original function."[6] The painting, however, offers weak resistance to dominant ideologies of black powerlessness. If anything, the old man's and young boy's earthy clothing and their sparsely furnished home seem a visual paean to poverty. How was this picture different from those painted during slavery? With so few positive renditions of African American men in visual culture it is tempting to seek refuge in the remote outpost of this humble cabin.

THE BANJO-PLUCKING DARKEY

The prominence of a banjo persuades many that Tanner was reclaiming a stereotype that, like genre painting, predates emancipation. "These two individuals were Tanner's direct answer to all the stereotyped images of the 'banjo-plucking darkey' so often seen in the art of that period," wrote Naurice Frank Woods. According to Marcia M. Mathews, writing in 1969, *The Banjo Lesson* "has none of the banality of ordinary genre."[7] Were there some subtle differences between Tanner's banjo player and the plethora of banjo pluckers in the art of others?

White stage performers in blackface had been mimicking plantation slaves as happy-go-lucky, banjo-strumming simpletons for northern audiences since the 1830s. In the early 1850s, with the advent of Tom shows, burlesques of *Uncle Tom's Cabin* were incorporated into blackface theatricals and Uncle Tom joined the pantheon of Jim Crow, Scipio "Zip" Coon, Lucy Long, and other comedic blackface regulars. Increasingly, banjo players made cameo appearances in genre paintings, most famously, in Johnson's

5. See McElroy, *Facing History.*

6. Boime, "Subversion of Genre," 419.

7. Naurice Frank Woods, "Lending Color to Canvas: Henry O. Tanner's African-American Themes," 17; Marcia M. Mathews, *Henry Ossawa Tanner, American Artist,* 37.

Negro Life at the South. As discussed in chapter 4, his rendition of slaves at leisure was so widely thought to be based on *Uncle Tom's Cabin* that after it was shown for the second time it became known as *Old Kentucky Home* (Fig. 3-5). Four years later, in 1863, John Whetten Ehninger painted his *Old Kentucky Home,* which was based on a scene in the story that takes place the night before Tom was to be sold down the river to the slave market. Aunt Chloe, with the master's son George Shelby at her side, watches Uncle Tom happily play a fiddle, accompanied by a younger slave on banjo. The association between banjo playing, seen in both Johnson's and Ehninger's paintings, with slave life as understood from *Uncle Tom's Cabin,* was purely a stage concept, conceived in plantation fictions of the antebellum past and reintroduced in sentimental novels after the war.[8] In Stowe's novel, there was no banjo. On the eve of his departure, Tom read his Bible then later held a prayer meeting for his fellow slaves. After he was sold in New Orleans, his second master, Augustine St. Clare, marveled at the "Methodist hymns" with which Tom delighted his daughter Eva. This important point establishes that the story and the character Tom became known to the public through visual and theatrical representations as much as they did through the written text.

After the Civil War, stage versions of *Uncle Tom's Cabin* grew ever more dependent on the banjo, which was viewed as an authentic slave instrument. Virtuoso banjo playing, always a highlight on the minstrel stage, became an important feature of Tom shows. In 1878, for example, Ford's Opera House boasted "Warren Griffin! The Greatest Living Banjo Player, who was formerly a slave at Milledgeville, Georgia, before the war." Actual black actors, such as Griffin, substantiated claims of authentic slave experience, superceding even the believable fiction of Stowe's account and the later play adaptations.[9]

During the early years of blackface minstrelsy, images of banjo players, made up and costumed as plantation slaves, first appeared on song sheets. By the gay nineties, sheet music, boasting happy slave banjoists, was plentiful in middle-class homes, perched atop pianos in many parlors. On the 1898 song sheet for "Uncle Jasper's Jubilee," for example, illustrator E. T. Paull depicted Uncle Jasper, his head rimmed in white tufts, gleefully kicking up his heels to the music of his younger, banjo-strumming pal. The

8. Francis Pendleton Gaines, *The Southern Plantation: A Study in the Development and Accuracy of a Tradition,* 204. According to Gaines, the banjo was rarely seen on plantations.

9. Robyn Warhol, "'Ain't I de One Everybody Come to See?!' Popular Memories of *Uncle Tom's Cabin,*" 658–60; Birdoff, *World's Greatest Hit,* 235.

old uncle and the younger, slow-witted "Sambo" were the two prevailing stereotypes of rural black males. A shabby cabin and crowing rooster completed the southern vernacular (Fig. 5-3).[10]

"Uncle Jasper's Jubilee" would have been advertised as a "coon song," although most of the songs in this musical category chronicled the antics of uptown swells and not country bumpkins. The song that launched the phenomenon was first called "All Pimps Look Alike to Me" and was written and composed by African American songwriter Ernest Hogan. "Coons" replaced "pimps" in the eventual title. "Uncle Jasper's Jubilee" notwithstanding, coon songs rarely rhapsodized about the old cabin because the "coon" was an updated version of the minstrel character—Zip Coon, an urban dandy. Gaudily adorned, with rough manners, the coon was prone to violence, had a gambling problem, and was known to squander his money, which left him inept as a provider.[11]

Tanner's painting came into being just as the coon song craze was taking over popular music and his "uncle" type had little in common with the city slicker ne'er-do-well. Nevertheless, it is helpful to reflect on the enormity of demeaning caricatures in circulation at the time. The coon functioned as a northern counterpoint to the southern uncle: whereas the uncle was content in his country home, the coon could not assimilate into the big city. Thus, it was implied, the coon should have stayed on the old plantation where he belonged, indirectly justifying the myth of an Old South where blacks found their rightful place.[12]

NOSTALGIA AS IDEOLOGY

A traumatized child will sometimes create a fantasy of an idealized family in an imaginary world as a means of emotional respite. As a result of the rapid breakdown of society from the war, the defeated South devised a similar coping mechanism by inventing a mythology about their prewar social order. The traditions and manners ascribed to those halcyon years were expressed in visual and narrative fictions, adding coherence to what came to be known as the "cult of the Lost Cause." In his study of black memorabilia from the 1880s and beyond, Kenneth W. Goings argued that

10. On "Sambo," see Boskin, *Sambo: The Rise and Demise of an American Jester*; on "uncles" and "coons," see Bogle, *Toms, Coons, Mulattoes, Mammies, and Bucks.*

11. Louis Chude-Sokei, *The Last "Darky": Bert Williams, Black-on-Black Minstrelsy, and the African Diaspora*, 74–75; Allen Woll, *Black Musical Theatre: From "Coontown" to "Dreamgirls,"* 4.

12. Gaines, *The Southern Plantation*, 139.

Fig. 5-3. "Uncle Jasper's Jubilee." Sheet music cover,
by E. T. Paull, 1898. *Collection of the author*

this Lost Cause ideology was spawned from a deep-seated need for psychic comfort: Lost Cause ideology was "a belief that the South had been on the verge of creating a civilization far superior to the one that existed in the North," an idyllic society equated with knightly codes of honor.[13] The term *Lost Cause* was first used in the 1860s by Edward A. Pollard, the editor of the *Richmond Examiner* during the war, to describe the "War of the Confederates."[14] By the 1890s, "the cult of the Lost Cause" had taken on a pseudoreligious zeal, with United Daughters of the Confederacy erecting monuments in courthouse squares to their Confederate ancestors.[15]

Uncle Tom's Cabin, once anathema to southerners, became in image and theatrical revision a repository of nostalgia for the Old South and thus was used to promote the ideology of the Lost Cause. Uncle Tom, along with bossy mammies, angelic southern belles and their handsome suitors, kindly matriarchs, and a whole cast of characters, still known today from plantation novels and the films made about them, played recurring roles to sustain nostalgia for, and an ideology of, the glorious Old South. Goings contended, "An ideology must be constantly created and verified in social life; if it is not it dies." Tom shows, which ran continuously from 1852 to 1931, and regularly thereafter, with their attendant posters, promotional cards, and song sheets kept the ideology alive and had the added benefit of erasing the harsh truth of slavery.[16] Robyn Warhol called this "political amnesia, hiding the fact of slavery in plain sight."[17]

Inherent in the myth of the idyllic Old South was the belief that both blacks and whites had been happier and better off before Yankee interference, before the "War of Northern Aggression." To substantiate this fantasy, ex-slaves who fondly remembered "massa" and "ole miss" were indispensable. Powerful northerners readily acquiesced to the mythology of the Old South for it offered a way to let bygones be bygones with the former foe and, most important, it justified a racial status quo. In the midst of this rampant propaganda, that Tanner took an old black man and gave him any semblance of self-determination probably was a major feat.

Judith Wilson called Tanner's accomplishment an "unprecedented act of black cultural self-assertion."[18] Given the limited range of how a rustic

13. Goings, *Mammy and Uncle Mose,* 9; Eric J. Hobsbawm, "Introduction," 6.

14. Edward A. Pollard, *The Lost Cause: A New Southern History of the War of the Confederates,* iii; Rollin G. Osterweis, *The Myth of the Lost Cause,* 11.

15. C. Vann Woodward, *Origins of the New South, 1877–1913,* 155–58.

16. Goings, *Mammy and Uncle Mose,* 9; William L. Van Deburg, *Slavery and Race in American Popular Culture,* 47; Loften Mitchell, *Black Drama: The Story of the American Negro in the Theater,* 32–33.

17. Warhol, "'Ain't I de One Everybody Come to See?!'" 662.

18. Judith Wilson, "Lifting the 'Veil': Henry O. Tanner's 'The Banjo Lesson' and 'The Thankful Poor." 203–4, 200.

African American male could be represented in the 1890s, perhaps she was right. Yet, by accepting the conventions of white-authored representation, what Wilson termed "allegiance to accepted pictorial codes," Tanner faced the same problem that Ernest Hogan did when he tried to write popular music and that Bert Williams encountered when he sought theatrical work. Williams, a West Indian immigrant and talented stage performer, was expected to don blackface and act out the comic or pathetic darkey in "coon songs" of the kind that Hogan had to pen if he was to earn his livelihood in music.[19] How could a creative African American build his own house if all he had were the master's blueprints?

TANNER'S BACKGROUND

Assuming that Tanner wanted to be assertive and contest white-authored definitions of African American men, the very fact that he became an artist was already an incursion into the domain of Eurocentric culture. As a child of twelve or thirteen, he had seen "a real, live artist" painting in the city park. After watching him for about an hour, Tanner decided to become an artist.[20] Tanner's parents were comparatively well-off church people, who had settled in Philadelphia when he was nine. His father, Benjamin Tucker Tanner, had been elected a bishop of the African Methodist Episcopalian church in 1888,[21] and his mother, Sarah Elizabeth Miller Tanner, was involved in missionary activities. Tanner's siblings were educated and highly accomplished and their home was a gathering place for Philadelphia's black intellectuals.

Having been somewhat delicate as a child, Tanner's parents approved of his career choice, because it was clear that strenuous employment would not be a viable option. A succession of amateur artists provided him with private instruction. Off and on from 1879 to 1885, he studied under Thomas Eakins at the Pennsylvania Academy of Fine Arts. Eventually, Tanner went to Paris, where he worked with Jean-Joseph Benjamin-Constant and Jean-Paul Laurens. There he became a member of the American Art Students Club, which led to his making the acquaintance of Lewis Rodman Wanamaker, the son of John Wanamaker, the Philadelphia department store founder and head of the firm's Paris branch. This connection proved fortuitous, with Wanamaker later providing the funds for hometown artist

19. Bogle, *Toms, Coons, Mulattoes, Mammies, and Bucks,* 25; Chude-Sokei, *The Last "Darky,"* 74–75.
20. Henry Ossawa Tanner, "The Story of an Artist's Life," 11662.
21. Rae Alexander-Minter, "The Tanner Family: A Grandniece's Chronicle," 28.

Tanner to travel to the Far East and to the Holy Land. Wanamaker likely introduced him to other wealthy Philadelphians. Through his connection to Wanamaker, he acquired two patrons, one of whom purchased *The Banjo Lesson* and the second *The Thankful Poor,* his other African American genre painting with a similar pair of old man and young boy.[22]

TRADE CARDS: THE NEW GENRE PAINTINGS

The caricatures of black people in wide circulation at the time, the kind of depictions that African American artist Romare Bearden and his coauthor Harry Henderson have claimed Tanner was trying to refute, were likely to be found on trade cards.[23] The folksy types with their anecdotal schemes that once inhabited genre paintings were ready-made for the colorful advertising cards that lithographers provided manufacturers to promote all manner of consumer goods and services. Common since the 1850s, trade cards were at the peak of popularity by the 1880s when new printmaking technology made it possible to use bright-colored inks, embossed textures, and gilding. The cards were distributed in stores or included with products and were visual entertainment, collected and mounted into scrapbooks for parlor enjoyment.[24] Trade cards were designed to attract prospective middle-class buyers. On them, scenes of daily life, some laced with puerile humor, exploited the social aspirations of white consumers by providing them with happy servants. They also inscribed distinct notions of race and ethnicity and social hierarchy. It was no accident that the word *stereotype* was a printer's term for the stock cuts used in early advertisements. It was in print media that America became acquainted with the thrifty Scot, the beer-drinking German, the organ-grinding, fruit-selling Italian, and, of course, the overbearing mammy and servile uncle, among others.[25]

The 1890s saw the debut of African American spokesfigures such as Aunt Jemima, Rastus the Cream of Wheat Chef, and the Gold Dust Twins. These recognizable characters joined the many generic mammies and uncles already in print.[26] Advertisers were as reluctant to show adult African

22. Mosby and Sewell, *Henry Ossawa Tanner,* 36, 90.

23. Romare Bearden and Harry Henderson, *Six Black Masters of American Art,* 49.

24. Robert Jay, *The Trade Card in Nineteenth-Century America,* 3.

25. Jo-Ann Morgan, "Mammy the Huckster: Selling the Old South for the New Century."

26. Marilyn Kern-Foxworth, *Aunt Jemima, Uncle Ben, and Rastus: Blacks in Advertising, Yesterday, Today, and Tomorrow.*

American men as the heads of households as other artists had been. Their reliance on old uncles for sales campaigns made for some strange encounters. The old man with a young child on his lap on a card for Ayer's Cathartic Pills (Fig. 5-4) was the forerunner to Tanner's *The Banjo Lesson*. By his chair a young boy kneels next to an open box containing the pills. "The country doctor," reads the caption, is in his dotage yet still he ministers to sick children. In an 1883 advertisement for Merrick's Thread, another old geezer mends a pair of pants, a chore usually relegated to women. "Gully, this cotton beats 'em all!" he proclaims. Old black men were used to sell everything from stove polish to sewing machines.

Just how sweeping an impact the picture cards made on the general public is attested by a remark Booker T. Washington made in his 1901 autobiography *Up from Slavery*. Describing the abject poverty of rural Alabama blacks, whom he had surveyed during his first Christmas season at Tuskegee, he observed "the people had gotten hold of some bright-coloured cards that had been designed for advertising purposes, and were making the most of those" as their way of celebrating.[27] In the cruelest irony, these poor folks—some, he noted, had but one spoon to share between them—found their holiday cheer supplied by eye-catching pictures on trade cards that degraded black people. Humorous pictures chronicled an African American world where no father tread, where mothers were the "mammies" that worked in white kitchens, and where black babies were pursued by alligators and black children could be scrubbed white with new cleansers.[28]

THE UNCLE

When companies relied on images of African Americans to sell consumer products they were promoting ideology with commerce. As they solicited whites, African American spokesfigures sustained the illusion that black people were perpetually content as subordinates. After the Civil War, the northern corporate interests depended on pictures of loyal, smiling former slaves to assuage their fears of any lingering resentment. Propaganda—such as, the cotton picked in the South by former slaves was "the thread that binds the country North to South"—stressed stability by inscribing hierarchy (Fig. 4-14). As a symbol of continuity, Uncle Tom was no coincidence.

Uncle characters thrived in American culture long before Stowe immortalized Uncle Tom.[29] In John Pendleton Kennedy's *Swallow Barn* of

27. Washington, with Thrasher, *Up from Slavery*, 65.
28. *Ethnic Images in Advertising; Ethnic Notions.*
29. William R. Taylor, *Cavalier and Yankee: The Old South and American National Character*, 300–310.

Fig. 5-4. Trade card, Ayer's Cathartic Pills. *Collection of the author*

1832, considered the precursor of the plantation tradition, "His name was Scipio, and his face, which was principally made up of a pair of lips hanging below a pair of nostrils, was well set off with a head of silver wool that bespoke a volume of gravity." Set in Virginia in a time when many of the old estates had been "cut up" and people had "gone over the mountain," this wistful old slave expressed nostalgia for the past.[30]

Perhaps the best-known uncle before Tom was the popular Uncle Ned who debuted in 1848 in a minstrel song by Stephen Foster. "Old Uncle Ned" sounded an elegy to a favored slave. The occasion of Uncle Ned's death validated the sentimental nature of slaveholders.

> When Uncle Ned died Massa took it berry bad,
> Tears dey run down like de rain.
> Old Missus turn pale and she gits berry sad,
> 'Cause she neber see Uncle Ned again.

> Chorus:

> So lay down de shovel and de hoe,
> And hang up de fiddle and de bow.
> No more hard work for poor old Ned,
> He's gone where de good darkeys go.

My, how wonderful "Massa" and "Missus" must be to show so such sadness at the death of an old slave, tolled the lyrics.

Foster's ballad became ingrained into people's consciousness, and by the time that Stowe's Uncle Tom took his place in the fraternity of "good darkeys," the pathos of "Old Uncle Ned" had only been swelling hearts of listeners for four years. Sentimental songs of longing for the antebellum past proliferated after the war, coterminous with ideologies of southern redemption and Lost Cause justification. Foster's plantation melodies remained in repertoires, and "Uncle Ned," like "Uncle Tom," became a sobriquet for old black men. Winslow Homer's 1875 painting of an old black man in front of a chicken coop titled *Uncle Ned at Home* was among the few to immediately find a patron. Homer once referred to his "darkey" pictures, a fairly common reference that was also used in catalog descriptions of his paintings. Thomas B. Clarke bought *Uncle Ned* from Homer in

30. John Pendleton Kennedy, *Swallow Barn; or, A Sojourn in the Old Dominion,* 18, 11,12.

his studio for $215 in 1879.[31] The name of "poor old Ned" was still thriving in 1893 when Tanner's *The Banjo Lesson* was displayed at James S. Earle and Sons Gallery in Philadelphia. A newspaper review called Tanner's work "[a]n old Uncle Ned, bald and venerable."[32]

An "uncle" had been an inspired choice through whom Stowe challenged the very patriarchy that Uncle Ned, Scipio, and others before Tom had unwittingly endorsed. Stowe used the qualities of loyalty and devotion to a master, which were presumed of slave uncles, to advocate an allegiance to the doctrine of Christian love. With one brilliant stroke, her black hero persuasively advanced a less patriarchal evangelical Christianity, one where slaves and women had an exalted place with the Lord. Tom espoused the higher purpose of eternal commitment to a God in heaven and, incidentally, spurred readers along in the cause of abolitionism. Unfortunately, by Tanner's time a fawning, old-regime defender of Lost Cause mythology had replaced Stowe's morally principled uncle across all the arts.

Adult male slaves had been powerful propaganda tools for the Union during the Civil War. Engravings in *Harper's Weekly* featured runaway slaves as soldiers (Fig. 1-24) or as family men, leading others out of bondage. In postwar periodicals, male ex-slaves became either old men with fond memories of slavery or disappeared from newsprint altogether. In a perverse turnabout from the stock cut of the sprightly runaway once used to post rewards for escaped slaves, song covers in the 1870s witnessed a wave of enfeebled ex-slaves skulking back to "The Dear Old Home We Loved So Well." A satchel flung over his shoulder, one sang "I'se Gwine Back to Dixie," while "Old Uncle Dan," aided by a cane, hobbled through the gate to his old homestead in a tautology of aging black men forgetful of any aspirations for inclusion that Reconstruction may have once instilled (Fig. 5-5). As North and South formed new social, economic, and political alliances, African American concerns faded from public debate. Adult black men had fought valiantly for the Union, but when the war was over, they became an abandoned generation, defrauded by empty promises of "forty acres and a mule." They were the heirs to a reinstated southern regime that

31. Goodrich, *Winslow Homer*, 105. The catalog listing for Homer's *Visit to the Mistress* read, "In a low-toned interior stands a lady, while three negro women are talking to her. One of these holds a child, and a third, an old mammy, is seated before the fireplace. The artist has depicted the peculiarities of the black race, in clothes, movement, and manners. The central figure of the darkey by the door is full of expression, and all maintain a respectful demeanor before the mistress of the house" (*Catalogue of the Private Art Collection of Thomas B. Clarke* [New York: 1899]).

32. Mosby and Sewell, *Henry Ossawa Tanner*, 118.

Fig. 5-5. The longing for the Old South witnessed on sheet music covers in the 1870s persisted, as can be seen on this "coon song" cover from the 1890s.

offered little more than the tawdry circumstances of their former bondage. Artists averted their eyes or pretended all was well in an imaginary world spawned by minstrel stage antics and romantic plantation fictions.

Considering the unanimity of old uncles and the absence of able-bodied males, husbands, and fathers in pictures after emancipation, Tanner had reason to believe the image of African American manhood needed redemption. This nevertheless begs the question, why not an adult male? Why a grandfatherly "uncle" instead of a father?

BOYS AND GEEZERS

Tanner's *The Banjo Lesson* presents not merely another uncle but a particular configuration of old man and young boy. For decades, genre paintings had lured the white northern businessman to American art by giving him an accessible means of valuing it. The formula of old and young was one such easily understood message: "The more things change the more things stay the same."

American genre paintings of the antebellum years were imbued with democratic ideals that valued the common citizen, *his* family, and *his* pursuits. A political subtext was inseparable from the usually folksy or humorous narratives of the pictures. Francis W. Edmonds (1806–1863), who was a New York banker before he achieved modest success as a painter, was by profession from a class that bought art. His own genre paintings, juxtaposing old and young in anecdotal situations, were the kind of status quo-affirming pictures he might have purchased himself. Edmonds used this formula in *The Bashful Cousin* (*ca.* 1841–1842) to comment on courtship. In this work (Fig. 5-6), an older man and his wife sit at a table while their daughter pursues her reluctant suitor to the front door. Boorish Dad slurps from his saucer, impervious to Mom tugging at his sleeve because his daughter's social aspirations are off to a rocky start, given her beau's lack of initiative. Promoting enculturation was the responsiblity of the middle-class woman and both mother and daughter were on the job. In genre paintings such as Edmonds's, old balances young, performing important social rituals that reinforced hierarchy, sustained social place, and fortified a concept of nation. A black female servant is so obscure, standing in the doorway to the kitchen behind the dining room where the white people are interacting, that she almost goes unnoticed.

In another example, a Richard Caton Woodville painting, *Old '76 and Young '48* (1849), heralds an old/young theme. The "old" veteran from the revolution of 1776 is engaged in debate with the "young" soldier of the

Fig. 5-6. *The Bashful Cousin*. Oil on canvas, 25 x 30, by Francis W. Edmonds, *ca.* 1842. *National Gallery of Art, Washington, D.C. Gift of Frederick Sturges Jr.*

Mexican War of 1848. Here again, black servants cluster in the background, outside the main room in a dark doorway, excluded from a discussion about this war that could greatly affect the future of slavery (Fig. 5-7).

It is highly unlikely that Tanner was motivated to sustain social hierarchy during that decade Rayford Logan would look back on as "the nadir" in African American history.[33] *The Banjo Lesson* was painted three years before the United States Supreme Court handed down its decision in *Plessy v. Ferguson*, making "separate but equal" the law of the land in an era of accelerating oppression. Yet here he was using the same old/young formula that genre painters had used to attract wealthy white patrons. As had genre paintings in the past, Tanner's work sold: *The Banjo Lesson* was purchased by Robert C. Ogden, a partner in the Wanamaker company; and

33. Rayford W. Logan, *The Negro in American Life and Thought: The Nadir, 1877–1901*.

Fig. 5-7. *Old '76 and Young '48.* Oil on canvas, 21 x 26 7/8 inches, by Richard Caton Woodville, 1849. *Walters Art Museum, Baltimore, Maryland*

John T. Morris, another local philanthropist, bought *The Thankful Poor.* Tanner's work gained the attention of Harrison S. Morris, the managing director of the Pennsylvania Academy of the Fine Arts, who was instrumental in securing future opportunities for the artist.[34] Perhaps it was his depictions of a beloved old uncle and a young boy that had attracted these rich northern patrons.

Ex-slaves flourished in popular imagery, on the stage, and in plantation fiction, selling nostalgia for the Old South and its ideology of racial hierarchy for the new century. Hackneyed popular versions of boys and geezers filled the void left by the demise of genre paintings. Survivors of slavery were partnered with youngsters in prints that chided their efforts at self-betterment. For example, in a William Ludlow Sheppard illustration for *Appleton's Journal* (July 23, 1870), "Beginning at the Beginning," a young man reads easily; but in the companion print, "Beginning at the End," his aged counterpart—alas, another "old uncle Ned" said the text—struggles

34. Mosby and Sewell, *Henry Ossawa Tanner,* 124.

awkwardly to hold the book (Fig. 5-8). Uncle Ned scratches his graying head in confusion, and even his feet seem befuddled: one shoe is on, the other off, and his feet curl up to rub each other. The boy points to words and sounds them aloud. He is barefoot and sits on the earth among sprouting weeds. Here was visual propaganda of continuity: confused old coots mired in the past, youngsters learning in the present, but still in the same old quarters. Freed people were stationary, ready to "slave away" in the South. The future, these formulaic scenarios implied, would be much like the past.

To return to an example cited in chapter 4, Homer had also implemented the old/young formula in his *Sunday Morning in Virginia* from 1877 (Fig. 4-6). The old black woman in this painting gazes vaguely into the distance as a gathering of children huddle around a younger woman holding a Bible. Since Homer had spent his early career as an illustrator, creating prints for books and the weeklies, he understood how to craft an image with wide appeal. Tanner was acquainted with Homer's work, and he referred to him as a "great marine painter" in 1909. *The Banjo Lesson* is in this old/young tradition and it is feasible that Homer's genre work motivated Tanner's resolution.

The Banjo Lesson could also have been inspired by the old/young formula of a small watercolor Thomas Eakins made in 1878. In *Negro Boy Dancing* (Fig. 5-9) a seated youth strums a tune for a young barefoot dancer. Behind them, a thin, willowy, and slightly stoop-shouldered older man leans on the chair back for support. Obviously a tiny watercolor is a far cry from a large oil painting, however, by 1879 Tanner was registered as a student at the Pennsylvania Academy of Fine Arts when Eakins was at the helm, so he may have seen the little picture. Not to be overlooked, in a tiny oval portrait that is barely discernable in the upper left corner of the painting, Eakins rendered Abraham Lincoln posed with a child on his lap, presaging Tanner's exact coupling of man and boy in *The Banjo Lesson*.

Closer in time and nearly identical in pose to Tanner's *The Banjo Lesson* is Thomas Hovenden's oil painting *"I's So Happy!"* of 1885. This old "uncle," with a bemused smile, sits, knees apart, banjo at the exact slant Tanner's would follow eight years later. Hovenden assumed the leadership of the Pennsylvania Academy in 1886 following Eakins's dismissal, and Tanner knew Hovenden. The two had shown paintings together at James S. Earle and Sons Gallery in Philadelphia in 1894.[35] The resemblance between Hovenden's composition and Tanner's is apparent. Trace Hovenden's banjo player and lay the transparency over Tanner's and they nearly meld. Under the flattering guise of imitation, Tanner may have been refuting his white

35. Ibid., 92.

" BEGINNING AT THE END." " BEGINNING AT THE BEGINNING."

Fig. 5-8. "Beginning at the End, Beginning at the End" from *Appleton's Journal* (1870). Wood engraving, by William Ludlow Sheppard.

colleague, wrenching dignity from the maw of sentimentality. Gone from his banjo player are the silly grin, the frontality, and the fractured speech of the title.

Linda Nochlin wrote of "a presence that is always an absence" in reference to an implied European viewer of Orientalist paintings: the Western artist as recorder invades the cloistered world of an Eastern harem with his European gaze to represent exotic women as objects for white male delectation. European American artists Johnson, Homer, and Hovenden directed a similar magisterial presence. Accustomed to being entertained by actors on the minstrel stage, any representation of urban black life or rural southern scenes was presumed to be for the pleasure of white viewers.[36]

Tanner, at least, did not succumb to pandering.[37] Even though he retraced a familiar iconology, his *The Banjo Lesson* was a private affair. His elder man

36. Linda Nochlin, "The Imaginary Orient," 122; Honour, *From the American Revolution to World War I,* 93.

37. Boime notes that Tanner portrays the scene as self-contained, "seemingly unaware of the spectator" (*Art of Exclusion,* 101).

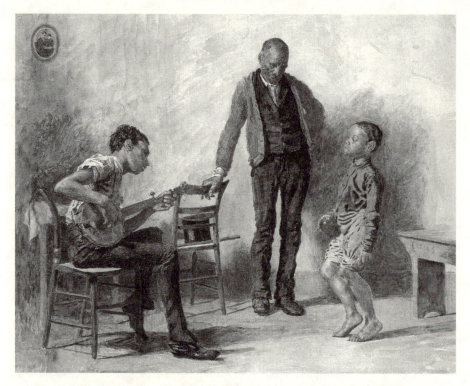

Fig. 5-9. *Negro Boy Dancing.* Watercolor, 18 1/8 x 22 5/8 inches, by Thomas Eakins, 1878. *The Metropolitan Museum of Art, New York, Fletcher Fund*

and youngster did not grimace and grunt for the amusements of whites but shared a task together, mature arms encircling youthful ones: no mugging for the viewer, no goofy dialects—"I's So Happy" indeed. The old man might have lacked the alertness with which youth anointed the boy, yet his earnest attention conveyed a message of family-based self-determination. The white man's "uncle" was at home in his own humble castle, where he was patriarch or, at least, head of his tiny household for a change.[38]

A similar Hovenden painting of 1882 shamelessly promoted nostalgia as ideology: in this work, a ragged old man has just set aside his banjo to beam complaisantly at the viewer. The title of the painting echoed the old man's thoughts of the past: *"Dem Was Good Ole Times."*

A fascinating photograph, which was published in the Mosby and Sewell catalog, recently came to public notice when Judith Wilson contacted Tanner's great-niece Rae Alexander-Minter. In it a gray-haired African

38. Mosby, *Across Continents*, 31–32.

American man and an eager barefoot boy pose, facing forward, in a studio setting. These people were, evidently, Tanner's models for *The Banjo Lesson*.[39] At first it was assumed that Tanner made the photograph during a brief visit to North Carolina in 1889, but the stretched canvas peeking out from behind the boy indicates that the shot was made in the artist's studio.[40] That Tanner took time to compose the subjects suggests that he had a patron in mind or even a commission already secured. Had Homer's *Sunday Morning in Virginia* become Tanner's Sunday afternoon in North Carolina?

UNCLE TOM AND LITTLE EVA

It is a fair assumption that Tanner was aware of Uncle Tom's iconic presence, so ubiquitous was his personage by the 1890s. Tom was even at the World's Columbian Exposition held in Chicago, where Tanner presented a paper entitled "The American Negro in Art."[41] There, on August 25, 1893, at an event billed as "Colored People's Day," Frederick Douglass spoke at Festival Hall, Paul Dunbar delivered a poem, the Fisk Jubilee Singers sang, and selections were performed from Will M. Cook's operatic *Uncle Tom's Cabin*.[42] The fair had "Tom's Original Cabin" on display.[43]

In images where he was partnered with Eva, Tom's portrayal especially served evolving social and political agendas.[44] The early Billings illustrations, addressed in chapter 1, had an undercurrent of taboo, with golden-haired Eva cozying up to the dark, broad-shouldered slave. Perhaps readers were titillated by the interracial intimacy but reassured by Tom's subtle containment as authority accrued to whiteness. When Billings embarked on the 127 cuts for that Christmas gift book, the "large, broad-chested, powerfully-made man" embodied Stowe's defiance of patriarchy.[45] Tom was a model Christian and surrogate father; Tom read a Bible, acted as Eva's confidant, and ministered to slaves and others.

In images by later artists Tom was older and increasingly illiterate, all of his potentially subversive prospects tamed. As a twosome, Tom and Eva

39. Photo reproduced in Mosby and Sewell, *Henry Ossawa Tanner,* 116.
40. Ibid., 119.
41. Ibid., 38.
42. David F. Burg, *Chicago's White City of 1893,* 210; Rossiter Johnson, ed., *A History of the World's Columbian Exposition,* 1:430.
43. Wood, *Blind Memory,* 197; Birdoff, *World's Greatest Hit,* 329; Gossett, *"Uncle Tom's Cabin" and American Culture,* 286; Daniel B. Corley, *A Visit to Uncle Tom's Cabin,* 3.
44. Turner, *Ceramic Uncles and Celluloid Mammies,* 69–88.
45. Stowe, *Uncle Tom's Cabin* (Boston: Jewett, 1852), 68.

were perennial favorites of illustrators. Reading together under the arbor, blissfully ensconced on a plantation redolent in the ambiance of a good master, they evoked an imaginary past. When there was a Bible in the illustration, Eva now read it. Tom puzzled over marks on a little chalkboard. A shell of his former self, slumped over or kneeling, Tom hovered low in the hierarchy of a benign regime, confirming an ideology of white supremacy with forgiveness that pleased North and South alike.

By Tanner's time, kindly, dim old Tom and spritelike, ethereal Eva were the most frequent characters found on covers of children's editions of *Uncle Tom's Cabin,* for whom abridged, illustrated versions were continually being designed. Eva redeemed southern white people. Her complete goodness was proof that the so-called aristocracy celebrated in Old South idolatry was indeed noble-minded. *Uncle Tom's Cabin* became less a jeremiad about a slave's humanity and more a commemoration of Lost Cause idealism. As Tom faded into decrepitude, Eva blazed as the star of the stage shows where her ascent into heaven signaled the final curtain.

Were there not so many Toms and Evas throughout turn-of-the-century popular culture it might be possible to ignore their iconic correspondence with the two in *The Banjo Lesson.* By the mid-1890s *Uncle Tom's Cabin* was the book most frequently checked out of the New York Public Library.[46] Imagined in silhouette, Tanner's active youngster and patient old man echo Stowe's enduring couple.

TEACHING PICTURES

The contention that Tanner chose a banjo as a conduit for passing on important cultural knowledge is suspect. Originally crafted by slaves using a hollowed-out gourd, the *bonja* or *banjar* may have been a way around slaveholder prohibitions against drum playing. As such, the instrument was an important tool for slave communication and for establishing community. The banjo became known in the North when white minstrel performers in blackface appropriated their invention.[47] Billy Whitlock, one of four original Virginia Minstrels of the 1830s, was such a banjo virtuoso that it became integral in minstrel shows from then on.[48] As the instrument most associated with blackface minstrel shows, and the song covers, playbills, and caricatures that promoted them, the banjo became the ultimate "master's tool" for impersonating blacks.

46. Gossett, *"Uncle Tom's Cabin" and American Culture,* 339.
47. Marian Hannah Winter, "Juba and American Minstrelsy," 224; Cecelia Conway, *African Banjo Echoes in Appalachia: A Study of Folk Traditions,* 55–63.
48. Hans Nathan, "The Performance of the Virginia Minstrels," 40.

Perhaps Tanner was knowledgeable about the role the banjo had played in slave history. Living in a fashionable northern city he may have known that the banjo had entered the middle-class parlor as a leisure pastime of marriageable young women looking to add to their accomplishments. Fellow Philadelphian Mary Cassatt, also a transplant to Paris, painted women and children playing the instrument. A mural she painted for the 1893 Chicago World's Columbian Exposition included stylish women gaily dancing to banjo music.[49] Tanner's work was at that fair and he likely knew of Cassatt's painted treatment of the banjo. Still, it seems unlikely that the educated, socially aware artist would expect that the instrument in the hands of a poor black man would be understood by a white, northern art audience for anything other than its contemporary connections with entertainment or as a testament to an Old South way of life.

The banjo of the 1890s was not the banjo of the Old South. Once associated with rural, self-taught players, the banjo was increasingly the choice of professional, trained musicians. The career of African American musician Horace Weston offers one example of how mainstream perceptions about the instrument were changing. After serving in the Union army during the Civil War, Weston joined Buckley's Minstrels and then in 1867 the Georgia Colored Minstrels, another major company. By the mid-1870s he was a well-known stage performer. He achieved national prominence in a production of *Uncle Tom's Cabin,* and he even toured Europe with the show. In the 1880s, the Stewart Company hired him to endorse their manufactured banjo. Stewart ads featured "Mr. and Mrs. Horace Weston," tastefully dressed in dark clothes, "as they appeared with Uncle Tom's Cabin Company."[50] The ads presented Weston as the professional musician he was, instead of the old plantation slave he performed in the Tom show. If Tanner had intended to convey dignity on a banjo player, Weston's example would have made a fine choice.

Tanner would also have been more convincing if he had accorded the man respect as a teacher. Given the overabundance of dumbfounded old codgers in late nineteenth-century visual culture, if Tanner's older man were truly transmitting knowledge, as art historians contend, that would be a significant breakthrough. As Guy McElroy argues in his study of African American representation, "images of men teaching were not at all common in the American genre tradition."[51] In popular images black men were practically never shown passing on wisdom. On a fin de siècle linen

49. Leo G. Mazow, ed., *Picturing the Banjo,* 20–25.

50. Philip F. Gura and James Bollman, *America's Instrument: The Banjo in the Nineteenth Century,* 152–60.

51. McElroy, *Facing History,* 102.

postcard with the caption "Grand-Pap Embarrassed" (Fig. 5-10), an older black man, barely literate, scratching his white-haired head, appears stumped by a simple word on a child's blackboard as his granddaughter looks at him with pity. There were no grandfatherly teacher/role models for black children in popular imagery. African American elders were not wise but foolish, not teachers but remedial learners. Even Uncle Tom and little Eva had reversed roles. Eva was an "old soul," destined for imminent saintliness, a prescient speaker of the word. With the exception of the Billings's drawings, Tom was under the girl's tutelage.

If Tanner intended to portray the young man as receiving a lesson, why not give the teacher more confidence? His Pennsylvania Academy training offered ample instruction in European traditions of using visual language to communicate authority. Perusing the vast resources at the Louvre when he was in Paris, he would have seen classical examples of authority figures such as the various sculptures of Apollo and of Caesars with their heads high, hands raised in gestures of command. There were portraits in the grand manner: standing figures that were meant to be viewed from a low vantage point, requiring a viewer to behold them from a position of obeisance. Even American art was rich with portrait subjects upon whose foreheads blasts of light beaconed enlightenment. With none of these tried and true maneuvers even attempted on the old man's behalf, could it be that here was not a wise grandfather passing on cultural knowledge to the fledgling child but perhaps another scenario? Could the boy be teaching the old man?

The Banjo Lesson was the second in a series that has been called Tanner's "teaching pictures."[52] In *The Bagpipe Lesson,* probably completed before he left Paris, a puffy-cheeked boy plays the bagpipe for a fatherly man and an even older figure in the shadows. *The Young Sabot Maker* (Fig. 5-11) was made in 1895 after Tanner had returned to France. Whether bagpipe, banjo, or shoes (*sabot* is French for "shoe"), the boys perform the demonstration. The sabot maker is especially dynamic, charging forward into his task, wood chips flown about, as his older companion all but disappears into the shaded darkness. In all three cases, the older figures are subdued, overwhelmed by the exuberance of youthful initiates, behind whom they stand or sit.

Scholars concur that *The Banjo Lesson* involves instruction. In what was probably its first critique, the reviewer who described "An old Uncle Ned, bald and venerable" for Philadelphia's *Daily Evening Telegraph* in 1893 also wrote, he "is earnestly instructing the youngster how to finger the strings of an ancient banjo." The perception held. *The Banjo Lesson* "portrays the

52. Mosby and Sewell, *Henry Ossawa Tanner,* 90.

Fig. 5-10. "Grand-Pap Embarrassed." Postcard.
(Copyright N. Brook.) *Collection of the author*

transmission of black America's musical heritage from one generation to another with dignity," maintain Bearden and Henderson. Lynda Hartigan refers to "heritage transmitted from generation to generation."[53] Boime perceives a "transmission of knowledge," the imparting of experience to a "younger generation," and Mosby terms the painting as manifesting "age-instructing-youth theme."[54] That verdict has been unanimous. Granted, an exchange appears to be taking place, but could not a font of revelation be flowing in the other direction? Perhaps Tanner came up with just this solution in an attempt to rectify a bad situation—to redeem the degraded "uncle." Perhaps youth instructs the aged.

HOPE

The Banjo Lesson recalls the intimacy of Tom and Eva, and at first glance it may seem that the older figure orchestrates a lesson. But, just as Eva's story had long ago upstaged Tom's, the key to understanding Tanner's

53. Lynda Roscoe Hartigan, *Sharing Traditions: Five Black Artists in Nineteenth Century America,* 104.
54. Boime, *Art of Exclusion,* 101; Mosby, *Across Continents,* 31.

Fig. 5-11. *The Young Sabot Maker.* Oil on canvas, 41 x 35 inches, by Henry Ossawa Tanner, 1895. *The Nelson-Atkins Museum of Art, Kansas City, Missouri. Purchase: the George H. and Elizabeth O. Davis Fund and partial gift of an anonymous donor, 95–22. Photograph by Jamison Miller*

accomplishment lies in his rendering of the boy. A close look at Tanner's handling of gesture reveals nuances that promote the boy as the activist. The boy is physically engaged, standing, energizing the instrument with moving hands and fingers. He tilts his head, cognizant of his own efforts. The old man offers support, framing the boy with his body, bending his head solemnly forward—motionless, receptive. His eyes close as he listens, harkening to a sound issuing from progeny. What a difference this is from old ex-slaves musing on good old Dixie.

The reversed roles are readable in the visual language of the picture. Tanner was adept at using light and dark values for emphasis, indebted to his teacher Thomas Eakins for what Mosby has termed a "commonality of pose and light."[55] When Tanner was at the academy during the early 1880s, Eakins had already completed major works dependent on dramatic chiaroscuro. In his renowned *The Gross Clinic* of 1875, light bathes the forehead and hand of the surgeon Dr. Gross, the central figure showcased within a cavernous, dark lecture hall full of aspiring doctors. The viewer understands that here is a gifted thinker/teacher and a skilled crafts-man/surgeon. Eakins amplified light and dark in symbolic ways, offering Tanner a possible solution for how to infuse his boy with intellect and dexterity.

By lighting the upper forehead of the boy, as if a spark of insight emanates from within, Tanner applied conventions from another category of art: portraiture. Gilbert Stuart's portraits of George Washington and Thomas Jefferson are in this mode. Tanner was no stranger to the technique. His portraits of people whose intelligence, or thoughtfulness, he would have esteemed share a "commonality of pose and light" with the likenesses of high-status white Americans. In 1897 he painted his father, Bishop Benjamin Tucker Tanner, as a scholarly theologian, head inclined slightly, forehead aglow (Fig. 5-12).

His mother, Sarah Elizabeth Miller Tanner, is similarly cast in a three-quarter pose with her head at a slant and her eyes thoughtful (Fig. 5-13). A second portrait of his mother, *Portrait of the Artist's Mother*, also painted in 1897, deviates just enough from James Abbott McNeill Whistler's maternal study—Whistler was Tanner's obvious mentor—to be persuasive testimony that Tanner intends that she seem contemplative: head on hand, her gaze extending into the far left distance, she recalls the sculpture *The Thinker* of Auguste Rodin. Her face and hand shine in a bright golden light while the background recedes into sepia haze.[56] Her pose is relaxed and her

55. Mosby and Sewell, *Henry Ossawa Tanner,* 114.
56. Mosby, *Across Continents,* 42.

Fig. 5-12. "Bishop Benjamin Tucker Tanner." Oil on canvas, 16 1/8 x 11 3/4 inches, by Henry Ossawa Tanner, 1897. *The Baltimore Museum of Art: Partial and Promised Gift of Eddie C. Brown, C. Sylvia Brown, and the children, Tonya Y. Brown Ingersol and Jennifer L. Brown, Baltimore BMA 2002.561*

expression pensive but self-assured. Both 1897 portraits of his mother show his tendency to cast light on the forehead.

In the photo allegedly rehearsing *The Banjo Lesson* there is no tilt to the young model's head, no thoughtful pause. The old man is equally lit as the boy, who stands stiff and awkward behind a cardboard facsimile of a banjo. The changes Tanner made in the eventual painting offer evidence that the

Fig. 5-13. *Mother of Henry O. Tanner.* Oil on plywood,
13 x 9 3/4 inches, by Henry Ossawa Tanner, 1897.
Smithsonian American Art Museum. Gift of Dr. Nicholas Zervas

respectful treatment was his invention, not an accident of light or pose.
Tanner illumined his room from the left, through a window perhaps, and
from low on the right, by the glow of a hearth fire. In a manner reminiscent
of Eakins's *Gross Clinic,* Tanner highlighted the boy's forehead, the site of
intelligence, learning, and inspiration, and his active hand, the touch of the

awakening musician. Although the right side of the man is washed in a pale bluish tone, and his face catches enough light to be readable, his forehead remains darkened.

Reviewing *The Banjo Lesson* in 1893, a *Daily Evening Telegraph* critic complained about Tanner's "hostile lights":

> Technically speaking, the artist has set himself a problem fraught with difficulties that might perhaps better be avoided except for study purposes. He has posed his figures between the chimney and the window, with warm firelight illuminating one side of his group, and cold daylight striking sharply against the other side. To paint his details in these two hostile lights, to make them blend where they come together, and to harmonize the whole . . . is an exceedingly trying task which he grappled manfully and with marked success, but which is after all, evidently enough not the happiest way in which the subject might have been treated. Students will be attracted and pleased by the searching distinctions he makes and the skill with which he brings the two discordant schemes of his picture into unity and bids them pull together, but picture-lovers will wish he had closed the window-blinds and let the glow of the fire shine all through the room, throwing deep shadows into the far corners.[57]

Had Tanner "closed the window" there would have been no illumination on the boy's forehead. Perhaps this was what bothered the writer, who may not have been accustomed to seeing light graze the temples of the lowly. This was in the same review that noted, "An old Uncle Ned, bald and venerable, has a bare-footed little darkey of seven or eight years between his knees." Despite the predictable stereotyping, the writer admitted that "the faces are informed with intelligence and expression," owing no doubt to Tanner's light cues.

In 1891 Tanner had joined other American artists flocking to Europe. In the bustling life-drawing studio at the Académie Julian in Paris it was difficult to secure a good location for sketching, yet Tanner seems to have consistently been able to set up his drawing board to the left of the model so as to get a three-quarter view for his mostly bust-length studies. While it is risky to attempt conclusions based on only a few examples, selections from surviving charcoal drawings reveal a preference for similar views. These studies of male figures from 1891 to 1893 were observed from a vantage point that gave Tanner a three-quarter view of the figure, as opposed to a front facing or profile pose (Fig. 5-14). This seemingly favored position is the same one he would later bestow on the boy.

57. *Daily Evening Telegraph*, October 7, 1893, cited in Mosby and Sewell, *Henry Ossawa Tanner*, 118.

Fig. 5-14. *Half-Length Study of a Negro Man.* Charcoal on paper, 19 1/2 x 9 1/4 inches, by Henry Ossawa Tanner, *ca.* 1891–1893. *Detroit Institute of Arts, Founders Society Purchase, African Art Gallery Committee Fund*

Another indication that Tanner preferred the three-quarter position to the forward facing or side view is the manner in which he presented himself for photographs. In a portrait of *ca.* 1900 (Fig. 5-15), a thoughtful, bespectacled Tanner, head slightly angled, eyes not meeting the camera, assumes the off-center pose. While Tanner was at the Académie Julian he joined over forty colleagues for a group picture. Tanner can be found in the

Fig. 5-15. Photograph, by Henry Ossawa Tanner, *ca.* 1900.
Photo courtesy of Dr. Rae Alexander-Minter, New York

back row, in a three-quarter pose, gazing into the distance. Almost everyone else in the photograph faces forward, their eyes fixed on the camera. Tanner's gaze and thoughts seem directed elsewhere; much the same can be said of his banjo-playing boy.[58]

That Tanner managed to make a unique statement of self-definition, in contrast to the cloying sentimentality or outright insults of his contemporaries, seems evident. Tanner's old/young formula adheres to genre conventions. His mature African American, however, is not in service to any "little missy" but at home with his own kin, and a bright young fellow he is. The glimmer of insight ignites the boy's forehead, divining a positive future in a message of hope and unity.

THE MARKET

Finally, the question remains of why Tanner painted no more images of African American "banjo lessons" or of the "thankful poor." If he felt compelled to rehabilitate portrayals of African Americans, why make only two old man/young boy paintings? If the uncle's reputation needed redeeming, did mammy's not also? Could the answer be simply that he needed money and was painting for the market?

Had Robert C. Ogden not purchased *The Banjo Lesson* it might be easier to assess the painting solely as recouping an African American perspective. When Tanner made the acquaintance of Lewis Rodman Wanamaker in Paris he probably also gained an introduction to Ogden.[59] More than just a prosperous white northern businessman, as David Levering Lewis has written, "Ogden's business was philanthropy," especially "helping" the southern black. Ogden saw himself as a "special emissary [to the South], devoting a good portion of his tax-free annual salary of a hundred thousand dollars to the region."[60] Ogden was a trustee of Hampton Institute, which had been established in Virginia during Reconstruction to educate freed people. And as a supporter of Tuskegee in Alabama, he was a tireless good-will ambassador from the mercantile North into what was becoming known as the New South.

Tanner appears to have honed his business acumen and mastered the art of networking his way to success. Savvy of how white money fueled the Tuskegee gravy train, he once requested that Booker T. Washington ask

58. Ibid., 39, 41.
59. Ibid., 92.
60. David Levering Lewis, *W. E. B. Du Bois: Biography of a Race, 1868–1919*, 271.

Andrew Carnegie to purchase one of his paintings. Perhaps the educator gave the artist a few tips about how to cultivate white philanthropists. A statement in Tanner's handwriting found in the files of the Pennsylvania School of the Deaf, composed while *The Thankful Poor* was on display there in 1894, reveals his skill for public relations. Written in a journalistic tone, the writing suggests Tanner was drafting his own publicity release or rehearsing for an interview.

> Since his return from Europe he has painted mostly Negro subjects, he feels drawn to such subjects on account of the newness of the field and because of a desire to represent the serious, and pathetic side of life among them, and it is his thought that other things being equal, he who has most sympathy with his subject will obtain the best results. To his mind many of the artists who have represented Negro life have only seen the comic, the ludicrous side of it, and have lacked sympathy with and appreciation for the warm big heart that dwells within such a rough exterior.[61]

Tanner's detachment seems contrived. "The newness of the field," for example, rings false, especially given Tanner's connection through the Pennsylvania Academy to Eakins, Hovenden, and Thomas Anschutz, who were preeminent among the few artists who painted African American subjects after emancipation. A condescending white critic might laud, "The warm big heart that dwells within such a rough exterior," but from Tanner the phrase smacks of calculation. Most telling, Tanner maintains a provocative distance from "such subjects," whom he calls "them," not "us."

ACCOMMODATION

So what was Tanner saying with *The Banjo Player?* Was Tanner plying the darkey trade? Or was this artist, whom W. E. B. Du Bois would assess as one of the "Talented Tenth," a standard-bearer for racial uplift? The mystery of Tanner's *The Banjo Lesson* persists. Perhaps he meant to turn the tables on the genre tradition, moribund in fine art but still thriving in popular images. He was likely appalled by how African Americans were defined within the enormous production of commercial print ephemera in the late decades of the century: wretched freedmen longed for the old plantation, uncles fawned over the master class, and dim-witted musicians were blithely oblivious of their impoverished circumstances. Pitiful specters of

61. Mosby and Sewell, *Henry Ossawa Tanner,* 114, 116.

emasculated manhood, these icons reconstituted for the white consumer a fantasy of an idyllic southern past and guaranteed the present and future a social hierarchy. Was the figure of the old uncle so beyond redemption that Tanner pinned his hopes on the boy, still unsullied and not a character in any Tom show or advertiser's scheme? Or was this an old man's final hurrah, holding tight to the banjo until his youthful companion can master it? The boy has taken over, but the old man backs him up.

Ultimately, Tanner needed patronage, and he was able to maneuver the fine line between maintaining self-respect and catering to the tastes of "the man." For any American painter in 1893, regardless of ethnicity, financial support depended on pleasing a certain class of patron. Booker T. Washington knew that access to power and funding for Tuskegee Institute with its African American education programs depended on individuals with firm notions of what was best for "the Negro." In 1895 Washington addressed southern scions of industry and national leaders in a speech at the Cotton States Exposition in Atlanta.[62] He appealed to these potential employers of his Tuskegee graduates by saying that they needed to look no further than to the southern black for valuable workers. Tanner had three paintings on display at this exposition,[63] and he may have been casting down his bucket in the rural South, following the advice that Washington had given to prosperous southerners, to pull from its murky waters the familiar old uncle. In his accommodating view of the noble poor, shown humble but self-reliant, Tanner's message confirmed the philanthropic ideals of Ogden and of other potential supporters. Given their expectations, and the limited parameters of variety open to any purveyor of African American subjects, Tanner imbued the scene with dignity as best he could. Maybe the next generation would have more opportunity. He could hope.

Years later when writing his memoirs, Tanner said nothing about why he chose this rare, for him, exercise in an African American genre subject. He never discussed *The Banjo Lesson* or *The Thankful Poor* in interviews or requested either painting for shows, including his New York retrospective of 1908. Tanner's only mention in relation to his work about that year he spent in the United States was that he had been able to earn enough money to return to Paris.[64] Ogden donated *The Banjo Lesson* to Hampton Institute,

62. Washington, with Thrasher, *Up from Slavery*, 134–37.

63. Mosby, *Across Continents*, 38. Tanner's *The Bagpipe Lesson* won a prize at the Atlanta Exposition. His work was not shown alongside the works of Winslow Homer, Mary Cassatt, or Thomas Eakins, but in a building called the Negro Building.

64. Mosby and Sewell, *Henry Ossawa Tanner*, 124–25.

where it still resides today. John T. Morris loaned *The Thankful Poor* to the Pennsylvania School for the Deaf. Today that painting is in the collection of William H. and Camille O. Cosby. The choice of subject and the sites where those initial prominent Philadelphia patrons installed their acquisitions enhanced their own reputations as benefactors of the less fortunate. An auction sale of all the work Tanner could amass financed his return to France.[65] There he spent much of the rest of his life painting mostly biblical subjects and occasionally portraits and landscapes. Never again did he directly engage in American genre painting, nor struggle to transcend the limited possibilities for honoring African American men so amply documented across the wide swath of nineteenth-century visual culture.

65. Tanner, "The Story of an Artist's Life," 11772, cited in Mosby, *Across Continents*, 33.

Bibliography

Adams, John R. *Harriet Beecher Stowe: Updated Edition.* Boston: G. K. Hall, 1989.

Adams, Karen M. "Black Images in Nineteenth-Century American Painting and Literature: An Iconological Study of Mount, Melville, Homer, and Mark Twain." PhD diss., Emory University, 1977.

Aiken, George L. *Uncle Tom's Cabin; or, Life among the Lowly: A Domestic Drama in Six Acts.* Chicago: Dramatic Publishing Company, [1852].

Alexander-Minter, Rae. "The Tanner Family: A Grandniece's Chronicle." In *Henry Ossawa Tanner,* edited by Dewey F. Mosby and Darrell Sewell, 22–33. Philadelphia: Philadelphia Museum of Art, 1991.

Ambrose, Douglas. *Henry Hughes and Proslavery Thought in the Old South.* Baton Rouge: Louisiana State University Press, 1996.

Ammons, Elizabeth, ed. *Critical Essays on Harriet Beecher Stowe.* Boston: G. K. Hall, 1980.

———. "Heroines in Uncle Tom's Cabin." *American Literature* 49 (May 1977): 116–79.

Ammons, Elizabeth, and Susan Belasco, eds. *Approaches to Teaching Stowe's "Uncle Tom's Cabin."* New York: Modern Language Association of America, 2000.

Anderson, Lisa M. *Mammies No More: The Changing Image of Black Women on Stage and Screen.* Lanham, MD: Rowman and Littlefield, 1997.

Avary, Myrta Lockett. *Dixie after the War.* New York: Doubleday, 1906.

Baldwin, James. "Everybody's Protest Novel." *Partisan Review* 16 (June 1949): 578–85.

Ball, Thomas. *My Threescore Years and Ten: An Autobiography.* Boston: Roberts Brothers, 1892.

Banfield, Beryle. "Racism in Children's Books: An Afro-American Perspective." In *The Slant of the Pen,* edited by Roy Preiswerk, 13–25. Geneva: World Council of Churches, 1980.

Banks, Marva. "*Uncle Tom's Cabin* and Antebellum Black Response." In *Readers in History: Nineteenth-Century American Literature and the Contexts of Response,* edited by James L. Machor, 209–27. Baltimore: Johns Hopkins University Press, 1993.

Banta, Martha. *Imaging American Women: Idea and Ideals in Cultural History.* New York: Columbia University Press, 1987.

Barker, Louisa. *Influence of Slavery upon the White Population.* New York: Anti-Slavery Tracts. No. 9, American Anti-Slavery Society (1855) 6–8.

Bauer, John I. H. *Eastman Johnson (1824–1906): An American Genre Painter.* Brooklyn: Brooklyn Museum, 1940.

Bean, Annemarie, James V. Hatch, and Brooks McNamara, eds. *Inside the Minstrel Mask: Readings in Nineteenth-Century Blackface Minstrelsy.* Hanover: Wesleyan University Press, 1996.

Bearden, Romare, and Harry Henderson. *Six Black Masters of American Art.* Garden City, NY: Zenith Books, 1972.

Beckham, Sue Birdwell. "'By 'n' By Hard Times: Eastman Johnson's 'Life at the South' and American Minstrels." *Journal of American Culture* 6, no. 3 (1983): 19–25.

Berzon, Judith R. *Neither White Nor Black: The Mulatto Character in American Fiction.* New York: New York University Press, 1978.

Birchfield, James D., "The Artistic Career of Thomas Satterwhite Noble." In *Thomas Satterwhite Noble, 1835–1907,* edited by James D. Birchfield, Albert Boime, and William J. Hennessey, 1–28. Lexington: University of Kentucky Art Museum, 1988.

———. "Thomas Satterwhite Noble: Made for a Painter." *Kentucky Review* 6, no. 1 (Winter 1986): 35–60.

Birdoff, Harry. *The World's Greatest Hit: "Uncle Tom's Cabin."* New York: S. F. Vanni, 1947.

Bledsoe, Albert Taylor. *Essay on Liberty and Slavery.* Philadelphia: J. B. Lippincott, 1856.

Bogle, Donald. *Toms, Coons, Mulattoes, Mammies, and Bucks: An Interpretative History of Blacks in American Films.* New York: Viking, 1973.

Boime, Albert. *The Art of Exclusion: Representing Blacks in the Nineteenth Century.* Washington DC: Smithsonian Institution Press, 1990.

———. "Burgoo and Bourgeois: Thomas Noble's Images of Black People." In *Thomas Satterwhite Noble, 1835–1907,* edited by James D. Birchfield, Albert Boime, and William J. Hennessey, 29–60. Lexington: University of Kentucky Art Museum, 1988.

———. "Henry Ossawa Tanner's Subversion of Genre." *Art Bulletin* 75, no. 3 (Sept. 1993): 415–42.

Boskin, Joseph. *Sambo: The Rise and Demise of an American Jester.* New York: Oxford, 1986.

Brent, Linda. *Incidents in the Life of a Slave Girl.* Edited by L Maria Child. New York: Harcourt Brace Jovanovich, 1973.

Broca, Paul. *On the Phenomena of Hybridity in the Genus Homo.* London: Green, Longman, and Roberts, 1864.

Brody, Jennifer DeVere. *Impossible Purities: Blackness, Femininity, and Victorian Culture.* Durham: Duke University Press, 1998.

Brooks, Daphne A. *Bodies in Dissent: Spectacular Performances of Race and Freedom, 1850–1910.* Durham: Duke University, 2006.

Brooks, Van Wyck. *The Flowering of New England, 1815–1865.* New York: E. P. Dutton, 1937.

Brown, Dee. *The Year of the Century: 1876.* New York: Charles Scribner's Sons, 1966.

Brown, Gillian. *Domestic Individualism: Imaging Self in Nineteenth-Century America.* Berkeley: University of California Press, 1990.

———. "Getting in the Kitchen with Dinah: Domestic Politics in *Uncle Tom's Cabin.*" *American Quarterly* 36, no. 4 (Autumn 1984): 503–23.

Brown, Sterling. *The Negro in American Fiction.* Port Washington, NY: Kennikat Press, 1937.

Bruce, Philip A. *The Plantation Negro as a Freeman.* New York: G. P. Putnam, 1889. Reprinted by Corner House, 1970.

Bryant, William Cullen, ed. *Picturesque America; or, The Land We Live In.* 2 vols. New York: D. Appleton, 1872.

Buck, Paul H. *The Road to Reunion, 1865–1900.* Boston: Little, Brown, 1937.

Burg, David F. *Chicago's White City of 1893.* Lexington: University of Kentucky Press, 1976.

Burns, Sarah. *Inventing the Modern Artist: Art and Culture in Gilded Age America.* New Haven: Yale University Press, 1996.

———. "In Whose Shadow? Eastman Johnson and Winslow Homer in the Postwar Decades." In *Eastman Johnson: Painting America,* edited by Teresa A. Carbone and Patricia Hills, 184–213. Brooklyn: Brooklyn Museum of Art, 1999.

Buster, Larry Vincent. *The Art and History of Black Memorabilia.* New York: Clarkson Potter, 2000.

Calo, Mary Ann. "Winslow Homer's Visits to Virginia during Reconstruction." *American Art Journal* (Winter 1980) 5–27.

Campbell, Stanley W. *The Slave Catchers: Enforcement of the Fugitive Slave Laws, 1850–1860.* Chapel Hill: University of North Carolina Press, 1968, 1970.

Caskey, Marie. *Chariot of Fire: Religion and the Beecher Family.* New Haven: Yale University Press, 1978.

Cassuto, Leonard. *The Inhuman Race: Racial Grotesque in American Literature and Culture.* New York: Columbia University Press, 1996.

Chesnut, Mary Boykin. *A Diary from Dixie.* Edited by Ben Ames Williams. Boston: Houghton Mifflin, 1949. Originally published in 1905.

Child, Lydia Maria. *An Appeal in Favor of That Class of Americans Called Africans.* Boston: Allen and Ticknor, 1833.

———. "The Influence of Slavery with Regard to Moral Purity." *Anti-Slavery Tracts,* 1835.

Chude-Sokei, Louis. *The Last "Darky": Bert Williams, Black-on-Black Minstrelsy, and the African Diaspora.* Durham: Duke University Press, 2006.

Cikovsky, Nicolai, Jr. *Winslow Homer.* New York: Harry N. Abrams, 1990.

Cikovsky, Nicolai, Jr., and Franklin Kelly. *Winslow Homer.* New Haven: Yale University Press, 1995.

Cimbala, Paul. "Black Musicians from Slavery to Freedom: An Exploration of an African-American Folk Elite and Cultural Continuity in the Nineteenth-Century Rural South." In *A Question of Manhood: A Reader in U.S. Black Men's History and Masculinity,* edited by Darlene Clark Hine and Earnestine Jenkins, 305–21. Bloomington: Indiana University Press, 1999.

Cockrell, Dale. *Demons of Disorder: Early Blackface Minstrels and Their World.* Cambridge: Cambridge University Press, 1997.

Colbert, Charles. *A Measure of Perfection: Phrenology and the Fine Arts in America.* Chapel Hill: University of North Carolina Press, 1997.

Conrads, Margaret C. *Winslow Homer and the Critics: Forging a National Art in the 1870s.* Princeton: Princeton University Press, 2001.

Conway, Cecelia. *African Banjo Echoes in Appalachia: A Study of Folk Traditions.* Knoxville: University of Tennessee Press, 1984.

Corley, Daniel B. *A Visit to Uncle Tom's Cabin.* Chicago: Laird and Lee, 1892.

Crandall, John. "Patriotism and Humanitarian Reform in Children's Literature, 1825–1860." *American Quarterly* 21 (Spring 1969): 3–23.

Cripps, Thomas. *Slow Fade to Black: The Negro in American Film, 1900–1942.* New York: Oxford University Press, 1977.

Croly, David Goodman, and George Wakeman (attributed). *Miscegenation: The Theory of the Blending of the Races, Applied to the American White Man and Negro.* New York: H. Dexter, Hamilton, 1864.

Cutrer, Emily Fourmy. "Visualizing Nineteenth-Century American Culture." *American Quarterly* 51, no. 4 (December 1999): 895–909.

Dalton, Karen C. C. "The Alphabet Is an Abolitionist." *Massachusetts Review* 32, no. 4 (1992): 545–73.

Davis, John. "Eastman Johnson's *Negro Life at the South* and Urban Slavery in Washington, D.C." *The Art Bulletin* 80, no. 1 (March 1998): 67–92.

Day, Beth. *Sexual Life between Blacks and Whites: The Roots of Racism.* New York: Crowell, 1974.

D'Emilio, John, and Estelle B. Freedman. *Intimate Matters: A History of Sexuality in America.* New York: Harper and Row, 1988.

Donovan, Josephine. *"Uncle Tom's Cabin": Evil, Affliction, and Redemptive Love.* Boston: Twayne, G. K. Hall, 1991.

Dooley, Mrs. James H. (S. M.). *Dem Good Ole Times.* New York: Doubleday, 1906.

Douglas, Ann. *The Feminization of American Culture.* New York: Knopf, 1977.

———. "Introduction." In *Uncle Tom's Cabin; or, Life among the Lowly,* by Harriet Beecher Stowe. New York: Penguin Books, 1986.

Downes, William H. *The Life and Works of Winslow Homer.* New York: Lenox Hill, 1911.

Driskell, David C. *Two Centuries of Black American Art.* Los Angeles County Museum of Art/New York: Alfred A. Knopf, 1976.

Drummond, A. M., and Richard Moody. "The Hit of the Century: *Uncle Tom's Cabin,*
1852–1853." *Educational Theatre Journal* 4 (1952): 315–22.

DuBois, Ellen Carol. *Feminism and Suffrage: The Emergence of an Independent Women's
Movement in American, 1848–1869.* Ithaca: Cornell University Press, 1978.

Dyer, Richard. *Heavenly Bodies: Film Stars and Society.* New York: St. Martin's, 1986.

————. *White.* London: Routledge, 1997.

Eastman, Mary H. *Aunt Phillis's Cabin; or, Southern Life as It Is.* Philadelphia: Lippin-
cott, Grambo, 1852.

Epstein, Barbara Leslie. *The Politics of Domesticity: Women, Evangelism and Temperance
in Nineteenth-Century America.* Middleton: Wesleyan University Press, 1981.

Ethnic Images in Advertising. Philadelphia: Balch Institute for Ethnic Studies, 1984.

Ethnic Notions: Black Images in the White Mind. Catalogue. Berkeley: Berkeley Art
Center, 1982.

Fiedler, Leslie. *The Inadvertent Epic: From "Uncle Tom's Cabin" to "Roots."* New York:
Simon and Schuster, 1979.

Fisch, Audrey A. *American Slaves in Victorian England: Abolitionist Politics in Popular
Literature and Culture.* Cambridge: Cambridge University Press, 2000.

————. "'Exhibiting Uncle Tom in Some Shape or Other': The Commodification
and Reception of *Uncle Tom's Cabin* in England." *Nineteenth Century Contexts* 17,
no. 2 (1993): 145–58.

Fishkin, Shelley Fisher. "Interrogating 'Whiteness,' Complicating 'Blackness':
Remapping American Culture." *American Quarterly* 47, no. 3 (September 1995):
428–66.

Fletcher, Tom. *One Hundred Years of the Negro in Show Business.* New York: 1954.

Foner, Eric. *Reconstruction: America's Unfinished Revolution, 1863–1877.* New York:
Harper and Row, 1988.

Foster, William Z. *The Negro People in American History.* New York: International
Publishers, 1954.

Foucault, Michel. *Discipline and Punishment: The Birth of the Prison.* Translated by
Alan Sheridan. New York: Random House, 1977. Originally published as
Surveiller et Punir: Naissance de la Prison, 1975.

Fredrickson, George M. *The Black Image in the White Mind.* New York: Harper and
Row, 1971.

Furth, Leslie. "'The Modern Medea' and Race Matters: Thomas Satterwhite Noble's
Margaret Garner." *American Art* 12, no. 2 (Summer 1998): 36–57.

Gaines, Francis Pendleton. *The Southern Plantation: A Study in the Development and
Accuracy of a Tradition.* New York: Columbia University Press, 1924.

Gardner, Albert Ten Eyck. *Winslow Homer, American Artist: His World and His Work.*
New York: Clarkson N. Potter, 1961.

Garretson, Mary Noble Willech. "Thomas S. Noble and His Paintings." *The New-
York Historical Society Quarterly Bulletin* 24, no. 4 (October 1940): 113–23.

Gienapp, William E. "Abolitionism and the Nature of Antebellum Reform." In
Courage and Conscience: Black and White Abolitionists in Boston, edited by Donald
M. Jacobs, 21–46. Bloomington: Indiana University Press, 1993.

Glazer, Lee, and Susan Key. "Carry Me Back: Nostalgia for the Old South in Nineteenth-Century Popular Culture." *Journal of American Studies* 30, no. 1 (1996): 1–24.

Goings, Kenneth W. *Mammy and Uncle Mose: Black Collectibles and American Stereotyping.* Bloomington: Indiana University Press, 1994.

Goodrich, Lloyd. *Winslow Homer.* New York: Macmillan, 1944.

Gordon-Reed, Annette. *Thomas Jefferson and Sally Hemings: An American Controversy.* Charlottesville: University Press of Virginia, 1997.

Gossett, Thomas F. *"Uncle Tom's Cabin" and American Culture.* Dallas: Southern Methodist University Press, 1985.

Gould, Stephen Jay. *The Mismeasure of Man.* New York: W. W. Norton, 1981.

Grady, Henry W. *The New South.* New York: Robert Bonner's Sons, 1890.

Griffith, Mattie. *Autobiography of a Female Slave.* New York: Redfield, 1857.

Grossberg, Michael. *Governing the Hearth: Law and the Family in Nineteenth-Century America.* Chapel Hill: University of North Carolina Press, 1985.

Grubar, Susan. *Racechanges: White Skin, Black Face in American Culture.* New York: Oxford University Press, 1997.

Gura, Philip F., and James Bollman. *America's Instrument: The Banjo in the Nineteenth Century.* Chapel Hill: University of North Carolina, 1999.

Gutjahr, Paul. *An American Bible: A History of the Good Book in the United States, 1777–1880.* Palo Alto: Stanford University Press, 1999.

———. "American Protestant Bible Illustration from Copper Plates to Computers." In *The Visual Culture of American Religions,* edited by David Morgan and Sally M. Promey, 267–85. Berkeley: University of California Press, 2001.

Hale, Grace Elizabeth. *Making Whiteness: The Culture of Segregation in the South, 1890–1940.* New York: Pantheon, 1998.

Hall, Jacquelyn Dowd. *Revolt against Chivalry: Jessie Daniel Ames and the Women's Campaign against Lynching.* New York: Columbia University Press, 1979.

Halttunen, Karen. "Humanitarianism and the Pornography of Pain in Anglo-American Culture." *American Historical Review* 100, no. 2 (1995): 303–34.

Hamilton, Kendra. "The Strange Career of Uncle Tom." *Black Issues in Higher Education* (June 2002): 22–27.

Hamilton, Sinclair. *Early American Book Illustrators and Wood Engravers, 1670–1870.* Princeton: Princeton University Press, 1968.

Harris, Michael D. *Colored Pictures: Race and Visual Representation.* Chapel Hill: University of North Carolina Press, 2003.

Harrold, Stanley. *Gamaliel Bailey and Antislavery Union.* Kent: Kent State University Press, 1986.

Hartigan, Lynda Roscoe. *Sharing Traditions: Fine Black Artists in Nineteenth-Century America.* Exhibition catalog, National Museum of American Art. Washington, DC, 1985.

Hébert, Kimberly G. "Acting the Nigger: Topsy, Shirley Temple, and Toni Morrison's Pecola." In *Approaches to Teaching Stowe's "Uncle Tom's Cabin,"* edited by Elizabeth Ammons and Susan Belasco, 184–98. New York: Modern Language Association of America, 2000.

Hedrick, Joan D. *Harriet Beecher Stowe: A Life.* New York: Oxford University Press, 1994.

———. "'Peaceable Fruits': The Ministry of Harriet Beecher Stowe." *American Quarterly* 40, no. 3 (September 1988): 307–32.

Henderson, William D. *Gilded Age City: Politics, Life, and Labor in Petersburg, Virginia, 1874–1889.* Boston: University Press of America. 1980.

Hersh, Blanche Glassman. *The Slavery of Sex: Feminist-Abolitionists in America.* Urbana: University of Illinois Press, 1978.

Hills, Patricia. *The Genre Painting of Eastman Johnson: The Sources and Development of His Style and Themes.* New York: Garland, 1977.

———. "Painting Race: Eastman Johnson's Pictures of Slaves, Ex-Slaves, and Freedmen." In *Eastman Johnson: Painting America,* edited by Teresa A. Carbone, 121–66. Brooklyn: Brooklyn Museum of Art, 1999.

Hine, Darlene Clark, and Earnestine Jenkins, eds. *A Question of Manhood: A Reader in U.S. Black Men's History and Masculinity.* Vol. 1. Bloomington: Indiana University Press, 1999.

Hobsbawm, Eric J. "Introduction." In *The Invention of Tradition,* edited by Eric J. Hobsbawm and Terence Ranger. Cambridge: Cambridge University Press, 1970.

Hodes, Martha. "The Sexualization of Reconstruction Politics: White Women and Black Men in the South after the Civil War." In *American Sexual Politics: Sex, Gender, and Race since the Civil War,* edited by John C. Fout and Maura Shaw Tantillo, 59–74. Chicago: University of Chicago Press, 1990.

Hoffman, Frederick L. *Race Traits and Tendencies of the American Negro.* New York: Macmillan, 1896.

Honour, Hugh. *From the American Revolution to World War I.* Vol. 4, *The Image of the Black in Western Art.* Cambridge: Harvard University Press, 1989.

Hughes, Henry. *Treatise on Sociology: Theoretical and Practical.* New York: Negro Universities Press, 1968. Originally published by Lippincott, Grambo in 1854.

Hult, Christine. "*Uncle Tom's Cabin:* Popular Images of Uncle Tom and Little Eva." *Nineteenth Century* 15, no. 1 (1995): 3–9.

Jacobs, Donald M. "David Walker and William Lloyd Garrison." In *Courage and Conscience: Black and White Abolitionists in Boston,* edited by Donald M. Jacobs, 1–20. Bloomington: Indiana University Press, 1993.

Jay, Robert. *The Trade Card in Nineteenth-Century America.* Columbia: University of Missouri Press, 1987.

Jefferson, Thomas. *Thomas Jefferson's Farm Book: With Commentary and Relevant Extracts from Other Writings.* Edited by Edwin M. Betts. Princeton: Princeton University Press, 1953.

Jenkins, Henry, Tara McPherson, and Jane Shattuc, eds. *Hop On Pop: The Politics and Pleasures of Popular Culture.* Durham: Duke University Press, 2002.

Jewell, Karen S. W. *From Mammy to Miss America and Beyond: Cultural Images and the Shaping of U.S. Social Policy.* London: Routledge, 1993.

Johns, Elizabeth. *American Genre Painting: The Politics of Everyday Life.* New Haven: Yale University Press, 1991.

Johnson, Rossiter, ed. *A History of the World's Columbian Exposition.* New York: Appleton, 1897.

Jones, Jacqueline. *Labor of Love, Labor of Sorrow: Black Women, Work, and the Family from Slavery to the Present.* New York: Random House, 1985.

Jordan, Winthrope D. *White Over Black.* Chapel Hill: University of North Carolina Press, 1968.

Kaplan, Sidney. *The Portrayal of the Negro in American Painting.* Exhibition catalog, Bowdoin College Museum of Art, 1964.

Kennedy, John Pendleton. *Swallow Barn; or, A Sojourn in the Old Dominion.* Philadelphia: Carey and Lea, 1832.

Kern-Foxworth, Marilyn. *Aunt Jemima, Uncle Ben, and Rastus: Blacks in Advertising, Yesterday, Today, and Tomorrow.* Westport, CT: Greenwood Press, 1994.

Kimball, Gayle. *The Religious Ideas of Harriet Beecher Stowe: Her Gospel of Womanhood.* New York: Edwin Mellen Press, 1982.

King, Edward. *The Great South.* Baton Rouge: Louisiana State University Press, 1972. Originally published in 1875.

King, Mae C. "The Politics of Sexual Stereotype." *The Black Scholar: Journal of Black Studies and Research* 4, nos. 6–7 (March–April 1973): 12–23.

Kirkham, E. Bruce. *The Building of Uncle Tom's Cabin.* Knoxville: University of Tennessee Press, 1977.

Knauff Christopher W. "Certain Exemplars of Art in America. IV. Elliot Daingerfield: Winslow Homer." *The Churchman* (July 23, 1898): 128.

Kushner, Marilyn. *Winslow Homer: Illustrating America.* Edited by Marilyn S. Kushner, Barbara Dayer Gallati, and Linda S. Ferber. Brooklyn: Brooklyn Museum of Art, 2000.

Lapansky, Phillip. "Graphic Discord: Abolitionist and Antiabolitionist Images." In *The Abolitionist Sisterhood: Women's Political Culture in Antebellum America,* edited by Jean Fagan Yellin and John C. Van Horne, 201–30. Ithaca: Cornell University Press, 1994.

Lears, Jackson. *Fables of Abundance: A Cultural History of Advertising in America.* New York: Harper Collins, 1994.

Lebsock, Suzanne. *The Free Women of Petersburg: Status and Culture in a Southern Town, 1784–1860.* New York: Norton, 1984.

Lehuu, Isabelle. *Carnival on the Page: Popular Print Media in Antebellum America.* Chapel Hill: University of North Carolina Press, 2000.

———. "Sentimental Figures: Reading *Godey's Lady's Book* in Antebellum America." In *The Culture of Sentiment: Race, Gender, and Sentimentality in Nineteenth-Century America,* edited by Shirley Samuels, 73–91. New York: Oxford University Press, 1992.

Levine, Lawrence W. *Highbrow/Lowbrow: The Emergence of Cultural Hierarchy in America.* Cambridge: Harvard University Press, 1988.

Lewis, David Levering. *W. E. B. Du Bois: Biography of a Race, 1868–1919.* New York: Henry Holt, 1993.

Lewis, Samella. *Art: African American.* New York: Harcourt Brace Jovanovich, 1978.

Linn, Karen S. *That Half-Barbaric Twang: The Banjo in American Popular Culture.* Urbana: University of Illinois Press, 1991.

Linton, William J. *The History of Wood-Engraving in America.* Boston: Estes and Lauriat, 1882. Republished by the American Life Foundation and Study Institute, with bibliographies and introduction by Nancy Carlson Schrock, in 1976.

Litwack, Leon F. *Been in the Storm So Long: The Aftermath of Slavery.* New York: Alfred A. Knopf, 1979.

Logan, Rayford W. *The Negro in American Life and Thought: The Nadir, 1877–1901.* New York: Dial Press, 1954.

Lords, Erik. "Keeping Jim Crow Alive." *Black Issues in Higher Education* 19, no. 8 (June 6, 2002): 28–30.

Lorimer, Douglas A. *Colour, Class, and the Victorians: English Attitudes to the Negro in the Mid-Nineteenth Century.* London: Leicester University Press, 1978.

Lott, Eric. *Love and Theft: Blackface Minstrelsy and the American Working Class.* New York: Oxford University Press, 1993.

Lund, Ralph Eugene. "Trouping with Uncle Tom: Fay Templeton and Mary Pickford and All the Other Little Evas." *Century* 115 (January 1928): 329–37.

Lurie, Edward. *Louis Agassiz: A Life in Science.* Chicago: University of Chicago Press, 1960.

MacCann, Donnarae. *White Supremacy in Children's Literature: Characterizations of African Americans, 1830–1900.* New York: Routledge, 1998.

Mahar, William J. *Behind the Burnt Cork Mask: Early Blackface Minstrelsy and Antebellum American Popular Culture.* Urbana: University of Illinois Press, 1999.

Marks, Edward. *They All Had Glamour: From the Swedish Nightingale to the Naked Lady.* Westport, CT: Greenwood Press, 1972. Originally published by Messner Books in 1944.

Martin, Francis John, Jr. *The Image of Black People in American Illustration from 1825 to 1925.* PhD diss., University of California, Los Angeles, 1986.

Marzio, Peter C. *The Democratic Art: Pictures for a Nineteenth-Century America: Chromolithography, 1840–1900.* Boston: David R. Godine, 1979.

Mathews, Marcia M. *Henry Ossawa Tanner, American Artist.* Chicago: University of Chicago Press, 1969.

Mattison, Rev. H. *Louisa Picquet, the Octoroon: A Tale of Southern Slave Life.* In *Collected Black Women's Narratives.* Schomburg Library of Nineteenth-Century Black Women Writers. New York: Oxford University Press, 1988.

May, Samuel J. "The Fugitive Slave Law and Its Victims." In *Anti-Slavery Tracts* No. 15. New York: Books for Libraries Press, 1970.

Mazow, Leo G., ed. *Picturing the Banjo.* Philadelphia: Pennsylvania State University Press, 2005.

McConachie, Bruce. "Out of the Kitchen and into the Marketplace: Normalizing *Uncle Tom's Cabin* for the Antebellum Stage." *Journal of American Drama and Theatre* 3 (1991): 5–28.

McCord, Louisa S. "Review of *Uncle Tom's Cabin.*" *Southern Quarterly Review* 23 (January 1853): 81–120.

McDannell, Colleen. *Material Christianity: Religion and Popular Culture in America.* New Haven: Yale University Press, 1995.

McElroy, Guy C. *Facing History: The Black Image in American Art, 1710–1940.* Washington, DC: Corcoran Gallery of Art, 1990.

Meer, Sarah. *Uncle Tom Mania: Slavery, Minstrelsy, and Transatlantic Culture in the 1850s.* Athens: University of Georgia Press, 2005.

Mencke, John. *Mulattoes and Race Mixture: Images, 1865–1918.* Ann Arbor: University of Michigan Research Press, 1976.

Miller, David C. *Dark Eden: The Swamp in Nineteenth-Century American Culture.* Cambridge: Cambridge University Press, 1989.

Mitchell, Loften. *Black Drama: The Story of the American Negro in the Theater.* New York: Hawthorne Books, 1967.

Mitchell, W. J. T. *Picture Theory: Essays on Verbal and Visual Representation.* Chicago: University of Chicago Press, 1994.

Moody, Richard. "Uncle Tom, the Theatre, and Mrs. Stowe." *American Heritage* 6, no. 6 (October 1955): 29–33, 102, 103.

Morgan, David. "For Christ and the Republic: Protestant Illustration and the History of Literacy in Nineteenth-Century America." In *The Visual Culture of American Religions,* edited by David Morgan and Sally M. Promey, 49–67. Berkeley: University of California Press, 2001.

Morgan, Jo-Ann. "Mammy the Huckster: Selling the Old South for the New Century." *American Art* 9, no. 1 (Spring 1995): 87–109.

Morgan, Thomas L., and William Barlow. *From Cakewalks to Concert Halls: An Illustrated History of African American Popular Music from 1895 to 1930.* Washington, DC: Elliott and Clark, 1992.

Morrison, Toni. *Beloved.* New York: Penquin Books, 1988.

———. *Playing in the Dark: Whiteness and the Literary Imagination.* Cambridge: Harvard University Press, 1992.

Mosby, Dewey F. *Across Continents and Cultures: The Art and Life of Henry Ossawa Tanner.* Kansas City: Nelson-Atkins Museum of Art, 1995.

Mosby, Dewey F., and Darrell Sewell. *Henry Ossawa Tanner.* Philadelphia: Philadelphia Museum of Art, 1991.

Nathan, Hans. *Dan Emmett and the Rise of Early Negro Minstrelsy.* Norman: University of Oklahoma Press, 1962.

———. "The Performance of the Virginia Minstrels." In *Inside the Minstrel Mask: Readings in Nineteenth-Century Blackface Minstrelsy,* edited by Annemarie Bean, James V. Hatch, and Brooks McNamara, 35–42. Hanover, NH: Wesleyan Press, 1996.

Nochlin, Linda. "The Imaginary Orient." *Art in America* 71, no. 5 (May 1983): 119–31, 186–90.

Nord, David Paul. "The Evangelical Origins of Mass Media in America, 1815–1835." *Journalism Monographs* 88 (1984): 1–31.

———. "Religious Reading and Readers in Antebellum America." *Journal of the Early Republic* 15, no. 2 (1995): 241–72.

Nott, Josiah C., and George R. Gliddon. *Types of Mankind; or, Ethnological Researches, Based upon the Ancient Monuments, Paintings, Sculptures, and Crania of Races.* Philadelphia: Lippincott, Grambo, 1854.

O'Gorman, James F. *Accomplished in All Departments of Art: Hammatt Billings of Boston, 1818–1874.* Amherst: University of Massachusetts, 1998.

———. "H. and J. E. Billings of Boston: From Classicism to the Picturesque." *Journal of the Society of Architectural Historians* 42, no. 1 (March 1983): 54–73.

Osterweis, Rollin G. *The Myth of the Lost Cause.* Hamden, CT: Archon Books, 1973.

Parry, Ellwood. *The Image of the Indian and the Black Man in American Art, 1590–1900.* New York: George Braziller, 1974.

Patten, Robert L. *George Cruikshank's Life, Times, and Art.* 2 vols. Cambridge: Lutterworth, 1992, 1996.

Pictures and Stories from "Uncle Tom's Cabin." Boston: John P. Jewett, 1853.

Pieterse, Jan Nederveen. *White on Black: Images of Africa and Blacks in Western Popular Culture.* New Haven: Yale University Press, 1992.

Pilgrim, David. "The Tom Caricature." Ferris State University, December 2000. http://www.ferris.edu/news/jimcrow/tom.

Pollard, Edward A. *The Lost Cause: A New Southern History of the War of the Confederates.* New York: E. B. Treat, 1867.

Porter, James A. *Modern Negro Art.* New York: Arno Press, 1969.

Powell, Lawrence. *New Masters: Northern Planters during the Civil War and Reconstruction.* New Haven: Yale University Press, 1980.

Quarles, Benjamin. *Am I Not a Man and a Brother: The Anti- Slavery Crusade of Revolutionary America, 1688–1788.* New York: Chelsea House Publishing, 1977.

Quick, Michael. "Homer in Virginia." *Los Angeles County Museum of Art Bulletin* 24 (1978).

Railton, Stephen. *Authorship and Audience: Literary Performance in the American Renaissance.* Princeton: Princeton University Press, 1991.

Rainey, Sue. *Creating a Picturesque America: Monument to the Natural and Cultural Landscape.* Nashville: Vanderbilt University Press, 1994.

Redmon, Allen. "Mechanisms of Violence and Clint Eastwood's *Unforgiven* and *Mystic River*." *Journal of American Culture* 27, no. 3 (September 2004): 315–28.

Reilly, Bernard F., Jr. "The Art of the Antislavery Movement." In *Courage and Conscience: Black and White Abolitionists in Boston,* edited by Donald M. Jacobs, 47–73. Bloomington: Indiana University Press, 1993.

Reno, Dawn E. *Collecting Black Americana.* New York: Crown Publishers, 1986.

Riggio, Thomas P. "Uncle Tom Reconstructed: A Neglected Chapter in the History of a Book." In *Critical Essays on Harriet Beecher Stowe,* edited by Elizabeth Ammons, 139–57. Boston: G. K. Hall, 1980.

Riss, Arthur. "Racial Essentialism and Family Values in *Uncle Tom's Cabin.*" *American Quarterly* 46, no. 4 (December 1994): 513–44.

Roberts, James. *The Narrative of James Roberts.* Chicago: Printed for the author, 1858.

Ross, Andrew. *No Respect: Intellectuals and Popular Culture.* New York: Routledge, 1989.

Rugoff, Milton. *The Beechers: An American Family in the Nineteenth Century.* New York: Harper and Row, 1981.

Ruskin, John. *The Library Edition of the Works of John Ruskin.* Edited by E. T. Cook and A. Wedderburn. 39 vols. London: George Allen, 1903–1912.

Samuels, Shirley, ed. *The Culture of Sentiment: Race, Gender, and Sentimentality in Nineteenth-Century America.* New York: Oxford University Press, 1992.

Saunders, Frederick, ed. *Festival of Song: A Series of Evenings with the Poets.* New York: Bunce and Huntington, 1866.

Savage, Kirk. *Standing Soldiers, Kneeling Slaves: Race, War, and Monument in Nineteenth-Century America.* Princeton: Princeton University Press, 1997.

Seaman, L. *"What Miscegenation Is! and What We Are to Expect Now That Mr. Lincoln Is Re-Elected."* New York: Waller and Willetts, 1864.

Shaw, Gwendolyn DuBois. *Seeing the Unspeakable: The Art of Kara Walker.* Durham: Duke University Press, 2005.

Sheldon, G. W. "American Painters: Winslow Homer and F. A. Bridgman." *The Art Journal* 40 (1878): 227.

Silber, Nina. *The Romance of Reunion: Northerners and the South, 1865–1900.* Chapel Hill: University of North Carolina Press, 1993.

Simpson, Marc, ed. *Winslow Homer: Paintings of the Civil War.* The Fine Arts Museums of San Francisco. San Francisco: Bedford Arts, 1988.

Smith, Jessie Carney, ed. *Images of Blacks in American Culture: A Reference Guide to Information Sources.* Westport, CT: Greenwood Press, 1988.

Smith, Susan Belasco. "Serialization and the Nature of '*Uncle Tom's Cabin.*'" In *Periodical Literature in Nineteenth-Century America,* edited by Kenneth M. Price and Susan Belasco Smith, 69–89. Charlottesville: University Press of Virginia, 1995.

Spillars, Hortense J. "Changing the Letter: The Yokes, the Jokes of Discourse; or, Mrs. Stowe, Mr. Reed." In *Slavery and the Literary Imagination,* edited by Deborah E. McDowell and Arnold Rampersad, 25–61. Baltimore: Johns Hopkins University Press, 1989.

Steward, James Brewer. *Holy Warriors: The American Abolitionists and American Slavery.* New York: Hill and Wang, 1976.

Stokes, Mason. *The Color of Sex: Whiteness, Heterosexuality, and the Fictions of White Supremacy.* Durham: Duke University Press, 2001.

Stowe, Harriet Beecher. *The Key to Uncle Tom's Cabin, Presenting the Original Facts and Documents upon Which the Story Is Founded Together with Corroborative Statements Verifying the Truth of the Work.* London: Clark, Beeton, [1853].

———. *Uncle Tom's Cabin; Or, Life among the Lowly.* Boston: John P. Jewett, 1852, 1853.

Strother, David Hunter. "Virginia Illustrated: The Adventures of Porte Crayon and His Cousins." *Harper's New Monthly Magazine* 12 (January 1856): 176–77.

Sundquist, Eric J., ed. *New Essays on "Uncle Tom's Cabin."* Cambridge: Cambridge University Press, 1986.

Tanner, Henry Ossawa. "The Story of an Artist's Life." *World's Work* 18 (June and July 1909): 11661–66, 11769–75.

Tatham, David. *Winslow Homer and the Illustrated Book.* Syracuse: Syracuse University Press, 1992.

———. *Winslow Homer and the Pictorial Press.* Syracuse: Syracuse University Press, 2003.

Taylor, Alrutheus Ambush. *The Negro in the Reconstruction of Virginia.* Washington, DC: The Association for the Study of Negro Life and History, 1926.

Taylor, William R. *Cavalier and Yankee: The Old South and American National Character.* New York: George Braziller, 1961.

Teller, James David. *Louis Agassiz, Scientist and Teacher.* Columbus: Ohio State University Press, 1947.

Thurber, Cheryl. "The Development of the Mammy Image and Mythology." In *Southern Women: Histories and Identities,* edited by Virginia Bernhard, Betty Brandon, Elizabeth Fox-Genovese, and Theda Perdue, 87–108. Columbia: University of Missouri Press, 1992.

Toll, Robert C. *Blacking Up: The Minstrel Show in Nineteenth-Century America.* New York: Oxford University Press, 1974.

Tompkins, Jane. *Sensational Designs: The Cultural Work of American Fiction, 1790–1860.* New York: Oxford University Press, 1985.

Truettner, William. "William T. Evans, Collector of American Paintings." *American Art Journal* 3, no. 2 (Fall 1971): 50–79.

Tuckerman, Henry T. *Book of the Artists: American Artist Life.* New York: G. P. Putnam, 1867.

Turner, Patricia A. *Ceramic Uncles and Celluloid Mammies.* New York: Anchor Books, 1994.

Tyler-McGraw, Marie, and Gregg D. Kimball. *In Bondage and Freedom: Antebellum Black Life in Richmond.* Richmond, VA: W. M. Brown, 1988.

Van Deburg, William L. *Slavery and Race in American Popular Culture.* Madison: University of Wisconsin Press, 1984.

Vlach, Michael. *The Planter's Prospect: Privilege and Slavery in Plantation Paintings.* Chapel Hill: University of North Carolina Press, 2002.

Walters, Ronald G. "The Erotic South: Civilization and Slavery in American Abolitionism." *American Quarterly* 25, no. 2 (May 1973): 177–201.

Warhol, Robyn. "'Ain't I de One Everybody Come to See?!' Popular Memories of *Uncle Tom's Cabin.*" In *Hop on Pop: The Politics and Pleasures of Popular Culture,* edited by Henry Jenkins, Tara McPherson, and Jane Shattuc, 650–70. Durham: Duke University Press, 2002.

Washington, Booker T., with Max Bennett Thrasher. *Up from Slavery.* New York: Dover Thrift Edition, 1995. Originally published in 1901.

Weinauer, Ellen M. "'A Most Respectable Looking Gentleman': Passing, Possession, and Transgression in Running a Thousand Miles for Freedom." In *Passing and the Fictions of Identity,* edited by Elaine K. Ginsberg, 37–56. Durham: Duke University Press, 1996.

Weinberg, H. Barbara. "Thomas B. Clarke: Foremost Patron of American Art from 1872 to 1899." *American Art Journal* 8, no. 1 (May 1976): 52–83.

Weisenburger, Steven. *Modern Medea: A Family Story of Slavery and Child-Murder from the Old South.* New York: Hill and Wang, 1998.

Welter, Barbara. "The Cult of True Womanhood: 1820–1860." *American Quarterly* 18 (Summer 1966): 151–74.

———. *Dimity Convictions: The American Woman in the Nineteenth Century.* Athens: Ohio University Press, 1976.

White, Deborah Gray. *Ar'n't I A Woman? Female Slaves in the Plantation South.* New York: W. W. Norton, 1985, 1999.

Wiegman, Robyn. *American Anatomies: Theorizing Race and Gender.* Durham: Duke University Press, 1995.

Williams, Judith. "Uncle Tom's Women." In *African-American Performance and Theater History,* edited by Harry J. Elam Jr. and David Krasner, 19–39. New York: Oxford University Press, 2001.

Williams, Linda. *Playing the Race Card: Melodramas of Black and White, from Uncle Tom to O. J. Simpson.* Princeton: Princeton University Press, 2001.

Williams, Patricia J. *The Alchemy of Race.* Cambridge: Harvard University Press, 1991

Williamson, Joel. *New People: Miscegenation and Mulattoes in the United States.* New York: The Free Press, 1980.

Wilson, Forrest. *Crusader in Crinoline: The Life of Harriet Beecher Stowe.* Philadelphia: J. B. Lippincott, 1941.

Wilson, Judith. "Lifting the 'Veil': Henry O. Tanner's 'The Banjo Lesson' and 'The Thankful Poor.'" In *Critical Issues in American Art,* edited by Mary Ann Calo, 199–219. Boulder: Westview Press, 1998.

Winter, Marian Hannah. "Juba and American Minstrelsy." In *Inside the Minstrel Mask: Readings in Nineteenth-Century Blackface Minstrelsy,* edited by Annemarie Bean, James V. Hatch, and Brooks McNamara, 223–41. Hanover, NH: Wesleyan Press, 1996.

Wolff, Cynthia Griffin. "Margaret Garner: A Cincinnati Story." In *Discovering Difference: Essays in American Culture,* edited by Christoph K. Lohman, 105–22. Bloomington: Indiana University Press, 1993.

———. "Passing Beyond the Middle Passage: Henry Box Brown's Translations of Slavery." *Massachusetts Review* 37, no. 1 (1996): 23–43.

Woll, Allen. *Black Musical Theatre: From "Coontown" to "Dreamgirls."* Baton Rouge: Louisiana State University Press, 1989.

Wood, Forrest G. *Black Scare: The Racist Response to Emancipation and Reconstruction.* Berkeley: University of California Press, 1968.

Wood, Marcus. *Blind Memory: Visual Representation of Slavery in England and America, 1780–1865.* London: Routledge, 2000.

Wood, Peter H., and Karen C. C. Dalton. *Winslow Homer's Images of Blacks: The Civil War and Reconstruction Years.* Austin: University of Texas Press, 1988.

Woods, Naurice Frank. "Lending Color to Canvas: Henry O. Tanner's African-American Themes." *American Visions* 6, no. 1 (February 1991): 14, 17.

Woodward, C. Vann. *Origins of the New South, 1877–1913.* Baton Rouge: Louisiana State University Press, 1951.

Wright, Lesley Carol. "Men Making Meaning in Nineteenth-Century American Genre Painting, 1860–1900." PhD diss., Stanford University, 1993.

Wyatt-Brown, Bertram. *Southern Honor: Ethics and Behavior in the Old South.* New York: Oxford University Press, 1982.

Yarborough, Richard. "Strategies of Black Characterization in *Uncle Tom's Cabin* and the Early Afro-American Novel." In *New Essays on "Uncle Tom's Cabin,"* edited by Eric J. Sundquist, 45–84. Cambridge: Cambridge University Press, 1986.

Yarbrough, Stephen R., and John C. Adams. *Delightful Conviction: Jonathan Edwards and the Rhetoric of Conversion.* Westport, CT: Greenwood Press, 1993.

Yarbrough, Stephen R., and Sylvan Allen, "Radical or Reactionary: Religion and Rhetorical Conflict in Uncle Tom's Cabin." In *Approaches to Teaching Stowe's "Uncle Tom's Cabin,"* edited by Elizabeth Ammons and Susan Belasco, 57–67. New York: Modern Language Association of America, 2000.

Yellin, Jean Fagin. *Women and Sisters: The Antislavery Feminists in American Culture.* New Haven: Yale University Press, 1989.

Young, Elizabeth. *Disarming the Nation: Women's Writing and the American Civil War.* Chicago: University of Chicago Press, 1999.

Young, Robert J. C. *Colonial Desire: Hybridity in Theory, Culture, and Race.* New York: Routledge, 1995.

Index